THE WORLD'S BEST
ADVERTISING PHOTOGRAPHY

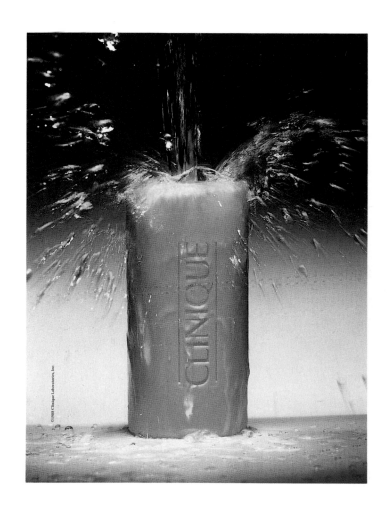

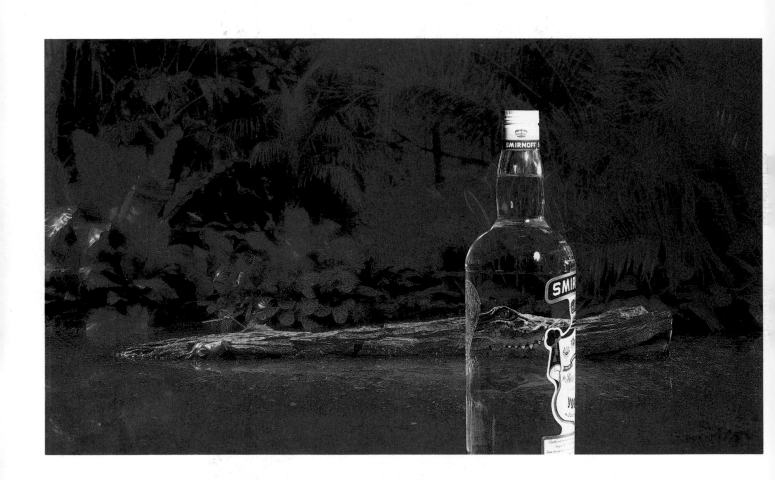

THE WORLD'S BEST
ADVERTISING PHOTOGRAPHY

DAVE SAUNDERS

B.T. BATSFORD LTD · LONDON

To Paul for his vision

© Dave Saunders 1994
First published 1994
Reprinted 1995

Typeset by Servis Filmsetting Ltd, Manchester

and printed in Hong Kong

for the publishers

B.T. Batsford Ltd
4 Fitzhardinge Street
London W1H 0AH

ISBN 0 7134 6925 0

A CIP catalogue record for this book is available from the British Library

Agency (A), Creative director (CD), Art director (AD), Copywriter (CW), Photographer (P), Model (M)

Previous pages:

Clinique (A) In-house, UK (P) Irving Penn

Smirnoff (A) Lowe Howard-Spink, UK (AD) John Merriman (P) James Cotier

Campbell Distillers (A) BMP DDB Needham, UK (AD) Mark Reddy (CW) Richard Grisdale (P) Jean-Baptiste Mondino

CONTENTS

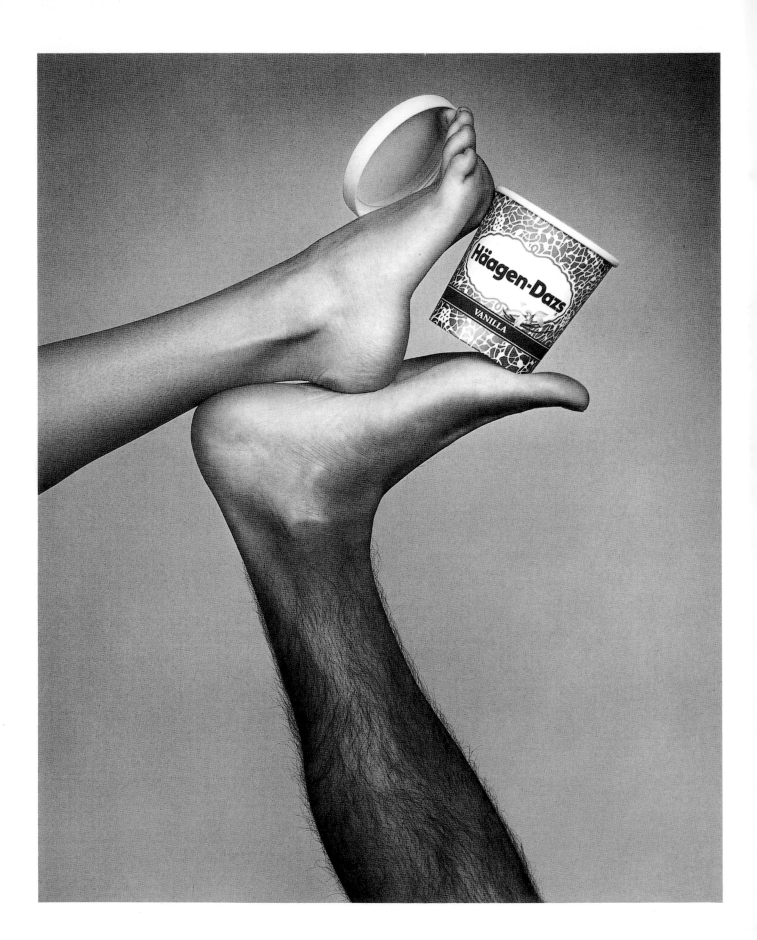

FOREWORD

Many of the people in this book have made a profound impact on me and my work. For this I am eternally grateful.

As I read through the manuscript, I remembered most of the shots and advertisements by heart. Maybe it was the photographer, the art director's name that made me remember. In the end, it's the picture, isn't it?

I hope this book helps you. It is a craft to do great work. And an honor to let my words go before such a group I've valued all these years.

David Jenkins
Creative Director, DDB Needham, Chicago

Häagen Dazs (A) Bartle Bogle Hegarty UK (AD) Rooney Carruthers (P) Barry Lategan

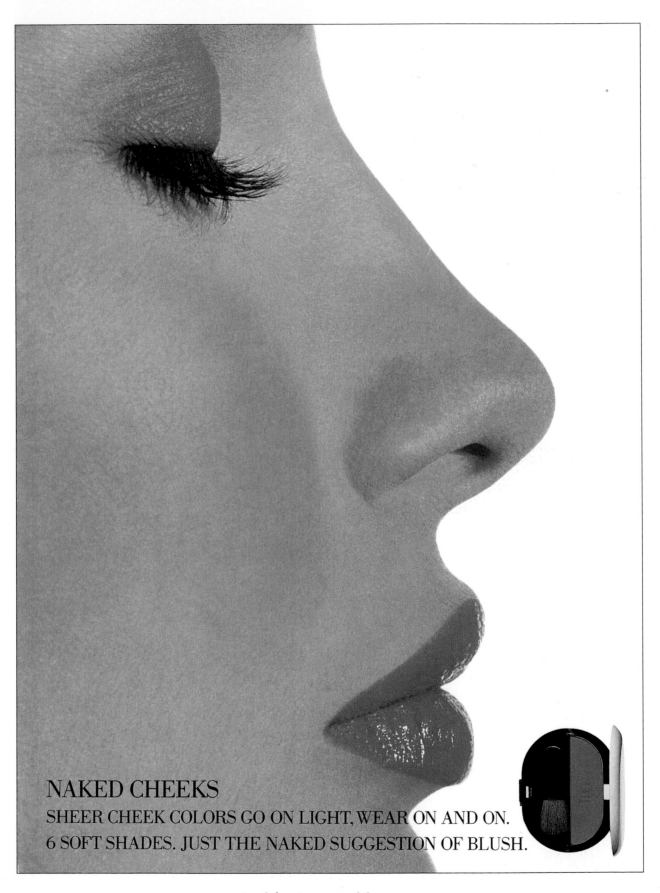

NAKED CHEEKS

SHEER CHEEK COLORS GO ON LIGHT, WEAR ON AND ON.
6 SOFT SHADES. JUST THE NAKED SUGGESTION OF BLUSH.

Revlon (A) In-house, USA (P) Irving Penn

ADAGE

THE SUCCESS OF EXCESS

Remember those surreal Benson & Hedges ads? And VW's disarming charm . . . Vuitton's extreme cases . . . Absolut originality . . . and the United Colors that divided loyalties? The golden age of print advertising gave us an ever-present, ever-changing art gallery. Our streets and magazines were adorned with dream-feeding, brain-teasing, rib-tickling soft sellers. You hold in your hands a celebration (and dissection) of the age of excess – an era when Annie Leibovitz was given her head; Richard Avedon turned fashion on its head; Irving Penn flaunted Issey Miyake; Albert Watson strutted DeBeers; Horst and Helmut Newton revelled in legs; Duncan Sim and Jean Larivière went to the ends of the earth; Jay Maisel relaunched luxury liners; Terence Donovan recreated Casablanca; Patrick Demarchelier redefined YSL opulence; Pamela Hansen romped with bras; Oliviero Toscani had fun with tongues; and all was peaches and cream for Michael Joseph. Then the climate changed. Sebastiao Salagado brought grain into Le Creuset's kitchen; Nadav Kander helped Dunham put the boot on the other foot; David Bailey gave us 40 dumb animals and AIDS: and Benetton turned the green bandwagon multi-coloured.

Extravagance seemed unseemly; no one gave a XXXX about lifestyle; and cigarette advertising was all but snuffed out. This is the story of the time when some of the world's best art directors and photographers were let loose with adrenalin-releasing budgets.

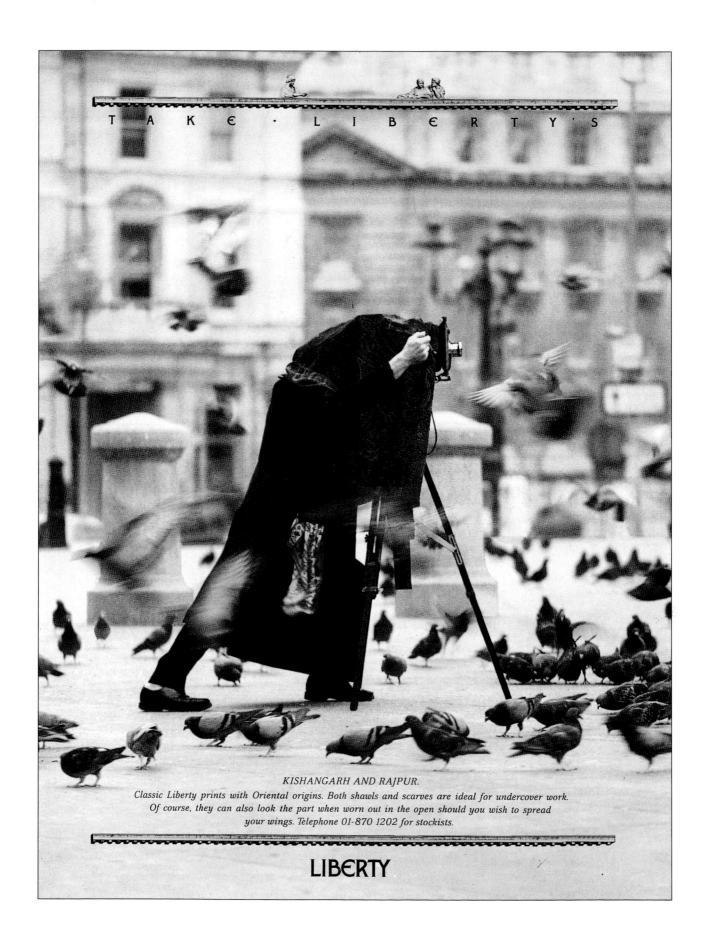

KISHANGARH AND RAJPUR.

*Classic Liberty prints with Oriental origins. Both shawls and scarves are ideal for undercover work.
Of course, they can also look the part when worn out in the open should you wish to spread
your wings. Telephone 01-870 1202 for stockists.*

LIBERTY

ADVOCATE

ART DIRECTORS . . . ON PHOTOGRAPHERS

At one point I decided to use Irving Penn for quite a simple still life. He shot a lot of angles, and the next day in the mail I received an envelope with one 8 × 10 transparency mounted in a frame. I called and asked when I'd get the rest. Penn's assistant told me that Irving had chosen the picture. Didn't he tell you he picks the picture?
Charlie Piccirillo (DDB Needham, New York)

There's not much point in paying people huge sums of money if you're going to deny them their skill and talent.
Frank Lowe (Lowe Howard-Spink, London)

I'm most pleased when a photographer comes up with something I wouldn't have thought of myself. That surprises me and enhances the concept of the ad.
Tom Lichtenheld (Fallon McElligott, Minneapolis)

Liberty Scarves (A) Bartle Bogle Hegarty, UK (AD) Robbert Jansen (P) Andreas Heumann

11

It's quite difficult bringing a photographer in early on, because you don't know where you're going. It's like trying to book a restaurant before you know which town you're going to be in. If photographers want to contribute ideas, then go and shoot ideas and let people see them.
John Hegarty (Bartle Bogle Hegarty, London)

You hire a plumber to do the plumbing. I try to choose the person best suited to the job, then give him or her every opportunity to do the job well.
David Jenkins (DDB Needham, Chicago)

It's very important that the photographer understands and agrees with the concept of an ad before shooting it. You don't need a good rapport with the photographer; if there's a bit of friction, they want to prove a point to you. That can give a better result.
Henry Wolf (Art Directors Club, New York)

If you've got a relationship with the photographer and he knows exactly what you're talking about, you can afford not to turn up on the shoot. The tighter the pre-production meeting, the looser the shoot. You give someone all the parameters they need.
Mark Denton (Simons Palmer Denton Clemmow & Johnson, London)

You seldom go to a photographer for an idea. An advertising photographer is someone who executes your idea. Someone with a good lighting technique and good organization. Then there's another type of photographer, people like Guy Bourdin. They are their own men, but when you can get them under control and they're still flying, that's when something really happens. That makes it exciting.
Paul Arden (Saatchi & Saatchi, London)

You must allow the photographer total and utter freedom. If you corner them and tell them what you want, what's the point of working with that person in the first place?
Alexandra Taylor (Saatchi & Saatchi, London)

I am not capable of taking the picture myself, but I want him to know how I feel about it. Then I want him to make two and two equal five. If he makes it equal four, I feel really disappointed.
Billy Malwinney (J. Walter Thompson, London)

It's about trust. You always hope to get something a little unexpected, that 10 per cent extra. That's the thrill.
Nigel Rose (Collett Dickenson Pearce, London)

I'm not looking for a photographer just to execute my idea exactly. It's a collaboration, and hopefully it will be turbocharged by what they bring to it. I have very strong opinions, but I'm willing to listen to anybody, and will abandon my ideas the moment someone brings something better.
Dennis D'Amico (Lowe & Partners, New York)

The difference between picking the right photographer and the wrong one is the difference between winning some awards and not winning anything.
Graham Fink (GGT, London)

The hardest part is choosing a photographer who is in sympathy with what you're doing, not because he's fashionable. I try to choose photographers who can add their 30 per cent to my 70 per cent and give you 110 per cent.
Peter Harold (WCRS, London)

In advertising photography you are selling with a camera. You're not just taking pictures. You must not let the photographic skill get in the way of a commercial communication.
Robin Wight (WCRS, London)

The photography should not shout 'I've done something clever here'. Its contribution must manifest itself within the culture and atmosphere of the conceptual idea. To add bite and originality to that idea.
Neil Godfrey (Collett Dickenson Pearce, London)

I don't think you direct *people like John Claridge; I think art direction is the wrong name for what we do. I don't direct, I work in advertising.*
Brian Stewart (Delaney Fletcher Slaymaker Delaney Bozell, London)

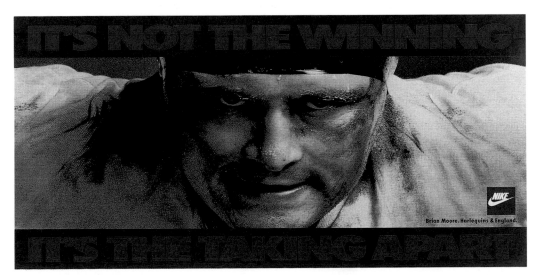

Nike (A) Simons Palmer Denton Clemmow Johnson, UK (AD) Mark Denton (P) Malcolm Venville

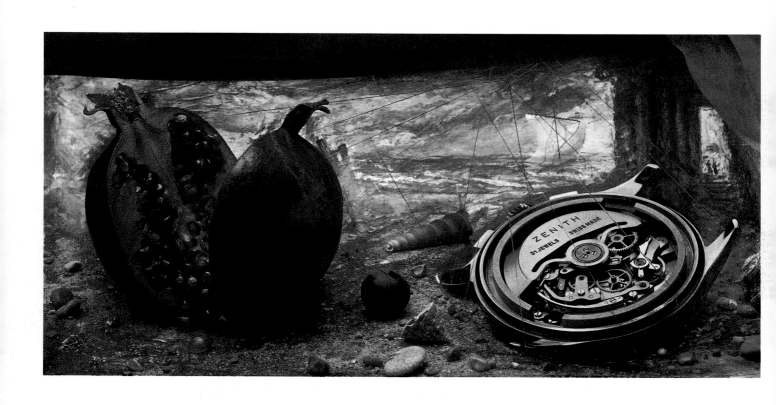

Zenith Watches (A) Indipendenti, Italy (CD) Roberto Brandi (P) François Gillet

CHAPTER 1

ADDUCE

IDEAS

You're out there, sandwiched between other ads, trying to be noticed. You have something to say, but nobody's listening.

You're an ad. You cost a serious amount of money to produce and you are now on a test run. First, there was a brief from the client to the ad agency. He wanted to sell widgets. Then came research into widgets and their market. A planner unjumbled the figures and formulated a strategy. An art director and copywriter submerged themselves in the statistics, then scribbled out reams of rough sketches – most of which went in the bin. They took six of the best to the creative director, who chucked out four. The client threw out another, leaving one. One idea for an ad. A photographer was called in to turn the layout into a picture. He produced his interpretation of the brief, which was then shuffled around on the page with a headline, copy and logo, to produce 'you'. The finished ad.

The question now is: 'Will you be strong enough to stand up in a harsh world?' You have to break through people's defences and lasso their attention for long enough to plant your message. The seed.

'Ads should slap you in the face, then kiss you.'
Jeff Weiss, creative director, Margeottes Weiss Fertitta, New York

All ads have a job to do. Some do it with sensitivity and style. Others don't. Some – like snipers – aim for the head or heart. Some – like perfume – envelop you in an aura of seductive fragrance. Others delve into the hidden recesses of your mind and touch subconscious nerves. A good ad leaves you wondering how the advertiser knew so much about you.

> *'People buy things from the gut; nearly every decision is made from the heart, not the head. If that wasn't the case, people wouldn't buy all sorts of cars, dresses and perfumes.'*
> Frank Lowe, chairman of the Lowe Group, London

How do some ads manage to wrap themselves around our emotions? Why do some ads succeed where others go unnoticed? How do ads make people want something they didn't know they wanted, or didn't know even existed?

Ideas. Great ideas. Ideas which are inspirational enough to open the lines of communication, then deliver the message in a digestible form.

Photographs help; they are powerful tools which can both attract attention and give information. They can stop you, and talk to you. Photographs give a tone, a feeling, an attitude. Irving Penn's photographs for Clinique express the client's point of view without words. Clinique is not a particularly expensive brand, but it *looks* expensive.

Who has these ideas? And how do they get them?

'I've never heard of a photographer having an idea.' David Ogilvy, now over 80, is co founder of Ogilvy & Mather, one of the world's largest advertising agencies, employing 6000 people in some 140 offices in over 40 countries. 'Oh yes I have,' he says, 'Elliott Erwitt. One of my biggest boasts is that I was the first to use Elliott Erwitt for advertising.'

That was in the early 1950s when, says Erwitt, 'the agency was a teensy little shop'. For one ad Erwitt had to show that the cellist, Pablo Casals, was returning to his native Puerto Rico for a music festival. The obvious solution would have been to show Casals playing the cello, but he wasn't there. Erwitt's idea was to photograph a room with a cello leaning against a chair. Ogilvy called it an immortal photograph with that magic element – story appeal.

'My advertising pictures that I like most are the ones that *work*,' says Erwitt. 'The ones that have been successful in their purpose, which is generally to sell something.'

Elliott Erwitt was born in Paris in 1928. His interest in photography was born at Hollywood High School. At 20, he moved to New York and now lives in an apartment overlooking Central Park. He began by photographing eminent authors for book jackets, then met Edward Steichen, Roy Stryker and Robert Capa, each of whom helped steer his career. In 1953 he became a member of Magnum Photos, six years after it was founded. Magnum photographers were storytellers who initiated, shot and edited their own stories.

> *'The question you have to ask yourself is "Do you think Cartier-Bresson could have taken the pictures he took if he had been briefed by an advertising art director?"'*
> Terence Donovan, photographer, London

Editorial photographers are currently in vogue with art directors. Sebastião Salgado, Don McCullin, Annie Leibovitz and Pamela Hanson are all used to great effect in some of the most

16

persuasive advertising. Within the strategy of the campaign, they are employed to *take*, rather than *make* a photograph. They are given a brief then let loose to seek out images which epitomize that brief.

The alternative is to construct a picture from a carefully conceived and drawn layout. As you pick and dip your way through this book you will find superb examples of each approach.

'Editorial photographers produce more convincing ads. Like the police campaign by Don McCullin.'
Derrick Hass, head of art, Publicis, London

Puerto Rico Tourist Board (A) Ogilvy & Mather, USA (AD) David Ogilvy (P) Elliott Erwitt

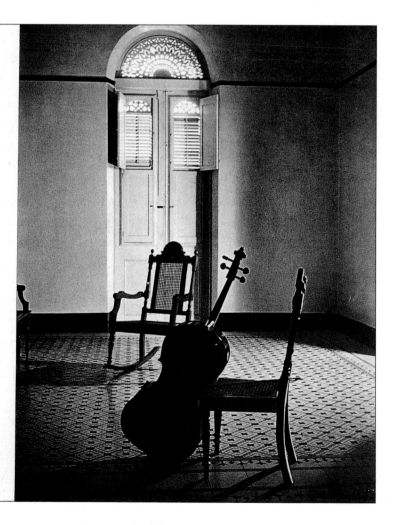

Pablo Casals is coming home – to Puerto Rico

THIS SIMPLE ROOM is in his mother's home at Mayaguez. The first concert Casals ever gave in Puerto Rico was from the balcony of this house last year—just beyond that fanlight.

While his mother's kinsmen listened from the street, Casals played her lullaby, smoked his pipe and wept.

The back of that armchair bears an inscription in Casals' own handwriting. "Este es mi sillón." This is my rocking chair.

Here are gentle thoughts from the world's greatest cellist—on Puerto Rico, the sea and himself:

"The first time I was aware that I was alive, I heard the sound of the sea. Before, I would have said that the most beautiful sea was the one I had in front of my Spanish house. But now I must confess that the sea I am looking at this moment is even more beautiful."

Of his plans for the future, Pablo Casals had this to say:

"The natural thing that occurs to me, is to come back to Puerto Rico and to do for this country everything within my power. I will be back for the festival I have planned for this coming Spring."

PUERTO RICO'S GREAT NEW MUSIC FESTIVAL IN SAN JUAN

The Casals Festival in San Juan opens on April 22nd and will continue through May 8th. Pablo Casals will conduct or perform at each of twelve concerts.

The Festival Orchestra brings together fifty-four of the world's most talented musicians. Principal performers include: Mieczyslaw Horszowski, Eugene Istomin, Milton Katims, Jesus María Sanromá, Alexander Schneider, Rudolf Serkin, Gérard Souzay, Maria Stader, Isaac Stern, Joseph Szigeti.

Two chamber music concerts will feature the Budapest String Quartet.

For further details, write Festival Casals, P. O. Box 2672, San Juan, Puerto Rico; or to 15 West 44th Street, New York 17, N. Y.

Commonwealth of Puerto Rico, 579 Fifth Avenue, New York 17, N. Y.

Living room of the house where Casals' mother was born—in Mayaguez, ▶ Puerto Rico's third largest city. Photograph by Elliott Erwitt.

It was art director Graham Fink's idea to use British war photographer Don McCullin to shoot the recruitment campaign for the Metropolitan Police, a client of Collett Dickenson Pearce. He wanted to give the ads a gritty, editorial feel which portrayed the harshness of the subject.

'If you don't pick the right photographer,' says Fink, 'it's your reputation that suffers. Don McCullin is a photojournalist who keeps asking what the headline says. He makes the picture work for your ad, whereas most photographers concentrate on the picture and don't care what the ad is about.'

Don McCullin's three decades of war photographs stand as a powerful witness to man's inhumanity to man. His career began in the Royal Air Force, where he worked as a photo-technician, and he has been travelling ever since. His photographic career was launched in 1959 when his pictures started to appear in the *Observer*. He then worked for the *Sunday Times* under the editor, Harold Evans.

Metropolitan Police (A) Collett Dickenson Pearce, UK (AD) Graham Fink (P) Don McCullin

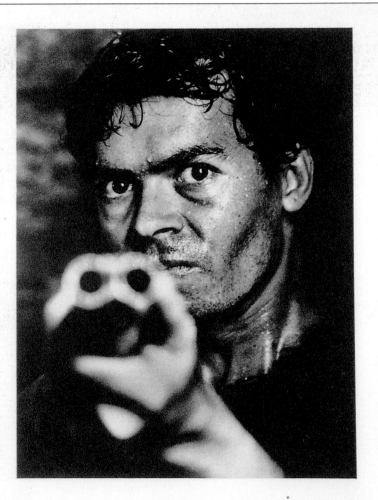

McCullin's approach was to move in close to the action. His involvement took him within a hair's breadth of his life . . . he was badly hit by mortar in Phnom Penh, fell through a roof in El Salvador and was saved by his Nikon from an AK-47 shot in Cambodia.

He now accepts advertising assignments, and Graham Fink chose McCullin to illustrate the theme of confrontation, with a disarmingly powerful shot, which echoed McCullin's experiences in the field. Art director Neil Godfrey, who took over the campaign, and copywriter Indra Sinha demonstrated street-level confrontation in a less obvious, yet equally arresting way. Although spitting cannot harm you physically, it is an outrageous invasion of someone's space, and triggers strong feelings of revulsion and distaste. Knowing that the picture is in fact a composite of three separate images and the spit is a mixture of white chocolate and lemonade, does not detract from its impact.

Metropolitan Police (A) Collett Dickenson Pearce, UK (AD) Neil Godfrey (CW) Indra Sinha
(P) Don McCullin

COULD YOU TURN THE OTHER CHEEK?

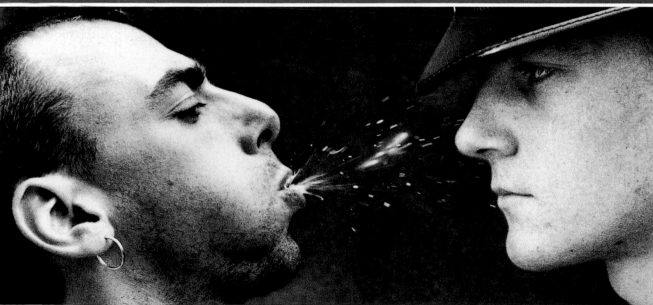

'Merely to let your imagination run riot, to dream unrelated dreams, to indulge in graphic acrobatics and verbal gymnastics is NOT being creative. The creative person has harnessed his imagination.'
Bill Bernbach, Doyle Dane Bernbach, 1911–1982

One technique Graham Fink uses to help him produce ideas is to walk around with his eyes half closed in order to see things differently. 'If you don't quite see something, you might think it's something else', says Fink. 'That can trigger an idea.'

For the same reason, he keeps his office dark and full of bizarre paraphernalia. It's like a curiosity shop, with a small table lamp, mannequin model wearing a cowboy hat, a robot, duck, papers stacked high, piles of books, sweatshirt draped over the saddle of a bicycle, records, prints and proofs scattered on the floor, television screens, loudspeakers, cans of Diet Coke and a toy lion.

'The boundaries between editorial and advertising photography have shifted considerably; they are now very thin.'
Albert Watson, photographer, New York

London photographer John Claridge *takes* pictures and *makes* them, depending on the circumstances. With over 20 years experience in advertising, Claridge knows the rules of the game and applies them with a clear understanding of the purpose of the communication. Claridge was born in London's East End, left school at 15, worked in the photographic department of McCann Erickson for a couple of years, then became assistant to photographer David Montgomery. At 19, he began on his own as an advertising photographer.

On one assignment for a relatively small client, art director Derrick Hass and copywriter Howard Fletcher felt it was worth blowing the entire budget on the photographer's fee. Using a lesser photographer could have resulted in a very patchy print. 'We did it as a freelance job and were given a meal as payment, because we used all our fee to buy Claridge', says Hass.

Richard Taylor of The Covent Garden Art Company briefed Hass over the phone: 'We want to promote the *make-up* side of our service – typography, mechanicals, type, paste-up.'

The ad had to get through to art directors, who are continually bombarded with all sorts of ideas and propositions. 'The word "make-up" fixed itself in my mind', says Hass. 'Make-up took me to "face". I envisaged page make-up as face make-up. And "face" is typeface. That gave me a totally relevant visual image with lots of visual puns.'

Hass and Fletcher took a rough of the ad to the briefing lunch with the client. They loved it. Claridge shot it, shifted up one eye and eliminated the nose in the darkroom. The ad appeared in *Campaign* magazine and also went out as a mailshot. As a result, the company had to work weekends to keep up with the increase in orders.

If you are outrageous for the sake of it, people won't recognize what you're trying to say – your proposition. They are not *looking* for ads; the ads must go out to meet them, but without overdoing it.

The London agency Saatchi & Saatchi produced an innovative and moving *pro bono publico* ad to raise awareness of motorneuron disease. The disease is fatal and results in rapid wasting of

the muscles. The ad hinged on the idea of a fading poster. First came the idea, then they set about seeing if it could be done. Eventually, a printer suggested leaving out the chemical fixer when printing the photograph on the poster. Over a period of three weeks, the image of the person in the photograph faded to nothing, while the words remained.

'Most people have seen it all; they are overloaded with visual clutter.'
Richard Noble, photographer, Los Angeles

Covent Garden Art Company (A) Freelance, UK (AD) Derrick Hass (CW) Howard Fletcher
(P) John Claridge

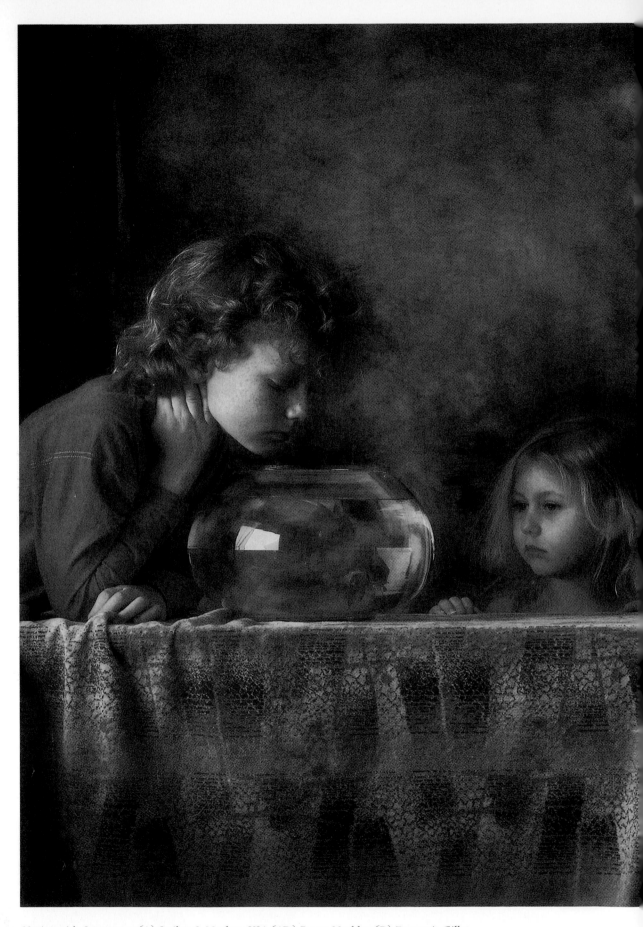

Nationwide Insurance (A) Ogilvy & Mather, USA (AD) Parry Merkley (P) François Gillet

Their questions were endless:
Can we feed them again yet?
Will they be okay
 when we turn out the lights?
Do fish sleep
 at the bottom of the bowl?

They finally went to sleep after
 I answered every question.
But I was left awake
 with one of my own...
What would happen to them
 if something happened to me?

――――――

Nationwide® is on your side
 with Home, Automobile,
 and Life Insurance...

N NATIONWIDE
 INSURANCE

French photographer François Gillet was approached by Parry Merkley, creative director with Ogilvy & Mather in New York, to develop themes for a Nationwide Insurance campaign. The photograph of the two children and a goldfish bowl was his own idea. 'Parry came to me without any sketch or rough, but he knew what he was after', says Gillet. 'It's a very unusual way to work, especially in the US, but it is a good approach to the problems requiring more sophisticated, human solutions.'

Gillet's first love was for art. While at school in France, he took evening drawing classes and later wanted to pursue a career in art. Ironically, he considered his painting to be 'too sacred to prostitute' to the commercial world. He studied photography at Bournemouth College of Art in England, then moved to Stockholm, where he worked in a commercial photography studio, and where he now has his own studio. Today, large format film is the canvas on which he creates his art.

'Advertising presents me with the opportunity to express myself and communicate with millions of individuals,' says Gillet; 'it's the dream of many artists. It gives me the constant proof that someone, somewhere appreciates my work.'

Car ads have a great propensity for looking like wallpaper. In the 1960s, the New York agency Doyle Dane Bernbach revolutionized the industry's approach to advertising with their cobweb-clearing, self-deprecating ads for Volkswagen. They talked to the reader as an intelligent friend.

'Our theory was to strip away the extraneous, and get down to the core', says Charlie Piccirillo, creative director with DDB Needham, New York. 'We used the three Ss: simple, surprise and a smile. Ads are not simple any more. I hope that advertisers will recognize that people have less time for ads these days and we have to be more focused, sharper, simpler and more postery. Otherwise people will be wasting an awful lot of money.

'The agency was criticized for being very 'New York', with Jewish writers and Italian art directors. But out of that came a wit and an Italian break-yer-knees kind of graphics to make you *feel* it, not just see it. We used intuition a lot; now we use research.

'Today we're so conscious of the changing man, but in advertising we should address the unchanging man, because we are trying to reach his loves, his anger, his emotions, his human nature, which never changes. He is still going to want a car that impresses people. He is still going to want to take care of his children. Those are the drives on which people buy products. Volkswagon ads are still reaching those places.'

'Be provocative. But be sure your provocativeness stems from your product. You are NOT right if in your ad you stand a man on his head JUST to get attention. You ARE right if you have him on his head to show your product keeps things from falling out of his pockets.'
Bill Bernbach, Doyle Dane Bernbach, 1911–1982

Piccirillo created the ad of a guy standing on an upturned car, photographed by David Langley. Like most of the VW ads, the photography was straightforward and was used to illustrate the idea simply and starkly. Helmut Krone, who originated the classic VW campaign, first chose New York photographer Wingate Paine for the gutsy quality of his black and white work. Paine shot everything with natural light and Krone wanted that simple, unlit look. Other VW ads were

subsequently shot by many different photographers, yet all the pictures looked alike because they all used the same technique. Today, several VW ads do not include the product, and the best ones still stay with you long after you turn away.

'We believe in presenting emotional images which succeed more than so-called unique selling propositions, which are in fact weak and tedious.'
Marcel Bleustein-Blanchet, chairman, Publicis, Paris

Art and soul. Is advertising ever really art? That depends on your definition of art. Certainly, some of the thought processes employed are similar to those experienced by someone creating art, and much advertising has a lot of artistry in it. The inspiration can come from the heart, and it should aim to touch the heart. But it must also do a very practical job. The art must be applied art.

'I warn you against believing that advertising is a science.'
Bill Bernbach, Doyle Dane Bernbach, 1911–1982

Volkswagen of America (A) Doyle Dane Bernbach, USA (AD) Charlie Piccirillo (CW) Mike Mangano (P) David Langley

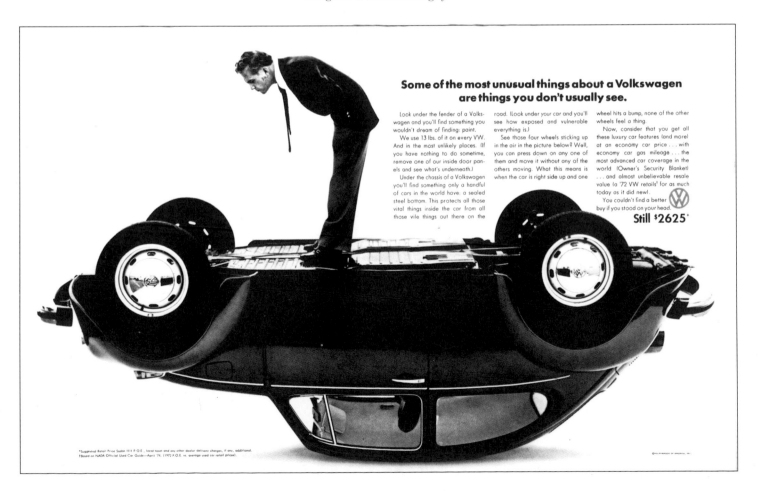

Or look at it another way. The heart and craft of advertising. Well-crafted ads can do a perfectly adequate – if prosaic – job. Whereas ads from the heart reach out to the emotions of the audience. It is true you can be technically adept at playing musical notes, yet *real* music comes from the heart, not the head. For some reason, many clients find it hard to believe that you can use art to sell products.

> *'If there is an enduring quality to it, it's art. It has to make a profound emotional impact –*
> *anger, love, sorrow.'*
> David Jenkins, creative director, DDB Needham, Chicago

Eggs. How do you get people interested in eggs? That was the question underlying the strategy behind the campaign for the Swedish Egg Producers. The Stockholm agency Hall & Cederquist opted for a set of images that were striking in their simplicity. 'We decided to look upon eggs, not as a food, but as an ancient symbol of life', says creative director, Mats Alinder. 'We therefore present them as pieces of art rather than everyday objects. If you want people to view eggs in a new way, you have to present them in a new way – dramatic, tempting, beautiful – anything but ordinary.'

Stockholm photographer Björn Keller discussed the concept and the roughs with the agency then photographed a series of six posters, which proved popular as art prints, as well as effective as ads.

> *'The goal is to say the most with the least.'*
> Arthur Meyerson, photographer, Houston

Great ideas can carry the imagination onto higher planes. Not surprisingly, some of these ideas fly over the heads of those whose feet are welded to the ground. Since new ideas can only be brought into existence by those who question existing ones, there's often an edge of rebelliousness among creative people.

> *'The most exciting moment is when you have a white sheet of paper and can draw on it.*
> *The way you imagine the ad's going to turn out, is the best it will ever be. From there, it's*
> *usually downhill.'*
> Malcolm Gaskin, creative director, Woolloms Moira Gaskin O'Malley, London

'There is a "creative process", and it doesn't involve staring at a blank sheet of paper', says Jay Chiat, chairman of Chiat Day, New York. 'You start the process by gathering all the material and consuming it. You then take a break for a while, before revisiting the material and the problem you are trying to solve. Then you let it gestate . . . go to a movie or read a book. Get away from it and let your subconscious work on it. Then revisit it again. This time, usually, you'll have an idea.'

Swedish Egg Producers (A) Hall & Cederquist, Sweden (AD) Mats Alinder (CW) Christer
Wiklander (P) Björn Keller

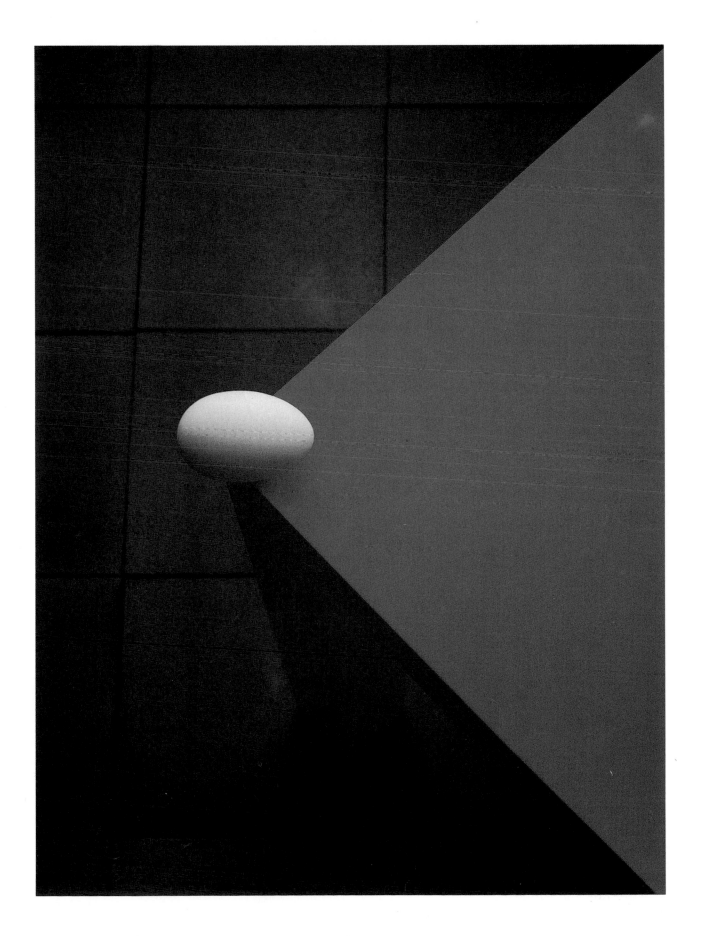

'One of the greatest pains to human nature is the pain of a new idea.'
Walter Bagehot, 1826–1877

When Ole Strøm, creative director at Avanti DDB Needham in Oslo, was faced with the task of advertising the *Guinness Book of Records*, he turned to the material and consumed it. He found a nugget of information and, using one of advertising's most cherished weapons – hyperbole – he turned it into an image with a discordant headline which draws the audience irresistibly into the ad: 'They had to get married.'

Strøm discovered that in 1986, there was a wedding in Bangladesh between an 11-month-old boy and three-month-old girl. They had to get married in order to end a long-running feud between two families over a farm. 'Our aim was to be surprising, easy to understand and humorous', says Strøm.

'The larger an art director's ears, the bigger the ad.'
David Jenkins, creative director, DDB Needham, Chicago

Many art directors have come to terms with the fact that there are no new ideas, only old ideas with new coats of paint. We live in a derivative world where absolute originality is rare indeed. Given one alphabet and one camera, there are only so many ways in which you can put out a message. Yet there is much to commend a new coat of paint and much to be gained by capitalizing on a product's heritage.

Like kids, animals help sell products. Koalas, horses and tigers trigger an association with a specific product promotion. This visual shorthand is generally more appealing and memorable than a logo, because it communicates on an emotional level, drawing on the viewer's response to the perceived characteristics of the animal. For example, besides being beautiful, powerful and smoothly agile, the tiger conveys a sense of confidence and supremacy which the consumer is happy to adopt. Esso/Exxon put these associations to good use by comparing the tiger with an engine.

People recall advertising that has not run for 15 years. Slogans and symbols that click last for ever. People perceive them as being synonymous with a particular brand. When advertising a brand with an existing history, you ignore this history at your peril. Another agency may have invested heavily to create this identity. Now that your agency is custodian of the brand for a few years, it's not always so clever to seek originality, and bypass a well signposted short-cut. It's hard enough to get people to remember your brand, so, if it already has a momentum, simply revitalize it with a new coat of paint, and your investment will go a lot further.

In the late 1950s, journalist John Cameron Swayze immortalized a slogan for Timex watches: 'Takes a licking and keeps on ticking.' The line is proving to be as enduring as the watches. It has been used on and off ever since, and is one of the top ten remembered advertising slogans in America.

'A great idea makes me gasp when I first see it; it is one I wished I had thought of; it's unique; it fits the campaign strategy to perfection; and it could be used for 30 years.'
David Ogilvy, co-founder and chairman of Ogilvy & Mather

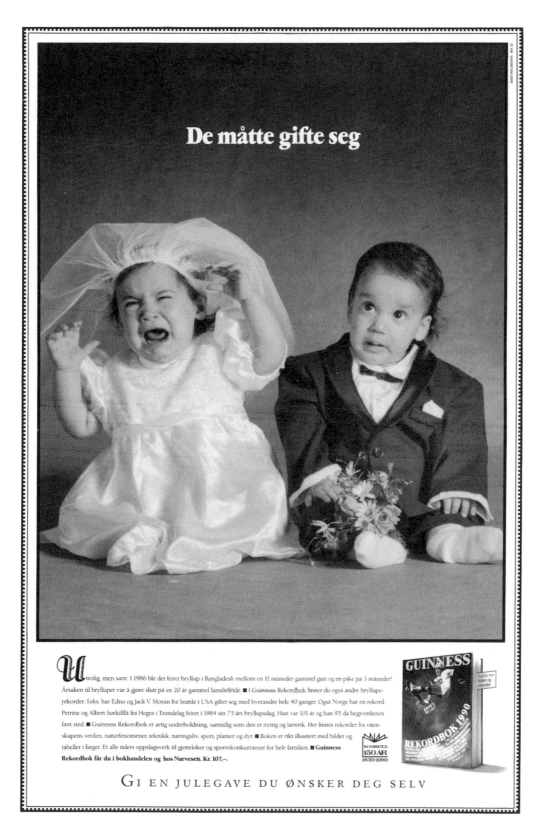

Timex moved its $15 million account to the Minneapolis agency Fallon McElligott in 1987, because the company was looking for a creative agency that could update the Timex tradition and show it in a contemporary manner. The agency, which has created a flow of memorable ads for *Rolling Stone* magazine, Porsche, Hush Puppy and Lee Jeans, produced a series of television commercials that were spoofs of old torture test commercials Timex had done in the 1960s. 'When my former partner, Houman Pirdavari, and I were thinking of ideas for the print campaign, we wanted to use the "Takes a licking and keeps on ticking" theme, but we couldn't do torture tests in print', says copywriter Bruce Bildsten.

They hit on the idea of featuring people who had taken a licking and kept on ticking, and this formed the strategy of the campaign. 'Americans are fascinated by stories about ordinary people who have done or survived something extraordinary', says Bildsten.

'We chose Hiro, the New York-based photographer, for the "Extraordinary People" campaign because he is simply one of America's greatest portrait photographers. And his work isn't overtly stylized, so we knew his portraits wouldn't overpower the idea, but would instead complement it. We had also heard that he was a pleasure to work with, and would be able to get beautiful shots of everyday real people.'

Hiro's brief was to take great close-up portraits of the subjects in the style for which he is famous, while also displaying the watches in a natural way. The subjects included Lisa Boyer, whose parachute had malfunctioned, Rodney Fox who had been attacked by a Great White Shark and a Jack Russell Terrier called Mugsy who, having been pronounced dead after being hit by a car, was buried in a three-foot grave and scratched his way to the surface. Each has taken a licking and kept on ticking. Each also happens to be wearing a Timex.

All the portraits except one were shot in Hiro's studio. Willie Duberry, aged 121, the oldest-known man in North America, was the only one to be photographed on location in his home town near Charleston, South Carolina. 'To keep Mr Duberry comfortable we had to set the temperature very high and keep the shooting time to a minimum', says Hiro, who was ready with his Hasselblad and Kodak Ektachrome. 'We had him in front of the camera for a total of ten minutes and I shot only one roll of film. We had planned to dress Mr Duberry, but he was already dressed perfectly. We didn't have to touch his hat or put make-up on his skin. We sat him down and photographed him just as he was.'

Besides appearing in a cross-section of magazines, including *Esquire, Playboy, Elle, Newsweek, Premiere* and *People*, the campaign received an avalanche of publicity everywhere from American talk shows to major magazines and newspapers. Calculations showed that the client received close to a million dollars worth of free publicity. The campaign has even been the subject of several political cartoons. Research showed that brand awareness for the Timex name rose dramatically. All this and a host of advertising awards too!

'There are two kinds of communication. One is the one-way communication which keeps pushing without considering the circumstances of the targets. We call this "bowling ball communication". Although it has an impact which can be likened to scattering skittles, its effect passes very quickly. The other is the mutual communication which we call "ping-pong ball" communication.'
Mitsumasa Maeda, art director, J. Walter Thompson, Tokyo

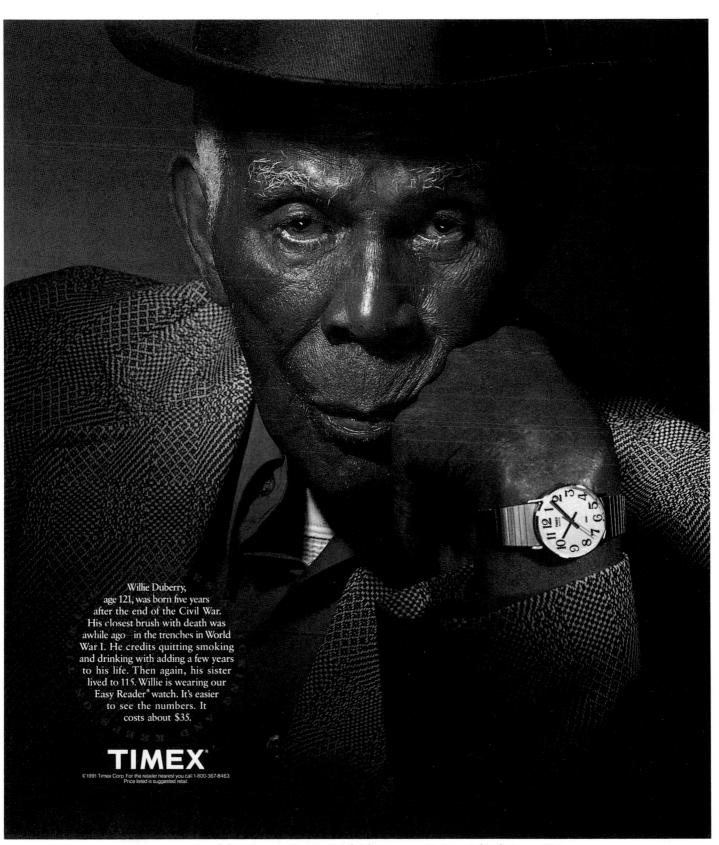

Willie Duberry,
age 121, was born five years
after the end of the Civil War.
His closest brush with death was
awhile ago—in the trenches in World
War I. He credits quitting smoking
and drinking with adding a few years
to his life. Then again, his sister
lived to 115. Willie is wearing our
Easy Reader® watch. It's easier
to see the numbers. It
costs about $35.

TIMEX®

© 1991 Timex Corp. For the retailer nearest you call 1-800-367-8463.
Price listed is suggested retail.

Timex Watches (A) Fallon McElligott, USA (AD) Houman Pirdavari (CW) Bruce Bildsten
(P) Hiro (M) Willie Duberry

31

European agencies with international clients – especially American ones such as Procter & Gamble, Coca Cola and McDonald's – constantly battle against the imposed restrictions of clients who fear colloquial interpretations of their product. For example, the whiter-than-white image that companies specify for their brands appears excruciatingly *banal* to the Scandinavian market. Credibility is lost and the products become subject to ridicule.

There may be only four-and-a-half million people in Norway, but a high proportion of them are well-read, intelligent and articulate – often in English as well as in Norwegian. They prefer lifestyle ads that are realistic rather than slick, and consider most American advertising to be so far out of touch that they have to alter it for local consumption.

'We have a problem with international clients', says Kjell Bryngell, art director with Saatchi & Saatchi in Oslo. 'We cannot just translate their ads. Even *good* international ads wouldn't work here. Norwegians are not that blue-eyed; they're more critical than Americans. The young people have grown up with nuclear weapons and environmental issues, so they're not going to take all that.'

'Excellence is a matter of taste and time. The French, for example, didn't like the
Impressionists to start with.'
Horst P. Horst, photographer, New York

Although today's shrinking world is enabling cultures to draw more readily on foreign influences, different countries still retain their own identities, and therefore their own criteria governing advertising. As a result art directors find it more difficult to cross international boundaries than photographers because the art director's original concept for an ad must emerge from the local culture.

'The advertising business is thinking how communication can be more international and
cross cultural boundaries, but I tend to feel that this compromises the creative product. I
can't talk to an Englishman in London the same way I would talk to a New Yorker.'
Allan Beaver, creative director, Levine Huntley Vick & Beaver, New York

In southern Africa the conditions and constraints are very different from those in Europe and America. 'Marketing and advertising in South Africa are unique', says Garnet Currie, managing director of Lindsay Smithers Bond in Durban. 'The businesses are driven by whites, but sitting in that bus are all the other nationalities. Whites are totally outnumbered, so we must stop thinking like whites and start thinking *Third World*.'

'We're dealing with grassroots communication, which you have to approach with an unconditioned mind', says Alex McCormac, chairman of Barker McCormac in Johannesburg. 'It's raw and natural.'

Most of the more sophisticated advertising in South Africa has, in the past, been aimed at the whites. But now the erosion of apartheid laws is enabling the emergence of a significant black middle class, with changing tastes and increasing disposable incomes. Today the black market has a spending power which is equal to or greater than the whites.

'Africa is really one big market with different nuances and tribes', says McCormac. 'In

Botswana there isn't a media as such, so you have to advertise products in a different way. You might buy a double-decker bus and drive it around the country, merchandizing or demonstrating. Yet the basic principle is the same: how do you communicate with people?

'Good advertising – good communication – in this country is simple and literal. If you try to be subtle or clever, the audience will miss the point. And humour doesn't often cross racial boundaries.

'Many agencies, including this one, have on the payroll black guys who become senior executives, but after a while they become white black men, who have lost touch with their own people.'

'Italy is like the Third World in its attitudes to advertising. There is a lot of good creative work lying in drawers. The public is ready to accept more adventurous work, but our hands are so often tied by the client.'
Stefano Colombo, art director, McCann Erickson, Milan

In south-east Asia, Hong Kong, Bangkok and Singapore produce the best advertising. Ogilvy & Mather and J. Walter Thompson produce billboard ads for China. Taiwan and Korea represent a large market, but the advertising is held back by cultural constraints.

'Korean culture, with its strong Buddhist and Confucian influences, considers sexual expression taboo and there is a tendency to place more emphasis on the mental and emotional, rather than the material.'
Sang-Hoon Park, photographer, Seoul

In south-east Asia there is a momentum to promote products, but advertisers must be aware of potential *faux pas*. 'In Thailand we have to be very careful when using dogs in ads. They are considered low and dirty', says Josh Mayer, copywriter from America working with J. Walter Thompson in Bangkok. 'The only time you can use a dog is if it's obviously a foreign dog – a healthy-looking animal – or a puppy. Thais are very literal. Rather than implying an atmosphere through the mood of a photograph, they will state it in the copy. In a print ad for a car freshener, the client wanted me to include the words "high class, elegant and rich". I didn't want to actually use the words, because that's the response we want the audience to give. I lost the battle and as a result it was a bad print ad.'

Nostalgia, too, puts on a different face in south-east Asia. It's 1950s cool jazz, but American, not Thai or Indonesian. Rather than looking back fondly at their own culture, they look to other cultures – Japanese, American and English. It is an area bent on progress, and it doesn't want to look back.

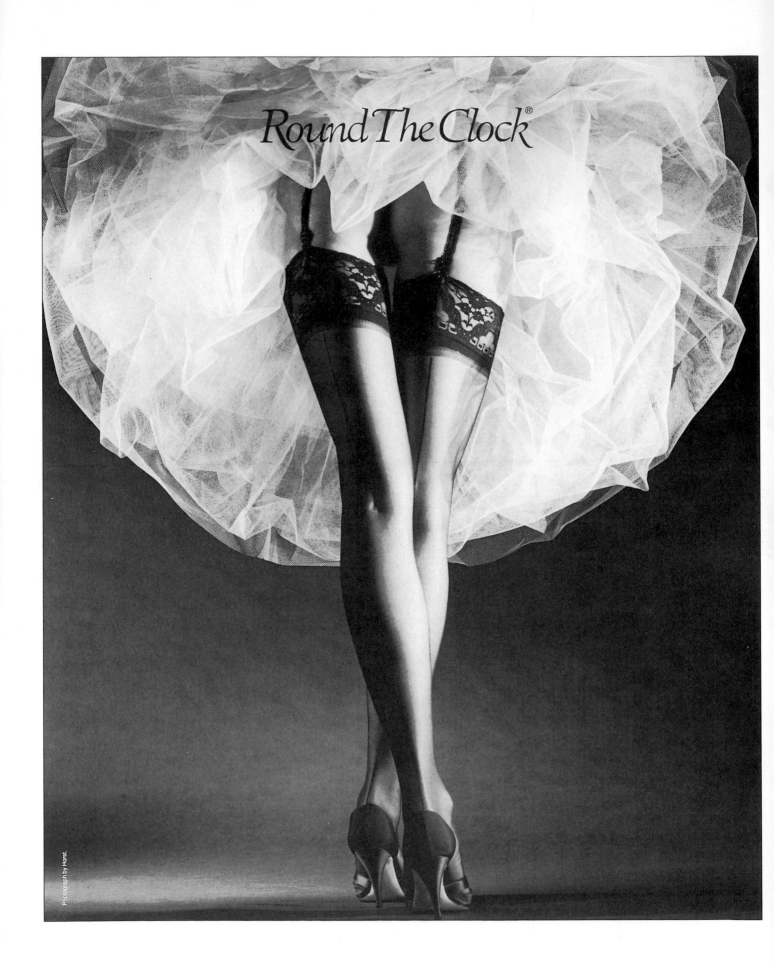

Round The Clock®

Photograph by Horst.

34

CHAPTER 2

ADHIBIT

MORE IDEAS

Sex isn't what it used to be. Ladies in provocative poses have been so ubiquitously displayed in many societies that their impact has been diluted. Today, other attention-grabbing themes have equally alerting consequences – humour, beauty, drama, intrigue, inverted logic, good taste or bad taste – each of which succeeds in infuriating some people, much as nudity has done.

'Nowadays, you can't photograph a girl without a naked bottom.'
Horst P. Horst, photographer, New York

Horst P. Horst was born in Germany and has spent most of his working life in New York. He received his first photographic assignment in 1931 when working in Paris with architect Le Corbusier. At the time he hadn't yet taken up photography, but knew *Vogue* photographer Baron George Hoyningen-Huene, and through him met Dr Agha, art director for American *Vogue*.

Round The Clock (A) Romann & Tannenholz, USA (AD) Denise Derossiers/Terry Whistler
(CW) Gad Romann/Gary Tannenholz (P) Horst P. Horst

Agha asked Horst to do a fashion photograph. 'I told him I didn't know anything about fashion photography or anything about *Vogue*', says Horst. 'But he sent me to the studio and provided an assistant. I was paid $3.50 for my first published photograph. After that I took pictures for *Vogue* twice a week.'

Since then he has worked prolifically for *Vogue*, *Vanity Fair* and *House & Garden*. But he is not averse to advertising. 'There's nothing wrong with advertising,' he says, 'but a lot of commerical work repeats so much. That becomes a bore.'

A campaign that *did* appeal came from the New York agency Romann and Tannenholz. Their client Round The Clock wanted to promote pantyhose, and agreed to move away from advertising the product's tactile benefits. 'We decided to focus on intangible benefits, stressing the sensuality of the pantyhose', says creative director Gad Romann. 'If women view them as a

Associacaō Brasília Olímpica 2000 (A) MPM, Brazil (AD) Felipe Taborda (CW) João Paulo Oliveira (P) Tuca Reinés

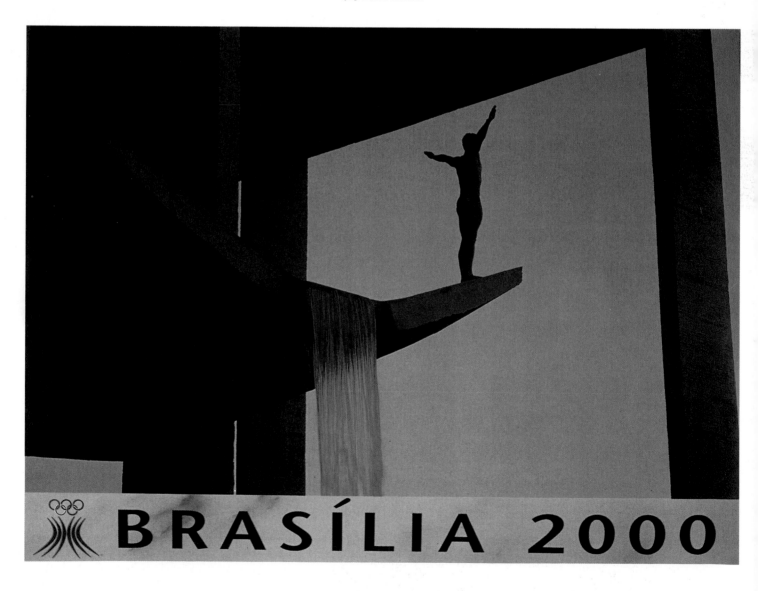

successor to silk stockings, which men also find very attractive, they will be willing to pay more for them. So we came up with the theme line "Pantyhose for men" as being the most spontaneous way to deliver on this promise.'

Romann approached Horst with the proposition: 'At the age of 75, we'll make you famous!' Horst couldn't refuse, and immediately responded to the stylish wit of the concept.

'We wanted Horst for the campaign because his pictures are very stirring and we knew he could be extremely provocative in black-and-white', says Romann. 'He likes to entice people with his sophisticated photography, and is also delightful to work with. He's one of the most mild-mannered provocateurs I've ever met!'

Although the campaign was attacked for being sexist, critics couldn't decide whether it was demeaning to men or women.

'I like simple things', says Horst. 'Nature and the human body. For me fashion has always been represented by an attractive woman in an appealing attitude or posture. And sex – in a beautiful, visual way – is most important.'

'If your advertising goes unnoticed, everything else is academic.'
Bill Bernbach, Doyle Dane Bernbach, 1911–1982

Photographer Tuca Reinés was born in São Paulo in 1956. After graduating in architecture, he began working as an editorial and advertising photographer. Seven posters represent just a part of a far-reaching campaign he photographed to promote the staging of the Olympic Games in Brasilia. The campaign also incorporated a 130-page book, calendars and postcards.

The ad agency MPM hired freelance art director and creative director Felipe Taborda to design the entire project. Taborda's brief to Reines was to explore the magnitude of space found in the city of Brasilia. 'Everyone says that the sky in this city is bigger than in any other, so I wanted him to work with this', says Taborda. 'Also, Tuca is very well known for his architectural photos, and this is another theme I wanted him to explore, as Brasilia's architecture is world famous. I wanted the buildings and monuments to look like a set specially made for the photos.'

Using a Pentax 6 × 7 with 165 mm lens, Reines shot the scene on Kodak EPP 120 film at 1/60 second with an aperture of f5.6.

'It's Catch 22: successful ads stand out because they are different, yet clients are afraid of being different.'
Wally Krysciak, creative director, McKim Advertising, Toronto

The soil steam treatment ad was one in a series of 15 posters produced by the Sydney ad agency Kazoo for the New South Wales Electricity Supply Industry. The campaign was designed by art director Adam Hunt and copywriter Russell Smyth to show imaginative applications of electricity – hence the line 'Energy with imagination'.

'Electrical steam-cleaning equipment is big and shiny, but boring', says Adam Hunt. 'So it didn't feature in the campaign. Instead we decided to show the more interesting end benefits of the process. New Zealand-born photographer John Adams was chosen because of his ability to deliver dramatic images with technical expertise. We felt that the farmer's hand holding a fistful of

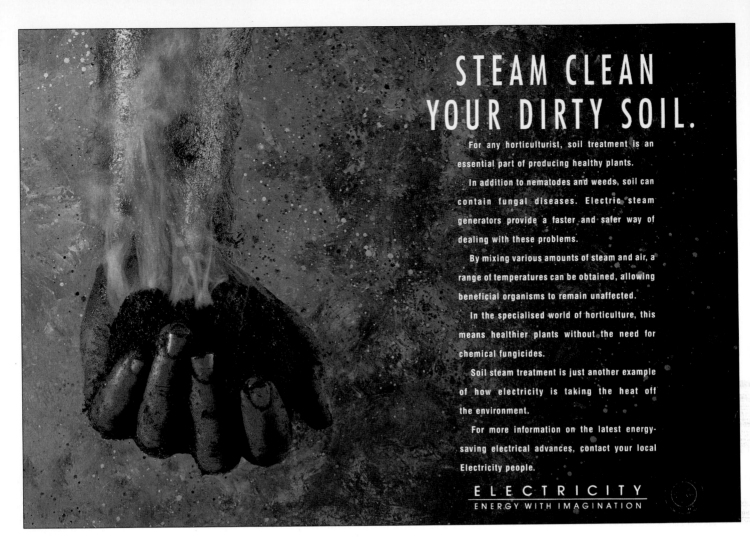

STEAM CLEAN YOUR DIRTY SOIL.

For any horticulturist, soil treatment is an essential part of producing healthy plants.

In addition to nematodes and weeds, soil can contain fungal diseases. Electric steam generators provide a faster and safer way of dealing with these problems.

By mixing various amounts of steam and air, a range of temperatures can be obtained, allowing beneficial organisms to remain unaffected.

In the specialised world of horticulture, this means healthier plants without the need for chemical fungicides.

Soil steam treatment is just another example of how electricity is taking the heat off the environment.

For more information on the latest energy-saving electrical advances, contact your local Electricity people.

ELECTRICITY
ENERGY WITH IMAGINATION

NSW Electricity Supply Industry (A) Kazoo, Australia (AD) Adam Hunt (CW) Russell Smyth (P) John Adams

the steaming soil powerfully demonstrated the chemical-free process used in soil treatment. It fitted perfectly with electricity being a healthy way to "clean your dirt".'

Some 50 advertising ideas were floated for *de Volkskrant* newspaper in order to reach a handful of award winning ads. The Amsterdam agency PPGH/J. Walter Thompson, took the symbol of a pen nib to represent journalism. Presumably computer keyboards and screens offer little scope for artistic interpretation. This pen nib was integrated into other, more abstract, symbols of investigative journalism – keys, drills, an alarm clock and an electrical socket, and the ads ran with the copyline: 'The best informed morning newspaper in the Netherlands.'

Art director Pieter van Velsen chose Hans Kroeskamp, one of Holland's foremost photographers, because he was most experienced in handling lighting. Van Velson showed Kroeskamp the sketches and explained the atmosphere he wanted to achieve, but otherwise left the interpretation of the photograph completely open.

There followed a good deal of experimentation with 30 different backgrounds to find the right tone and texture. The background in this case comprises metal, scratched with sandpaper and covered with Vaseline.

Often models are constructed five times bigger than life-size, so they are easier to light, but the model of the plug is normal size. 'Because I had to work in a small area, the lighting was more

difficult', says Kroeskamp. 'But it gave the photograph a more realistic look. A good thing about this shoot was that I had time to spend perfecting the image. Some of the pictures took three days.'

In advertising photography, nothing is impossible. Any ideas can be realized, any illusion created. All you have to do is work out how best to do it. We're talking here about *making* pictures. Consider, for a moment, the logistical labyrinth of organization that went into Mankowitz's underwater shot.

London photographer Gered Mankowitz made a name for himself in the 1960s photographing pop stars such as Marianne Faithfull, The Rolling Stones and Jimi Hendrix. He then moved into editorial photography and worked for *The Observer*, *The Times*, *The Daily Telegraph*, *Harpers*, *Queen* and *Tatler*. In the 1980s he moved into mainstream advertising, though he still occasionally dips back into the music business to shoot album covers for the likes of Elton John or George Harrison. He describes himself as: 'a people-humour-special effects photographer, who creates living cartoons.'

Most of the time Mankowitz is asked to work out technical solutions to concepts which have already been carefully planned and drawn. By the time the ad reaches him, so many people are committed to it that there are very few opportunities to change anything. And the bigger the budget and the more special effects and models used, the tighter the control has to be. 'I can only get involved by suggesting props or clothes and lighting', says Mankowitz.

De Volkskrant (A) PPGH/JWT, Holland (AD) Pieter van Velsen (P) Hans Kroeskamp

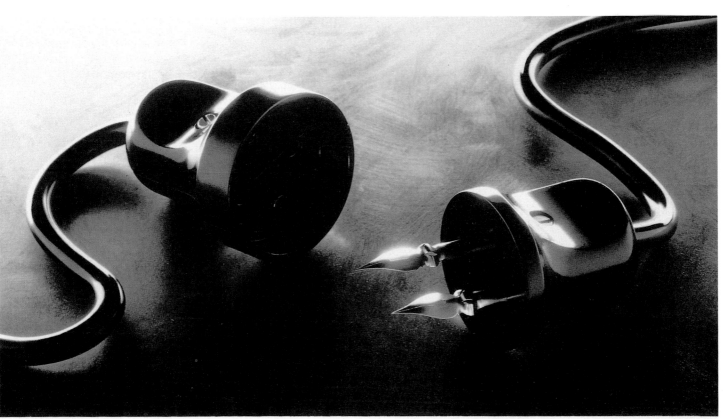

de Volkskrant
HET MEEST INFORMATIEVE OCHTENDBLAD VAN NEDERLAND.

'It's very difficult for an art director to get the seed of an idea through the photographer onto a page. If it's taken through too many filters, it loses its energy and becomes watered down.'
Clive Arrowsmith, photographer, London

Every job is precious to the art director. Most art directors don't see many of their ideas realized. One success a month is a very good average. Yet there always comes a point when they have to relinquish control; they have to give their idea away to the photographer. 'I've got a great responsibility to the art director', says Mankowitz. 'And I want him to feel comfortable and confident about that.'

Art director Simon Butler conceived an ambitious ad for Lloyds Bank at the London agency Lowe Howard-Spink. The husband and wife in the scene are *not* happy. She's frustrated with him because he tried to patch up the ceiling with sticky tape. And he's not too proud of the resulting flood.

The original rough looks much like the finished picture, although Butler and Mankowitz each continued adding to the props as preparations progressed: the plastic goldfish, the lit dolphin lamp, the watercolour painting of a sea scene where the paints are washed off.

Butler insisted from the outset that the picture should make it obvious that the room was half submerged. The camera had to be positioned low enough to show the wavy line of the surface of the water. Butler also stipulated that the snorkels should go above the picture and into

Lloyds Bank (A) Lowe Howard-Spink, UK (AD) Simon Butler (CW) Gethin Stout (P) Gered Mankowitz

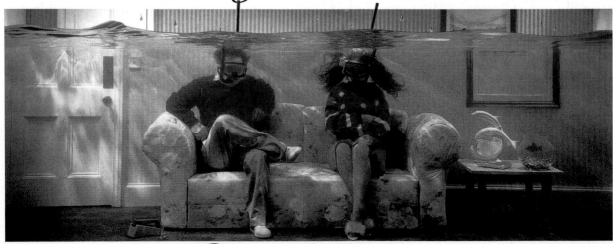

40

the copyline. The drops of water, which were carved in plastic, then polished and suspended on thin nylon wire, had to be unrealistically large in order to be seen.

One of the major brain-teasers was how to achieve the effect that water has on vertical lines. This was a visual problem that had not been anticipated and Mankowitz was given the task of finding a workable solution. The choice was between simulating the broken lines or doing it for real in a tank.

None of the regular special effects people felt confident that they could incorporate all the elements artificially. At the time there was a television commercial which featured a pub with people playing snooker and drinking, all taking place underwater. The special effects people who had worked on this ad agreed to tackle it for real. But first Mankowitz had to work out the exact scale, then build a tank based on the biggest piece of glass available from stock – 8 × 4 ft and $1\frac{1}{2}$ inch thick.

The tank, which accounted for half of the total budget, measured about 15 ft wide and 18 ft from the glass to the back wall. The front face held the 8 × 4 ft piece of glass, through which the photograph was shot. The camera could not be inside the tank, as it would not have shown the surface of the water. 'The technicalities were immense', says Mankowitz. 'The water pressure was enormous. There had to be very safe limits, as the glass could have burst and killed us all.'

The tank had to be built *in situ* in a studio hired for a fortnight. As the tank held 3500 gallons of water, it needed a solid floor and ready access to a hydrant and big drains.

The lighting posed its own problems. The thick glass introduced a green cast to the picture, which had to be filtered out. But above the water level, the filtration was different. Filters on all the lights had to correspond. The scene could not be lit from the front, so lights were bounced from behind onto the sides of the pool which were covered in white plastic to reflect as much light as possible.

A heating and filtration system was installed to keep the water clear and to make it more comfortable for the divers. The wallpaper was sheet plastic, printed with waterproof printer's ink. The sofa was specially made and the fabric tested to check that the colours didn't run. Everything was marine varnished. The painting, which was done on Formica, was tested in cold water for two days and seemed to be completely unaffected, then it was marine varnished. But . . .

'We came in the morning after testing and the water had gone bright yellow!' says Mankowitz. 'The combination of the warm water coupled with this painting which had not been varnished on the back, changed the water colour. So we then had to flush everything out and refill it with cold water, which the divers coped with magnificently. We had a big hot box just outside the tank, so they could warm up again very quickly.

'Once everything has been worked out, you've then got the performance. It's like starting a horse race, you bring all the elements together then lift the starting gate and go.'

Shin Sugino, one of Canada's busiest photographers, was chosen by Toronto agency Ambrose Carr, to execute an image for Honda. Sugino emigrated to Canada from Japan in 1965 at the age of 19. He studied photography at Toronto's Ryerson Polytechnical Institute and soon became an acclaimed fine art photographer. Shin 'went commercial' at the beginning of the 1980s because 'I was sick of being poor'. He opened his own studio and began winning awards with ads for Kodak, IBM, Yves Saint Laurent, Polaroid, Levi Strauss, Porsche and Honda.

'A lot of fine art photographers have a complex about saying they do commercial work', says Sugino. 'It took me a long time to stop apologizing for being a commercial photographer. I have no illusions whatsoever that the commercial work is artistry. It's craftsmanship, it's applied art. It is a service industry and the commercial shooter is only an interpreter of other people's messages.'

Gary Carr's brief for the Honda motorcycle was simple. The execution was more involved. It was December, the weather was bad and the countryside devoid of greenery. 'The client had a thing about a particular shade of green, and we thought about spraying the side of the road that colour and shooting it outside, but it wouldn't have looked right', says Sugino.

They opted for a studio shoot, painted a green canvas and mounted the motorcycle on a stand so the wheel could spin. 'During the two second exposure we slid the camera sideways while my assistant moved the background in the opposite direction, which gives the streaks on the motorcycle. We had to use a movie film dolly in order to achieve a movement that was smooth enough.'

Honda (A) Ambrose Carr, Canada (CD) Gary Carr (AD) Blaine Kennedy (CW) Jim Borwick
(P) Shin Sugino

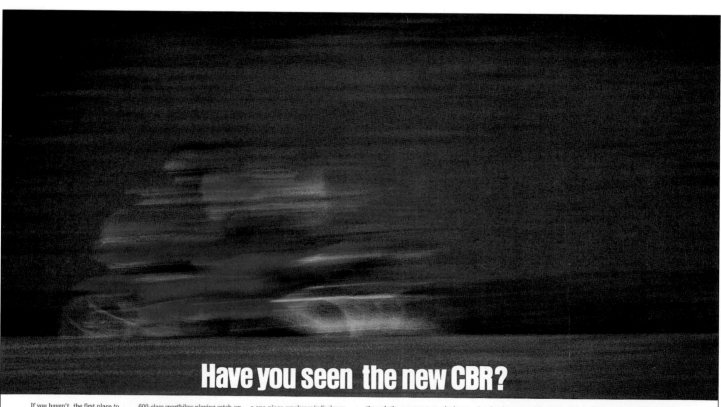

Have you seen the new CBR?

If you haven't, the first place to start looking is out front. Way out front of the competition.

Because, just as the first generation CBR600F1 changed the face of sportbikes forever, the totally re-designed, second generation CBR600F2 will again have all other 600-class sportbikes playing catch-up.

For 1991, the CBR600F2 packs the most powerful 600-class, Honda engine ever. And that includes a mid-range punch that's normally reserved for 750cc or bigger machines. At the same time our engineers have cut the engine's weight by utilizing a one-piece crankcase/cylinder assembly. You get the best of both worlds. More power and a lighter, more nimble machine.

To translate power into performance, the CBR's chassis geometry has been tuned for tighter, more rigid handling. You'll glide as easily through the corners as you do down the straightaways.

We've wrapped the CBR600F2 in wicked new graphics and colours that'll draw stares when you're moving, and even more when you're standing still. An all-new, wind-cheating fairing is as good at deflecting the elements as it is good looking.

To see the bike that's going to rule the streets and the track in 1991 stop by your Honda dealer.

And make sure you take a long, hard look. Because unless you're riding one, that's the only good view you're going to get.

To find out about how you can test ride the new Honda CBR600F2 and the name and number of your local Honda dealer, call 1-800-263-2866.

HONDA
Come ride with us.

RIDE SMART. RIDE SAFELY. Always wear a helmet, proper clothing and eye protection when you ride your Honda motorcycle. Remember, the way you ride reflects upon all riders. Don't drink and ride. Be a specialist. Take a Canada Safety Council Motorcycle Rider Training Course.

Originally the client wanted to include an inset with a clear photograph of the motorcycle, but the art director persuaded him that people would be more likely to visit the showroom to see the bike if the mood picture was used on its own.

Tokyo's branch of the agency J. Walter Thompson prides itself on creating advertising that combines a Japanese sense of expression with Western advertising strategy, according to art director Mitsumasa Maeda. He believes that their ads often approach the target market in a European/American way – direct, logical and persuasive in tone.

The market for Kodak Professional Film consists of professional photographers, who are familiar with most films and almost certainly have their favourites. Junichiro Morita, art director in charge of JWT's Kodak account, appreciated that he needed to use a different approach from ordinary ads which target the general consumer. 'Our advertising must evoke trust towards the film-maker, and the images shown must be ones which only Kodak can accomplish', says Morita. 'We began with three basic ways of thinking: (1) The campaign must make a new suggestion for expression in photography, (2) It is not just advertising the product, but also needs to enhance the corporate image of Kodak, and (3) It must be created with the co-operation of the photographer and Kodak together.'

The job of the photographer is defined as translating a complicated strategy into visual terms. He or she can do this more effectively if involved early on in the planning process. Tetsuro Takai was one of the fortunate few.

Since becoming an independent photographer at the age of 27, Takai has continually experimented with different styles. He showed some of his experimental work to Morita, and explained the thinking behind the images. He struck lucky, being in the right place at the right time with the right ideas. Morita was in the process of developing the new Kodak campaign and discovered that Takai's thoughts were following the same path as his.

One of the experimental images was immediately translated into a poster which launched the new campaign, and Takai was spurred on to develop further the theme: 'What's next?' – new possibilities with Kodak film.

In Japan there is a trend towards less obvious advertising, where the selling proposition is buried within a more mysterious message. This campaign was no exception.

'It was our task to show new modes of expression, which could be accomplished with Kodak film', says Takai. For the second year of the campaign, Morita wanted to see how Takai's thinking would develop, given the theme of 'Japan'.

'The emotion comes first and what you're selling comes afterwards.'
Malcolm Gaskin, creative director, Woollams Moira Gaskin O'Malley, London

'I was interested in Japanese painting, and took great interest in traditional Japanese colours', says Takai. 'I really wanted to create these colours with film. Japanese-style paintings are unique in that, although the objects depicted are concrete, they convey very abstract and sensuous feelings. I tried to achieve this in photography.'

Not so much a case of photographing an object, as picturing what you *feel* about it.

'The idea is close to that of the Impressionist school of painting. It is an attempt to visualize our country with our eyes and our hearts', says Morita. 'If we can put on film a visual which reflects

our mind, the image is more powerful and more lastingly printed in the hearts of those who look at the pictures.'

In this photograph, the Zen priest is sitting in a bamboo forest listening to the sound of nature. It is achieved by sandwiching three separate exposures, one of the forest, one of hand-drawn clouds and the third of the priest. In natural sunlight Takai photographed the bamboo forest with a 35 mm Nikon F2 with 28 mm lens, and duplicated the image onto 8 × 10 inch transparency. He then drew a cloud-like background which was also copied onto 8 × 10. Next, a black-and-white photograph of the priest was shot on a 5 × 4 Sinar camera, and the subsequent print copied onto 8 × 10. The three positive transparencies were combined to produce the final image.

In trying to clarify his thought processes, Takai acknowledges he is entering a spiritual realm which is difficult to explain, especially to the Western mind. Takai explains something of the process . . .

Kodak (A) J. Walter Thompson, Japan (AD) Junichiro Morita (CW) Eisaku Sekinhashi (P)
Tetsuro Takai

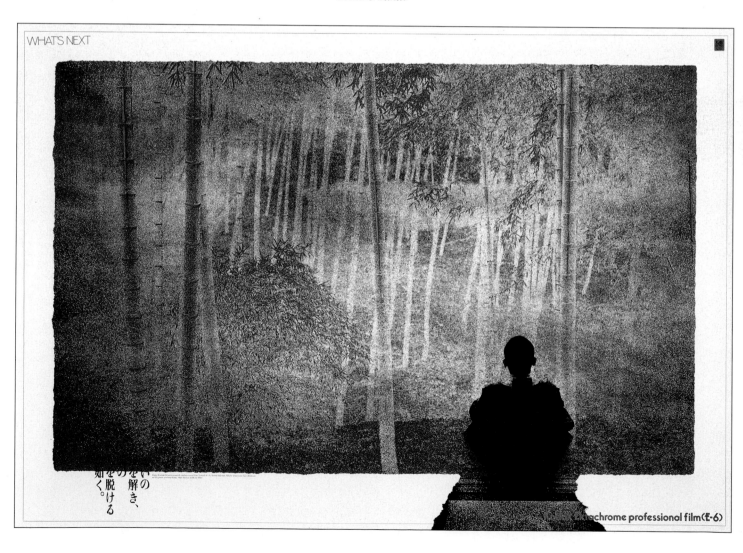

'Calm ourselves, clear our mind, put curbs upon our various desires, and just concentrate on the objects, then we shall be led to the right reason . . . If we keep asking nature, nature shall certainly answer us, and we can feel at one with its mysteries. We can blend with nature, where there is no life, no death any more. The expression, which is unique to Japanese painting, is something beyond time and space. It is visually unscientific and irrational. It is not the objective way which portrays objects with light and shadow, but it portrays objects subjectively, through our senses, hoping to express our feelings. According to the image, I take the balance of space into consideration, add the colours, and there, a spiritual world is settled on a photograph.'

Pure art? Photographers who shoot to order are applied artists, and there is no shame in channelled talent.

'Doing ads is entirely different from doing work that is accepted by serious galleries.'
Nadav Kander, photographer, London

Takai's approach proved a great success and attracted the attention of another art director at J. Walter Thompson. Mitsumasa Maeda was formulating a new campaign for Uyeda Jewelry and invited Takai to join the discussion with him and the client. 'It was very different to express the image envisaged by three people in just one visual of a photograph', says Takai.

Uyeda Jewelry has a 100-year history in Japan, a solid reputation and a target market that values beautiful jewelry. Maeda aimed to reinforce the product's heritage of uncompromising devotion to quality, while also being flexible enough to respond to the times.

'People watch television or read magazines when they are in a peaceful and comfortable atmosphere', says Maeda. 'So my ideal is to create beautiful and comfortable ads which communicate. For Uyeda, we needed to inject visual freshness into the advertising. The architectonic key point [the key point of the picture composition] was the combination of the jewelry and the plants, which enhance the beauty of the jewelry.' Maeda visited every florist in Tokyo in search of interesting material to go with the jewelry.

Takai first combined photographs of flowers with the jewelry to create the effect of a painting. He then shot plants with the jewelry, and finally the jewelry on its own. His aim was to portray the 'sparkling colour, powerful volume and energetic feeling' which the jewelry possesses.

'The world of still-life is totally static, and it remains silent until I, myself, try to cause some action', says Takai. 'We often discover new things in objects if we keep on watching them. I will then reach a point where I feel the subject requires me to portray it in this way.'

In 1986, Yves Saint Laurent created an in-house advertising agency, and Jérôme Faillant-Dumas was chosen to head the art department. 'Mr Yves Saint Laurent and Pierre Berge know better than anyone else how to guide their image', says Faillant-Dumas. 'And with an in-house agency, the understanding is direct and the communication has greater impact.'

The 'Y' campaign embodies the image of *haute couture*. 'A world of classic simplicity and discreet luxury, for the refined woman who evokes both purity and sobriety.'

Patrick Demarchelier is one of the world's hottest photographers of class and style. He is the first non-British photographer to be invited to photograph a member of the Royal Family. His

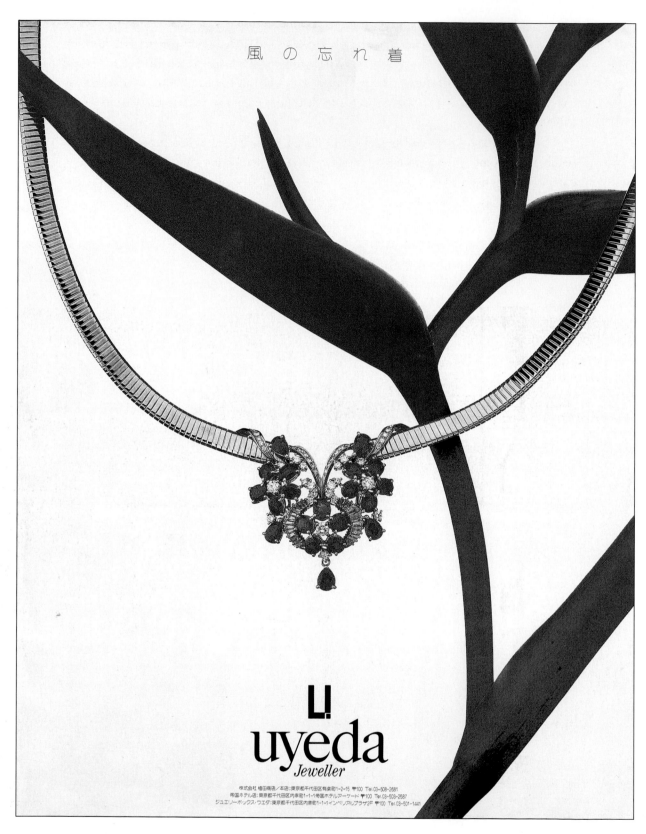

Uyeda Jeweller (A) J. Walter Thompson, Japan (AD) Mitsumasa Maeda (CW) Mitsuo Uihida (P)
Tetsuro Takai

photographs of Princess Diana have appeared both inside and on the cover of British *Vogue* magazine. His portraits of celebrities and personalities could fill a pretty weighty volume.

Demarchelier was chosen to photograph top model Elaine Irwin from Elite Model Management for the 'Y' campaign because he is in touch with the image of Yves Saint Laurent. 'His sensuality, classical yet modern style perfectly echoes the image we wanted to convey', says Faillant-Dumas.

Using a Pentax 6 × 4.5 and special Fuji RSP2 film, Demarchelier works extraordinarily fast, secure in his point of view. He keeps things simple, direct and honest. His unruffled, easy-going manner relaxes his models and allows them to give of their best to produce an enduring image, which, in this case, appeared in the worldwide press and on point-of-sale material.

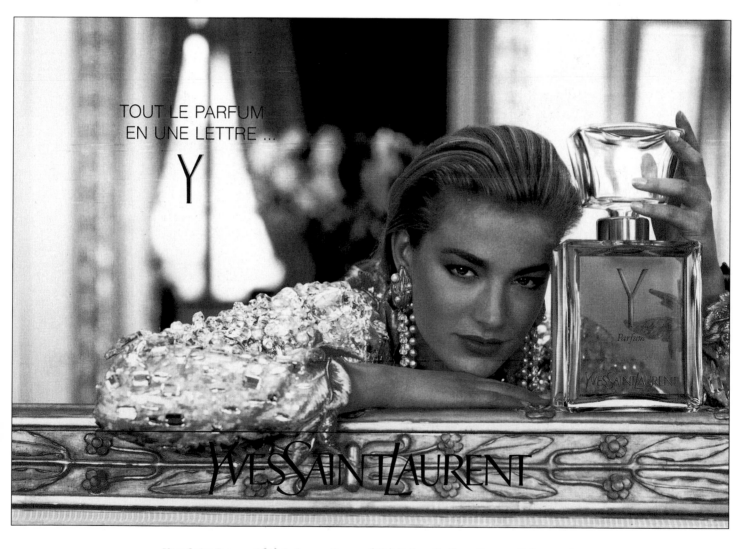

Yves Saint Laurent (A) In-house, France (AD) Jérôme Faillant-Dumas (P) Patrick Demarchelier (M) Elaine Irwin

The endorsement of a product by a personality is a strategy that has been around for decades. In 1950 Marlene Dietrich puffed a Lucky Strike, Ronald Reagan was pictured with a Chesterfield hanging from his mouth, and in 1954 John Wayne's image matched Camel cigarettes. Marlene Dietrich, Jean Harlow, Clara Bow and Elizabeth Taylor were all used to advertise Lux soap, along with Bette Davis and Joan Crawford who also put their faces to Max Factor.

In the early days, Hollywood satisfied the public's desire for glamour, and advertisers tapped into this aspirational source. Yet today, cover girls have stepped into that role for several reasons: the rise of television reduced the exclusivity and glamour of film stars, with greater attention being paid to local personalities. And, until recently, the romantic movie has been declining in popularity, and few film stars have glorified an appropriate form of glamour. Also, world markets for health and beauty products are now much bigger and include Third World countries: for example, more Lux soap is sold in Indonesia than in the entire USA. In many cases it makes no economic sense to pay the vast fees demanded by movie stars for rights to appear in ads in a large number of countries, where their image may not actually enhance the product.

During the 1980s top models rose (together with their fees) to become the new glamour celebrities, in some quarters replacing the Hollywood greats. Lauren Hutton, the Revlon girl in 1972, became the face of Barneys, Cindy Crawford signed a million dollar contract with Revlon, Christy Turlington, Linda Evangelista and Naomi Campbell all endorsed various beauty products.

Today, personality endorsement is still milked for all its worth, especially in the US, where Cher, Yoko Ono, Bette Midler and Tina Turner lend their faces to ads for *McCalls* magazine, the in-crowd photographers accept invitations to photograph and pose for The Gap, and the American Express campaign compiles its own 'who's who' of everyone who is anyone.

Lux has a long history of using film star endorsed campaigns around the world. The London branch of J. Walter Thompson used the technique of a model to evoke the glamour. The photography recaptured the atmosphere of the height of the Hollywood black-and-white movie era. Part of the brief to the agency was to recreate the attributes of the romantic feature film, without using film stars. Mood was of the essence. The photographer had to be able to handle lighting sensitively, while also directing a star performance from the model. The room, the model and the soap had to be lit with sufficient depth to be clear on a single exposure. Norman Parkinson, Horst P. Horst and Terence Donovan were all considered.

Terence Donovan's passion for photography took him to the top of his profession in the 1960s. His passion for learning has kept him there. 'One of the dangers of being over 28 is that you start to think you know everything', says Donovan. 'It's quite good to learn you know nothing.'

Born in 1936 and brought up in London's East End, the son of a truck driver, Donovan won a place at what is now the London College of Printing at the age of 11, to train as a lithographer. By chance he saw someone photographing a camera. 'It was a very Zen-like moment', he says. 'And from then on I wanted to be a photographer. Even today I go into my darkroom and remember being 12, when I couldn't afford a red light so put a red rag over the bulb.'

In 1956 he worked as an assistant to John French, but soon struck out on his own and began contributing to *Nova*, *Queen*, *About Town* and *Vogue*. He is essentially self-taught and has a voracious appetite for books and encyclopaedias.

'I'm driven by the intrigue of new unsolved projects. I always feel that my knowledge of

photography is just beginning, which is very odd after nearly 40 years of doing it! I come from a breed of photographers who are maniacal enthusiasts. In the sixties we didn't think about making bread at photography, we just wanted to be photographers. Then photography became a rather smart thing to do.'

Lux Soap (A) J. Walter Thompson, UK (AD) Dick Poole (P) Terence Donovan

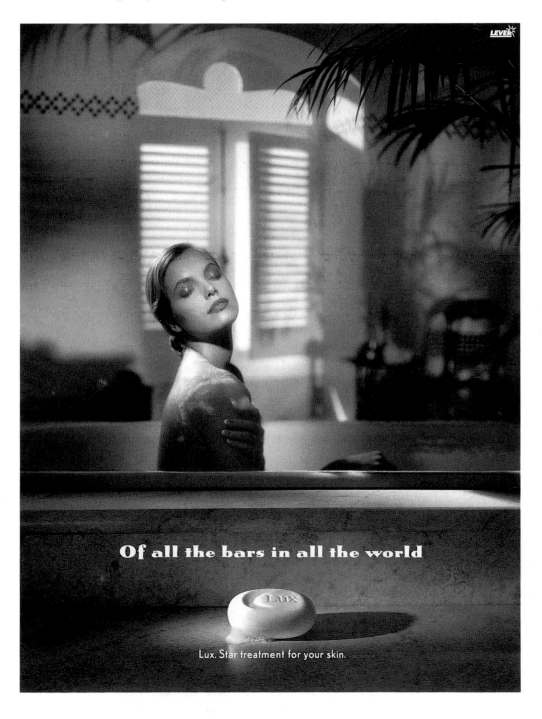

'Donovan's forte is his marvellous sense of style, his lighting and feel for black and white', says art director Dick Poole. 'On one sheet of film he was able to bring together a period room setting with a sensitive beauty spot and a still-life of the product.'

For the first subject in the campaign, Poole's brief to Donovan and his set designer comprised a videotape of the 1942 movie *Casablanca* and some rough ideas. As there was no bathroom scene in the film, he said 'If there *was* a bathroom, what would it have looked like?' As a result, Morocco was brought to Holborn Studios.

'A skilled art director has the ability to make you think you're good at something', says Donovan. 'For Lux I was given a layout and a lot of freedom. But there is no such thing as a simple advertising job. There's always a sting. You assemble all the items, then you have to try to turn logistics into magic. That's a tough transition, and if you're not happy with the techniques, you're just fighting on marshy ground. In a still photograph a model can give you a very brief and trite performance for a nano-second, and you've got it. That doesn't work in movies. You can direct somebody up to a point but then you can just simply record it. Whereas in stills you can steal it. You can make somebody laugh for three seconds and you've got the picture.'

'An important idea not communicated persuasively is like having no idea at all.'
Bill Bernbach, Doyle Dane Bernbach, 1911–1982

Pepsi and Coca Cola are world leaders in the field of image promotion. They represent the epitome of commercialism – the ultimate advertising success stories. They will receive the same smile of recognition from a farm labourer in the high Andes and factory worker in Irkutsk. Hoardings, logos, vending machines and shop signs are as ubiquitous as the drinks themselves. Clearly, the photography in the ads has to reflect this global status.

The manufacturers know exactly what their product should look like, and will only consider using photographers who can produce pictures you can almost feel, taste . . . even hear.

June Manton, art director with Lintas in New York, gave Gerry Zanetti a specific brief for the Diet Coke ad 'Best Motion Picture'. The headline was to be in a particular position, and Zanetti's photograph had to fit the space. A certain kind of drip had to be produced by spraying it with water, and the frosting was created using a plastic substance. Because of the position of the headline, the Coke had to spray out in exactly the right place and with a certain kind of motion.

The fluid? Zanetti used the real thing and shot it in one picture. The Coke was plunged through a tube and frozen in flight with flash at a given distance from the can. 'It's basically a technical lighting exercise', says Zanetti. 'We did that with a device that tripped the shutter when the fluid reached a certain point. The only variable was how quickly or slowly you pumped it out; the faster you plunged it, the more blur you got in the photograph. At first it was coming out too thick, too modular, so we put a little piece of wire in the opening to break it up. We shot maybe 40 8 × 10 transparencies in a day to get this one.'

Diet Coke (A) Lintas, USA (AD) June Manton/ Peter Nicotra (CW) Michael Jordan (P) Gerry Zanetti

While a creative team from Ogilvy & Mather in New York was in California shooting a commercial for American Express, the agency's creative director, Parry Merkley, was asked to come up with a compatible print campaign. 'I really didn't want to do a celebrity campaign, because I felt that it was exploiting people', says Merkley. 'But it seemed to me the quickest way to endorse a product, without a lot of explanations. So I wanted to find a different way of doing it, maybe more honestly.'

As with many successful ideas, Merkley turned the 'product endorsement' formula around. He hit on the notion of paying tribute to the card members, as opposed to them paying tribute to the company. The value of this approach goes beyond the enhanced credibility of a non-commercial soft sell. In a tasteful way it shows the good company you keep by being a member.

Glossy 'commercial' photography would have worked against the message. Merkley wanted to find a journalistic photographer who could create visual interviews which portrayed the character of the personality. He ripped out some pages of Annie Leibovitz's book and made up a set of rough layouts, adding the line: 'Card member since 19___.'

The client loved it, but wanted a paragraph of copy explaining why these people use the card. Fortunately Merkley persuaded them to let the picture tell the story. With the minimum of copy, eyes would linger longer on the photograph.

'Each portrait is an essay on the person', says Merkley. 'It helps you understand more about them. All the elements in the photograph are related to the person, and not just there for shock value or purely visual impact. There's an integrity about that, which I am very attracted to.'

Annie Leibovitz has a larger-than-life reputation. She is tall in stature and tall in status. She cut her teeth doing reportage photography for *Rolling Stone* magazine, and still regards her work as 'journalism'. Her's was the foetal photo of John and Yoko shot the day Lennon was killed. She was already moving into the spotlight that illuminated her subjects. When her photograph of a very pregnant Demi Moore appeared on the cover of *Vanity Fair*, the media really zoned in on Leibovitz, and, 95 television slots, 64 radio shows and 1,500 newspaper articles later, *she* became as much a celebrity as the richly famous she immortalized. By this time the American Express campaign had already helped establish her credentials within the advertising industry.

Merkley first approached Leibovitz with an offer:

'I want to use you.'

'Everybody in advertising says that, and then they end up reshooting.'

'I want you for your editorial interpretative work.'

'Everybody says that!'

But she agreed to try it on one condition, that there were no clients or account people on the shoot. In fact, not even Merkley.

He was nervous about it, but told American Express the terms. Hesitantly, they went along with it. Merkley did attend the first shoot, with Tip O'Neal in front of the camera, and the client liked the results enough to let go of the reins.

Parry Merkley understood Leibovitz's reticence about relinquishing any degree of control over her work. 'I see wonderful photography in people's books,' says Merkley. 'Then compare their personal work with tear sheets of their ads. The art-directed work is so depressing. All I wanted to do with American Express was to provide a stage for a major talent to work on. She'd been working for 15 years without me, why should she need me now?'

'You're only as good as your opportunities. Really talented people don't have the chance to shine and produce creative work if there are no good clients.'
Derrick Hass, head of art, Publicis, London

This is a campaign where the photographer took the concept and expanded it. Annie Leibovitz researched each of her subjects by reading their novels, watching their movies and talking with them. Most of the portraits were shot over three days with the following schedule: Day one: visit their home, discuss their wardrobe and additional clothes brought as possible alternatives. Then location scouting for the rest of that day. Day two: set up test shots, more location scouting, then begin shooting by the end of that day. Day three: shooting in maybe two more locations, both morning and evening.

'Most people can't understand why it takes so long,' says Merkley, 'because they're used to being photographed in a studio within an hour or 20 minutes even. We explain that these photographs have a tendency to live on beyond the campaign, and we want each person to have all the advantages of looking as good as they can.'

Merkley gave Leibovitz a lot of latitude, encouraging her to keep shooting to ensure they had enough appropriate material. This also helped the subjects relax. When most people see Leibovitz at work, they are drawn into the spirit of the shoot by her great focus and dedication. Everything is very quiet and very concentrated. The Mamiya 6 × 7 works overtime. She fills in with flash and stops way down so the colours come out supersaturated. The pictures have a surreal, legendary quality to them.

'That's exactly what we wanted,' says Merkley, 'real people enhanced. Annie calls it "heightened reality".'

Everyone looks at the photographs differently. The client looks at them with a view to how they represent the company. The photographer looks at them and asks what they say about him or her as an artist and photographer. The person in the picture asks 'What do they say to my public?' And the art director looks at them with a view to how the consumer will respond. If all these people, with different criteria, like a certain photo, it's a real winner.

The campaign first broke in June 1987, and soon became a benchmark for its genre. In 1990 American Express put the campaign on hold while they re-evaluated it to make sure it was right for the 1990s. The more they looked at it, the more they found that it was even better suited to the early nineties than it was to the late eighties.

American Express offices around the world began implementing the campaign in their own vernacular using local personalities. Leibovitz's schedule was on overload, with other commitments including a million dollar contract with *Vanity Fair*. Alternative photographers had to be cultivated in the Far East and Latin America. While the stand-ins were allowed a little interpretive space, their pictures had to complement the originals in order to retain the heritage of the campaign.

American Express (A) Ogilvy & Mather, USA (CD) Parry Merkley (P) Annie Leibovitz
(M) James Clavell

James Clavell. Cardmember since 1967.

(Be careful with the Kaminomoto)

Wella Pacific Beauty Care (A) The Ball Partnership, Singapore (CD) Robert Speechley

(AD & CW) Neil French (P) Willie Tang

CHAPTER 3

AD HOC

FUNNY IDEAS

Sad, isn't it? So much of life has lost its *joie de vivre*. People have forgotten how to smile. Especially when money is involved, as it tends to be in advertising. Money is a serious business. We can't afford to *enjoy* it.

Balls. Billiard balls. A hairy little contribution from the Ball Partnership ad agency in Singapore seizes the issue by the short and curlies and restores a sense of fun.

Cue Kaminomoto . . .

Kaminomoto, a hair tonic, is a Japanese product distributed in Singapore by Wella. Unshackled by rules, the marketing people briefed the ad agency to 'sell more Kaminomoto'. Writer/art director Neil French began by checking the restrictions pertaining to such products. 'We found we couldn't mention hair restorer', says French. 'This meant that we couldn't show the pack, because, reasonably enough, it declared the purpose of the product. We also couldn't show pictures of men with and without hair, or anything that might *suggest* that the product grew hair on the male pate.'

'Oddly enough, this made life very easy. I was determined to use the "before and after" visual cliché, which would immediately establish the product as a hair restorer. The obvious next step was to use another cliché – "as bald as a billiard ball" and add a line which implies that spilling a dash of the product would grow hair on practically *anything*.'

It was not only within the strategy, it used humour effectively: to break through audience defences, to illustrate a point, to establish a rapport by sharing a joke, to release the tension of a sensitive subject.

'Our job is not *to spend our client's money quietly, and with as little fuss as possible: our job* is *to make our clients famous; to sell their products; to help make them* rich. *That way, we avoid poverty ourselves.'*
Promotional ad for The Ball Partnership, Singapore

Photographer Willie Tang kept the picture naïvely simple, with no clever lighting or additional props. 'He understands the value of an idea, and how easy it is to bury an idea under heaps of technique', says French. Tang's wife spent many hours plucking the eyebrows of the office staff and gluing each separate hair to the billiard ball.

As the ad was not allowed to say that Kaminomoto hair tonic actually restores hair, it didn't. The alternative approach, however, *implies* powers that the product does not have. Most people meet this hyperbolic proposition with a smile, yet the Advertising Standards Authority, that monitors such things in Singapore, asserted that the ad had gone too far. The agency asserted that it was perfectly reasonable. And, while the play bargaining shuttled back and forth, the agency produced two more ads, one with a smooth and hairy dog, the other with a hairy crab. After much steaming and posturing, the campaign was razed to the skin, *joie de vivre* once more receded and respectability was restored.

'Logic and overanalysis can immobilize and sterilize an idea. It's like love – the more you analyse it the faster it disappears.'
Bill Bernbach, Doyle Dane Bernbach, 1911–1982

Humour is one of the most powerful communication tools in western culture; people expect it and accept it. But if you prefer a gentler, more spontaneous brand of humour, try giving an open brief to a photographer who has a penchant for observing visual quirks. Then sit back and enjoy the results.

'If I choose the right photographer, I don't have to art direct him, I just have to brief him', says Brian Stewart, joint creative director with Delaney Fletcher Slaymaker Delaney Bozell in London. 'If I art direct him, I am limiting him to my imagination. For a Nikon ad, I briefed Elliott Erwitt on the phone, and simply said "Bring me an amusing photograph". We talked long and hard about what constituted an amusing photograph. It's very dangerous because what one person thinks is funny leaves another cold. I told Elliott what I thought would make an uncomfortably funny photograph: we didn't, for example, want racial jokes, although there are some very funny racial jokes. And I didn't think this was the place to have political jokes, or religious jokes. I did not want a fantastic photograph that the client wouldn't agree to run.'

Elliott Erwitt's camera seems to have a built-in sense of humour. It seeks out the bizarre and ridiculous, then snaps them before the fleeting moment is gone. But unexpected meetings and snatched images generally have no place in commercial work. 'Usually a picture has been researched to death before you take it', says Erwitt. 'Somehow they are able to research pictures

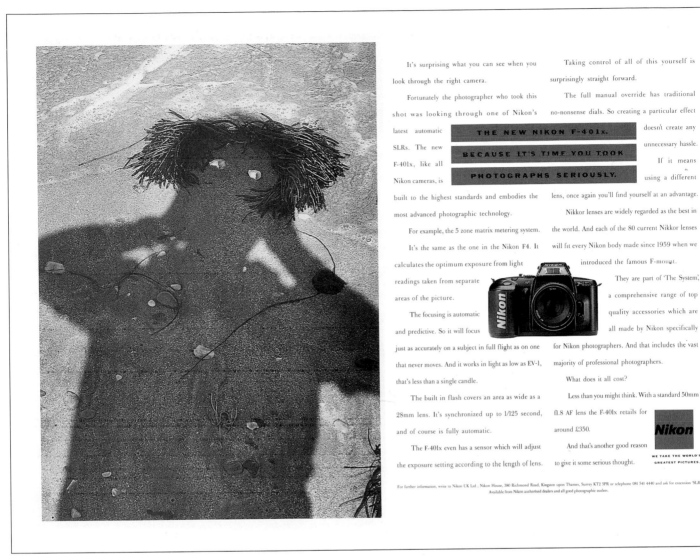

The advertisement text reads:

It's surprising what you can see when you look through the right camera.

Fortunately the photographer who took this shot was looking through one of Nikon's latest automatic SLRs. The new F-401x, like all Nikon cameras, is built to the highest standards and embodies the most advanced photographic technology.

For example, the 5 zone matrix metering system.

It's the same as the one in the Nikon F4. It calculates the optimum exposure from light readings taken from separate areas of the picture.

The focusing is automatic and predictive. So it will focus just as accurately on a subject in full flight as on one that never moves. And it works in light as low as EV-1, that's less than a single candle.

The built in flash covers an area as wide as a 28mm lens. It's synchronized up to 1/125 second, and of course is fully automatic.

The F-401x even has a sensor which will adjust the exposure setting according to the length of lens.

Taking control of all of this yourself is surprisingly straight forward.

The full manual override has traditional no-nonsense dials. So creating a particular effect doesn't create any unnecessary hassle.

If it means using a different lens, once again you'll find yourself at an advantage.

Nikkor lenses are widely regarded as the best in the world. And each of the 80 current Nikkor lenses will fit every Nikon body made since 1959 when we introduced the famous F-mount.

They are part of 'The System', a comprehensive range of top quality accessories which are all made by Nikon specifically for Nikon photographers. And that includes the vast majority of professional photographers.

What does it all cost?

Less than you might think. With a standard 50mm f1.8 AF lens the F-401x retails for around £350.

And that's another good reason to give it some serious thought.

THE NEW NIKON F-401x. BECAUSE IT'S TIME YOU TOOK PHOTOGRAPHS SERIOUSLY.

Nikon
WE TAKE THE WORLD'S GREATEST PICTURES.

For further information, write to Nikon UK Ltd., Nikon House, 380 Richmond Road, Kingston upon Thames, Surrey KT2 5PR or telephone 081 541 4440 and ask for extension 'SLR'. Available from Nikon authorised dealers and all good photographic outlets.

Nikon (A) Delaney Fletcher Slaymaker Delaney Bozell, UK (CD) Brian Stewart (P) Elliott Erwitt

that don't exist. Often they give you a drawing to follow, which takes the fun and spontaneity out of it. The most pleasurable assignments are those with no specific brief, but where you know what result you have to achieve. You're free; you can use your imagination and you really try hard. You are able to perform better because it's more of a personal effort.'

'If you tie yourself down, you leave no room for surprises. The brief should be "This is what we want the picture to say", not "This is what we want the picture to look like".'
Max Forsythe, photographer, London

When trying to entice amateurs into the camera-buying marketplace, there's a risk that you will alienate the professionals. Brian Stewart avoids this in Nikon ads by always using good photographers. Erwitt shot the picture first in the park with daisies for the eyes, then reshot it on the beach, and produced an even funnier picture.

Such visual quips are much more likely to inspire an involuntary chuckle than those artificial studio shots involving contrived situations where the models look surprised, panicked or, worst of all, happy!

'What excites me most about advertising is discovering an unexpected ad, buried in the everyday pack of mediocrity, some fresh twist, some cliché turned upside down.'
Jay Chiat, Chiat Day, New York

A flat tyre may not make your day, but unless you're completely hardened, the irony of this photograph by Jim Arndt should raise a smile. An extensive search by the Minneapolis agency, Fallon McElligott, brought to light a crop of similar pictures, which supported the strategy for Windsor Canadian.

This shot, though, was commissioned specifically. 'We had to cast for an out-of-shape man and find a suitably beaten-up truck', says Arndt. 'We filled it with two vanloads of tyres and dropped it on its axle. The only problem was that it was during the summer and the street was soft. The axle sank into the pavement and it was very difficult to get a jack under the truck to lift it up and put a wheel back on.'

As the campaign builds, you become more prepared to stop for each successive picture. The ads become friends. The headline strikes a resonant chord, because we've all been there. And as your affinity with the ad grows, so does your empathy with the product, in theory. OK, the ads are selling whisky, but you can still savour the shared moments of the ad, without being bitten by a hard-selling proposition. And, just maybe, if you *are* a whisky drinker, you'll be tempted to specify this particular brand next time.

Norwegian advertising is highly rated for being intelligently creative, even if budgets are generally very limited. When the economic belt tightens, the agencies owned by creatively motivated people, such as JBR, still manage to shine through. They show that a creative environment will unleash a wit and an impish irreverence, that vies with the best in the world. The resulting ads are frequently clever and deliciously tart.

JBR is Norway's fastest growing agency. Its creative director, Ingebrigt Steen Jensen, is one of Norway's brightest lights in advertising. 'We run a highly competitive agency', says Jensen. 'The majority of our senior people have a background in team sports. They enjoy competition – especially winning – and they know that individual brilliance is useless without team spirit. We try to compete with our competitors, not among ourselves. Also, all senior creatives are stockholders, and therefore partners in running the agency and defining its goals.'

Jim Beam Windsor Canadian (A) Fallon McElligott, USA (AD) Tom Litchenheld (CW) John Stingley (P) Jim Arndt

Fortunately, every day comes with an evening.

Jensen's successful advertising is based on a five-point plan:

1 Break the rules.
2 Treat the audience as people almost as intelligent as yourself.
3 Go to extremes to get attention.
4 Be aware of the great responsibility you have as part of the most powerful industry in the world. And use the responsibility to do good.
5 Produce advertising that is not only good for the client, but also for the target audience, society and the world as a whole.

Many of the agency's ads are culture-specific and can be understood only within the Norwegian context. But invariably humour is king. For example, a brown goat's cheese was the clear winner of a competition to find the most Norwegian of Norwegian products. To illustrate just how Norwegian it is, JBR show two American tourists eating the cheese, one as if it's a hamburger, the other as if it's a steak, with a crowning line *in English*: 'But Betty dear, you are not supposed to eat it like that.'

Norske MEIERIER (A) JBR, Norway (AD) Einar Fjøsne (CW) Kjetil Try (P) Yann Aker

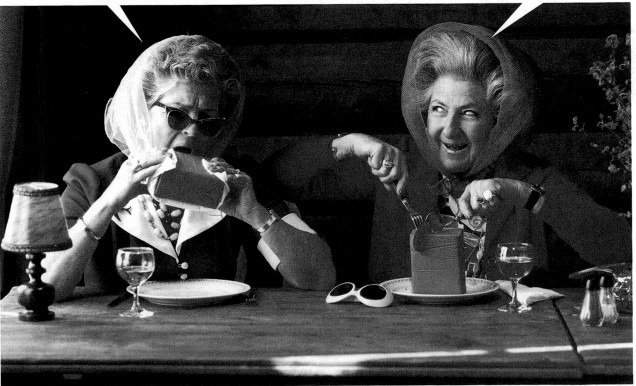

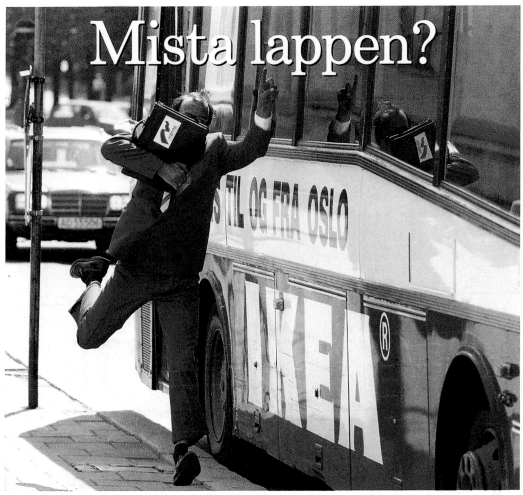

Mista lappen?

Gratis buss fra Universitetsplassen til IKEA hver time fra kl. 09.30.

Når verden går en imot — og det gjør den jo hvis den får anledning til det — er det godt å vite at noen aktiviteter er blottet for fallgruber.

En tur til IKEAs varehus på Slependen har f.eks. en tendens til å gå bra, selv for personer som er notorisk forfulgt av bagatellmessige uhell.

Er du blant dem som har problemer med veiskilt, er det bare å ta IKEA-bussen. Den går fra Universitetsplassen kl. 09.30, 10.30 osv. utover dagen, med siste avgang kl. 18.30. Bussen returnerer fra IKEA hver hele time.

Og den er aldeles gratis med tanke på de ubemidlede. Eller førerkortløse.

Virksomheten på selve varehuset er også så enkel at de fleste kunder klarer å holde seg innenfor lovens rammer.

Papirarbeidet er således begrenset til en enkel prislapp som henger på varen, med all nødvendig informasjon om mål, materialer og farver.

Ingenting skal rapporteres. Ingen skjemaer skal sendes nordover. Ingen revisorer er påkrevet.

Det eneste du må huske på er å betale, men kassene er godt synlige for de fleste. Og denne prosessen er ikke bare lovlig, men også billig.

Vi bestiller i store kvanta, transporterer uten mellomledd, lagrer rasjonelt og kniper inn på alt unntatt kvaliteten. Du bidrar ved å velge selv, hente møblene på lageret, frakte dem hjem og montere dem på egenhånd.

Sammen sparer vi så mye penger at selv en Statsansatt kan få det alminnelig fint. Uten å måtte drive eiendomsvirksomhet eller aksjeselskaper på si.

For den riktig uheldige har vi dessuten innført en unik sikkerhet: Vi garanterer deg 30 dagers full angrefrist hvis du skulle føle at du har gjort noe dumt.

Og ikke et ord til pressen.

Det er ingen skam å ta bussen.

OSLO Slependen. Man.—fre. 10—20, lør. 9—17.

IKEA (A) JBR, Norway (AD) Einar Fjøsne (CW) Ingebrigt Steen Jensen/Kjetil Try (P) Pål Rødahl

Politicians, too, are easy targets for parody, satire and mimicry. JBR's ads for the furniture store, IKEA, lay into politicians with a vengeance. One member of parliament had just lost his driving licence for speeding. He kept trying to argue that he was innocent and this fuelled a furore that raged in the press for weeks. The agency picked up on the scandal by using a lookalike actor running for the IKEA bus. The caption read: 'Lost your licence? Free bus to IKEA every half an hour.' The lookalike was so convincing that even the politician thought it was a picture of himself.

'People should be suspicious of advertising. Advertisers are biased; they are giving you selective truth.'
Robin Wight, creative director, WCRS, London

J. Walter Thompson has been one of Britain's three top-billing ad agencies since records began. *Campaign* magazine described the London office of the agency as the jewel in the crown of JWT's worldwide network. Somehow, originality finds its way through the labyrinth of influences which dampen creativity in many of the world's larger agencies. Add to these obstacles the rules and regulations governing cigarette advertising and you have a challenge fraught with pitfalls.

'We found that, by using over-the-top humour, we got away with a lot', says art director David May. 'For example, there's a rule saying you can't show people smoking. And, in the Old Holborn ads, they're *not* smoking.'

Gallaher (A) J. Walter Thompson, UK (AD) David May (CW) Steve Jenkinson (P) John Claridge

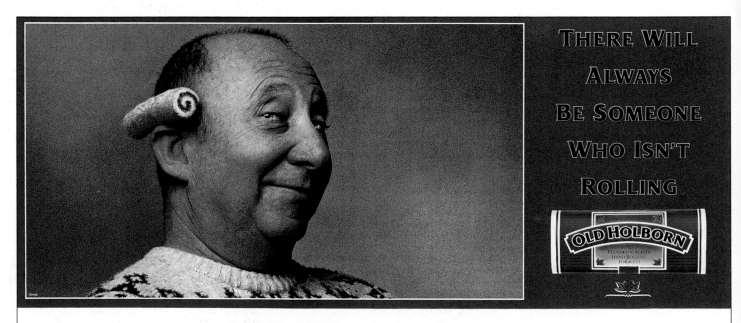

Warning: SMOKING CAN CAUSE FATAL DISEASES
Health Departments' Chief Medical Officers

Humour, in this case a particularly offbeat brand of humour, is used to target a younger market. In Britain, people are accustomed to unusual and inventive cigarette advertising, and they are ready to look for hidden meanings. So the creative team decided to go along that route in order to invite comment and speculation. The campaign uses objects that are associated with tobacco and smoking, however obscurely: a rope, fish and flower.

David May looked through old photos in antique markets to find pictures of bizarre-looking people. Then John Claridge photographed the object, taking care to match the lighting perfectly with the lighting on the face of the old photograph. The pictures were then montaged and hand-tinted.

For the later ads in the series, they dispensed with the old photograph, and shot the complete picture. A huge casting session unearthed similarly quirky-looking characters. Then the brief to Claridge was to photograph the man, in this case with a Swiss Roll behind his ear, looking like he was enjoying the anticipation of smoking this unusual roll-up, as if it was something he did every day.

TDK (A) GGK, Italy (AD) Jamie Ambler (P) Terence Donovan (Hand tinting) Dan Tierney

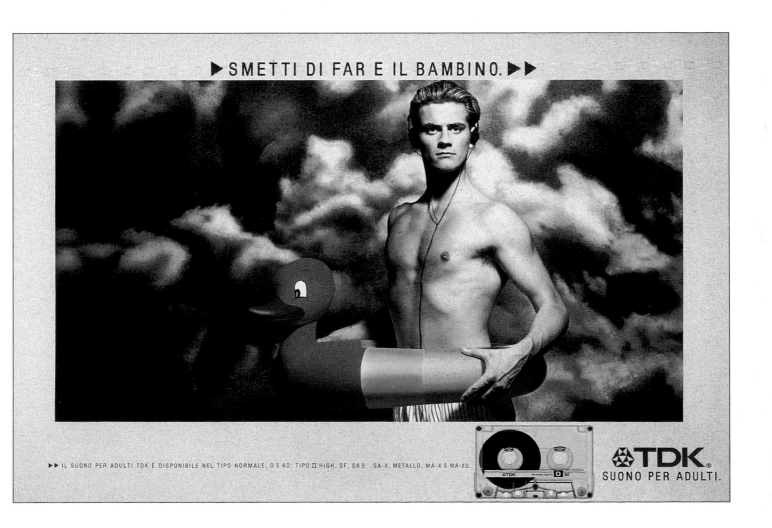

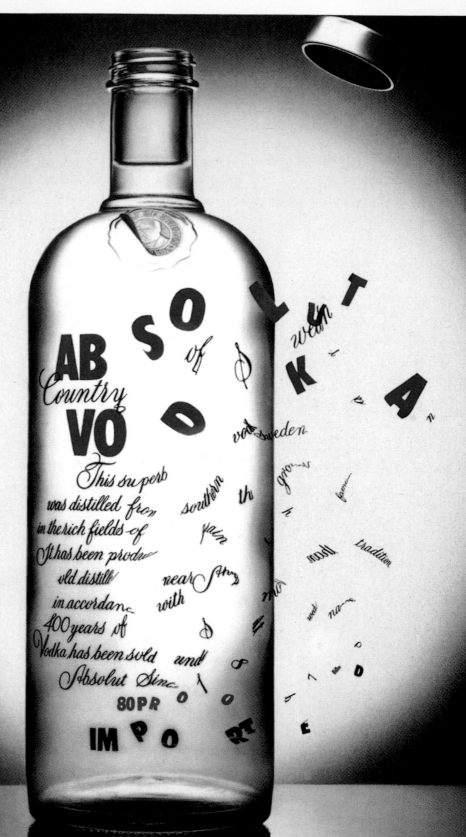

ABSOLUT CHICAGO.

AD INFINITUM

SAME, BUT DIFFERENT

SAME, BUT DIFFERENT

SAME, BUT DIFFERENT

SAME, BUT DIFFERENT

SAME, BUT DIFFERENT

SAME, BUT DIFFERENT

SAME, BUT DIFFERENT

SAME, BUT DIFFERENT

SAME, BUT DIFFERENT

SAME, BUT DIFFERENT

SAME, BUT DIFFERENT

SAME, BUT DIFFERENT

*Carillon Importers (A) TBWA, USA (CD) Arnie Arlow (AD) Tom McManus (CW) David Warren
(P) Steve Bronstein*

'A good concept has the ability of being executed in various ways over a long period of time.'
Arnie Arlow, creative director, TBWA, New York

It's there again. Seductively reader-friendly. A quick glance, 0.5 seconds. Building or bottle? Move on.

It's there again. I'm not going to read it. One second. Absolut . . . something.

It's there again. One second. Maybe two. Absolut Miami . . . oh yeah. Nicely done. So what?

It's there again. I'm busy. Don't crowd my mind. Nice though. Move on. Move back. Art deco. Miami. That familiar bottle. A model or retouching job? Charming idea. I'm hooked. Another in the city series. Manhattan, Chicago, San Francisco . . . an unexpected development in a long-running, long-punning campaign.

Absolutely hooked. Defences are down. I've joined the game. Who cares if I drink vodka or not? I've bought the ad.

'We have found that between 92 and 98 per cent of advertising just doesn't work. There's so much stuff out there that consumers' defences are really up. They are on sensory overload.'
Tom McElligott, McElligott Wright Morrison White, Minneapolis

The average consumer sees over 1000 advertising messages every day. Little wonder most of them are ignored. Yet, in the maelstrom of messages, this is one ad campaign that has achieved absolute recall. Almost. It certainly elevated Absolut from obscurity to brand leader within six years.

Research in the UK by Millward Brown investigated the difference in effectiveness between the best ads and the worst. The good stuff, they discovered, is 300 times more effective at breaking through barriers.

The Absolut saga began over a decade ago when Carillon Importers decided to market the Swedish vodka in America. Research said 'Don't do it!'. The clear bottle was so innocuous, how could it make any sort of impact? It was a parity product that stood little chance of surfacing. However, immune to such logic, Carillon's president Michel Roux forged ahead.

'To separate their product and make it visible, entrepreneurs have to use advertising imaginatively and continually.'
Arnie Arlow, creative director, TBWA, New York

Roux invited the New York office of TBWA to pitch for the account. Three nights before the presentation, Geoff Hayes, TBWA's senior vice president, was doodling on a layout pad in front of the TV: 'I was just drawing the bottle with a halo,' he says, 'and it just seemed to come together visually.'

He called in several photographers' portfolios and was struck by the clean, pristine look of Steve Bronstein's images. 'The bottle had acquired a reputation for being a difficult object to photograph', says Bronstein. 'They came to me specifically to do some experimental work, and come up with a "look" for it.'

Using a 8 × 10 Arca Swiss camera, Bronstein backlit the bottle against sand-blasted neutral

grey Plexiglass to create a soft glow that gave a dimension to the subject. He front-lit a shiny black cardboard base to provide a slightly blue cast. 'The key to success in a lot of assignments is having the time to experiment and work out the problems', says Bronstein.

Backlighting usually produces an uninspiring white background. Yet, with a white circle behind the bottle and the rest of the background black, the bottle gained the vitality and style it needed to win the account for TBWA, and it went on to win a place on the shelves of all the trendiest bars across America.

Absolut Perfection, with a halo over the bottle, was the first ad created for Carillon Importers by Geoff Hayes and Graham Turner and photographed by Steve Bronstein. That was in 1980.

'At that point nobody thought we had a campaign. It was just an ad', says creative director Arnie Arlow. 'However, when we did the next one, there seemed to be a way of continuing it, and little by little it grew into a campaign. It is helped by the fact that the campaign adheres to a very important principle of art: it has unity and variety. The message has remained the same, yet there's a tremendous amount of variety. The consistency provides a solid foundation, which makes us all feel secure, and the variety makes it exciting.'

'If you're going to build a brand, there has to be a personality that consumers can relate to over time. But you cannot rationalize mediocrity for the sake of consistency.'
Tom McElligott, McElligott Wright Morrison White, Minneapolis

In less than a decade, Absolut's advertising helped swell the product's annual revenue ten-fold. By 1991, the brand accounted for 60 per cent of the total $500 million imported vodka market and was growing at a rate of 30 per cent a year.

'The Absolut campaign is a client's dream', says Arlow. 'The bottle is centre stage. The name of the product is in the headline. And there isn't too much borrowed interest.'

Success also owes a lot to the campaign's gentle sense of fun which invites consumer participation. 'It's a kind of game,' says Arlow, 'a little tongue in cheek that prompts people to think: "We understand it, don't we? We're special." At a club or restaurant they'll order an Absolut and feel it says that they are a certain kind of person with a certain level of taste.'

In *Absolut Chicago*, the letters and bottle cap are apparently being blown away for the Windy City ad. A computerized engraver made tiny brass letters, which were suspended on wires and glued to sheets of glass in front of and behind the bottle, to look as if they were flying off.

'I try to do these things in-camera', says Bronstein. 'At least then I have some control and know what it looks like. If you shoot the different elements separately and then give it to the agency, you're putting the job in someone else's lap. They may do a good job, but they may not.'

After about 60 different Absolut ads, Bronstein is still the Absolut photographer. Yet more recent photographs seldom include the bottle itself, only its outline. And the simplicity which drove the early ads has been superseded by more complex scenarios involving additional model-making skills.

'As the brand has become so familiar, we've been able to be more esoteric and obscure, which allows for more creative opportunities', says Hayes.

Miniatures are especially challenging. In clumsy hands or under less discerning eyes, they would look corny or trite. 'Some ads look easy on the finished page, but they are hard to do', says

Bronstein. 'You have to have a very light touch to do it effectively. The execution has to be just right or they can fall flat.'

'People only really started noticing the ads after four or five years. It takes a lot of advertising to break through public consciousness,'
Geoff Hayes, senior vice president, TBWA, New York

Most of the ads were quite straightforward compared with *Absolut Miami*, one of Bronstein's favourites. This was the ultimate collaborative effort. Conceived and art directed by Steve Feldman and Harry Woods, it was drawn by architect Gary Rosard, built by the firm McConnell & Borow and photographed by Steve Bronstein.

The idea emerged while the creative team was working on another project. 'We were looking at a book about architecture in Miami,' says Feldman, 'and *boom*! Doing an art deco building just seemed the obvious way to go.'

For a concept meeting, Feldman roughed out a preliminary sketch. But Bronstein felt it could be stronger, and persuaded them to bring in an architect. The agency agreed. 'We wanted it to be a building that could really exist,' says Woods, 'so when you look at that model, you do a double-take.'

Architect Gary Rosard set to work on his contribution to the creative process. He produced sketches of the art deco bottle-building among the hotels of Collins Avenue in Miami. After several consultations with the agency, he came up with the final blueprint. And if you think the design is far-fetched, compare it with the Sheraton Hotel and Towers in Ankara, Turkey. The resemblance is striking.

The model took five weeks to make, with three or four people working on it most of the time. The model-makers began by constructing a cardboard mock-up of the set in order to check the basic shape and size of the elements from the camera's view point. Bronstein chose to move the flanking buildings to show their sides, and thus avoid them looking two-dimensional.

The exterior of the buildings closely matched real ones in Miami. The Absolut building was constructed out of quarter-inch Plexiglass. A series of four cylinders of varying diameters were made and glued together. The smallest diameter cylinder formed the bottle neck, reaching a height of just under three feet.

'We chose colours that had a 1930s look', says Mark Borow. 'We also went with cooler colours for the main bottle, because we're selling vodka – a cool, clear product.'

The attention to detail adds authenticity to the illusion. Many tiny props were built out of Plexiglass, floral wire and Lectraline tape – patio furniture, beach umbrellas, flowers, shrubs and so on. The sculpted palm trees had fronds made of painted feathers. The lawn was 'railroad grass', available from model railway suppliers. The beach was a sheet of sanded foam board, and the water, a rectangular sheet of Gatorboard covered with aluminium foil and airbrushed different shades of translucent blue. The backdrop was airbrushed by Sandro Laferla, using a photograph of a real sky as a reference.

All the windows are backlit transparencies – copychromes of interiors taken from architectural and design magazines. The floors are colour photocopies of suitable art deco patterns found in a book.

Carillon Importers (A) TBWA, USA (CD) Arnie Arlow (AD) Steve Feldman (CW) Harry Woods
(P) Steve Bronstein

'When you work with miniatures,' says Bronstein, 'your chances of success are generally greater if you make them a little dark or a little grainy. Small imperfections in the model can be disguised by using strong shadows and a low light level. Also, the more mood you can put into it the better. So I lit this to suggest the end of the day, with low light and long shadows.'

Bronstein took black-and-white and colour Polaroids to help him determine the appropriate lighting to use. The key light – a 2000 watt tungsten bulb – was positioned to the left, representing the sunlight. Then 15 separate strobe lights were positioned to illuminate the

backdrop, the water and the overhead beadboard. A vertical grid of three 600 watt strobe lights were set up behind the Absolut building to shine through the 'windows'. Bronstein discovered that the fill-in lights washed out the shadows on the beach produced by the trees, so these had to be drawn on the sand using terracotta pastels.

With Ektachrome film in his 4 × 5 Horseman camera, Bronstein took some test shots. These showed that the grass was too yellow, and, rather than change the lighting, which was balanced for the buildings, the grass was sprayed a darker shade of green.

Being a complicated set, the completed model for *Absolut Miami* remained in Bronstein's New York studio for about three weeks to allow for minor adjustments and to ensure that both the agency and client were happy with it.

The Absolut campaign plays games for fun. Benson & Hedges cigarette advertising plays games because it has to. 'Don't show people enjoying a cigarette', says the Code of Advertising Standards and Practice in Britain. 'You can't include anything associated with children, or imply that smoking makes you more attractive to the opposite sex.'

At different times and in different countries, cigarette advertising has had to contend with a variety of strait-jackets. No blue skies, no kids, nothing healthy-looking, wholesome or appetising. It's all rather academic now, as cigarette advertising has been largely snuffed out. But, in their day, cigarettes were responsible for some of the world's most innovative and intriguing campaigns. As the restrictions on cigarette advertising became increasingly stringent, the creative solutions became more inventive.

When Gallaher approached the London advertising agency, Collett Dickenson Pearce (CDP) in 1963, the company offered the agency the Senior Service account. 'No', said John Pearce, the chief executive. 'Give us this little brand with a gold box.' This relatively expensive weekend cigarette had performed poorly, and was in need of a relaunch. CDP splashed the Benson & Hedges *Pure Gold* campaign across the pages of glossy magazines with bold images which outshone other cigarette advertising.

Then, during the 1970s, the tax laws changed, making the market for filter-tipped cigarettes more competitive. By 1977 restrictions dictated that cigarettes could not be portrayed as objects of desire, such as a gold bar. Thus, out of necessity, Benson & Hedges broke new ground when Alan Waldie took a sideways look at the problem and launched the surreal campaign. 'We had to fill the hoardings with *something*', says Waldie. 'The least we could do was make it bright and visually interesting, and hopefully educate people to expect more subtle visual ideas.'

Fortunately the client, Gallaher, had the courage to say 'Yes', and the goalposts of advertising were suddenly enlarged. By closing certain doors, the Code of Advertising Standards and Practice helped push cigarette advertising in new and often highly innovative directions.

Carillon Importers (A) TBWA, USA (CD) Arnie Arlow (AD) Steve Feldman (CW) Harry Woods
(P) Steve Bronstein

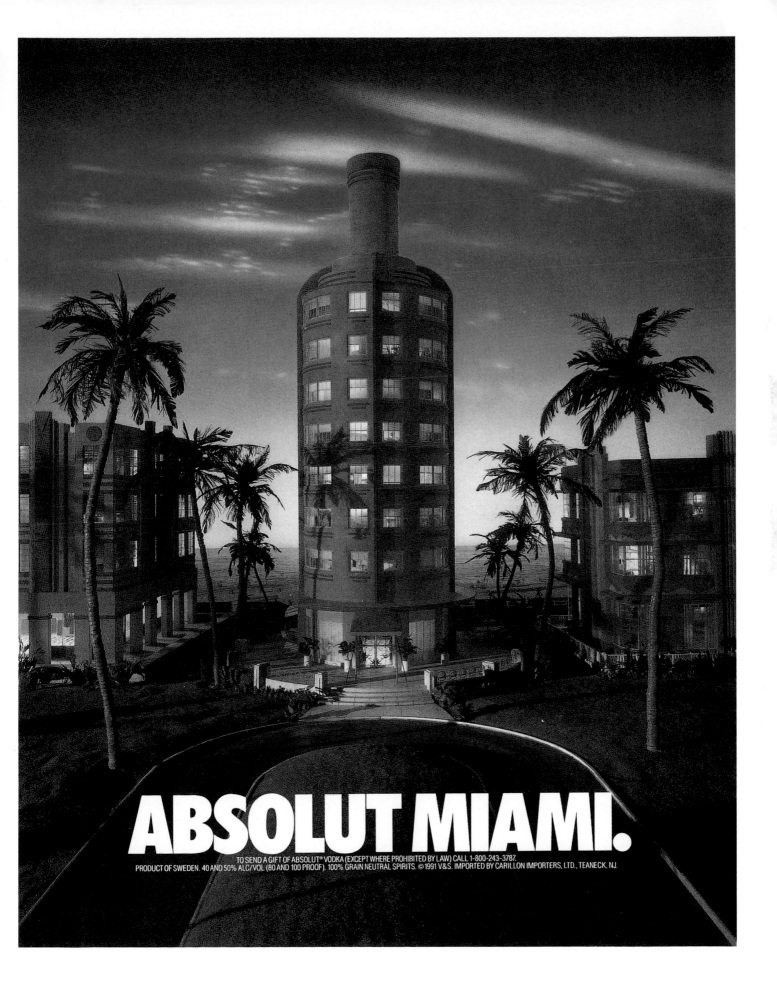

ABSOLUT MIAMI.

The interesting issue about cigarette advertising is not the moral one, but the ingenious ways in which agencies have responded to the restrictions. 'The constraints made the creatives think more laterally', says Godfrey. 'That's when some of the best work has been done. But you have to know what you're doing. Benson & Hedges has been imitated so much, and people often do it for the wrong reasons. They do it for products that actually have something to say.'

'With our industry being watched so carefully by governmental agencies, what we CAN say in our ads is forever narrowing and the sharpest tool left for us is HOW we say it.'
Bill Bernbach, Doyle Dane Bernbach, 1911–1982

Waldie went to some of the best photographers in London – Brian Duffy, Adrian Flowers and David Montgomery – in order to maximize the chances of success. 'I felt that if *they* couldn't make it work, we didn't have a campaign', says Waldie.

Duffy shot *Mouse hole* and *Bird cage*, Flowers shot *Ducks*, and Montgomery *Stonehenge*. The campaign never looked back. It soon grew into one of the world's most original and prestigious advertising campaigns, and within two years the cigarette was elevated to brand leader, where it remained for well over a decade.

Gallaher (A) Collett Dickenson Pearce, UK (AD) Graham Fink (P) Ed White

MIDDLE TAR As defined by H.M.Government
DANGER: Government Health WARNING: **CIGARETTES CAN SERIOUSLY DAMAGE YOUR HEALTH**

Surrealism, already accepted in painting, had found new expression in advertising. The sources of inspiration for this campaign were the great surrealists, such as Dali and Magritte. Elements of surrealism – that which is unreal – had been used in advertising for a long time, but the Benson & Hedges campaign was a breakthrough in the way advertising communicated with people, and it spawned a lot of imitators. In terms of visual stimulation, cigarette advertising had become good for you.

'British advertising owes a great debt to the early Benson & Hedges ads which broke the ice. They turned it all into a bit of fun, saying, in effect, that you can get involved without being bitten.'
Neil Fazakerley, creative director, BMP DDB, London.

At any one time several art directors worked on the ads with several different photographers. Within the imposed restrictions and within the surreal strategy, there was no conscious move to produce a particular style. The concepts always sought to push the basic idea to the limits in any direction. Yet if the ads have a continuity, it is in the stylish way in which they are produced, rather than any continuity of theme.

'For me, the best ones have always been good ideas, beautifully photographed', says Paul Briginshaw, art director with CDP. 'You can't just rely on a good photograph. You have to have a good idea, and the photography must not be allowed to get in the way of that idea.'

Art director Graham Fink was just two years out of college when he was given his head and let loose on his first B & H ad. The gamble paid off. Fink's idea of a swarm of golden cigarette packets leaving two beehives sounds bizarre, amusing *and* surreal, yet could have looked cheap and tacky if Fink had settled for second best.

'This was such a big number for me,' he explains, 'I had to be absolutely sure about who I was working with. I had worked with photographer Ed White before, and I knew he would aim for the perfection the shot needed.'

'The photography plays a very important part in enhancing the idea and giving it atmosphere. 'Bees' is a very three-dimensional subject, all about depth, colour and mood.'
Nigel Rose, art director, CDP, London

Model-maker Chris Lovell has been responsible for several Benson & Hedges models. His was the task of building the old-style beehives and about 3000 'bees'. The largest bee was the characteristically gold cigarette packet, the rest were models of varying sizes down to a quarter-inch high, mostly held in place by wires.

The shoot became an obsession. 'After three weeks, we had an acceptable result', says Fink. 'After ten weeks, the picture knocked everyone out. But we then went on for another six!'

Restrictions dictated that only one clear Royal Warrant should be seen in the picture, and that must not be tampered with, so in *Bees*, all but one had to be blocked out. Then, because of the romanticized image it portrays, a blue sky or sunset couldn't be used. So, the sky was smeared with Vaseline which turned it white. That was surreal and therefore not real and consequently acceptable.

'In advertising you're not creating art, you're trying to sell a product. Cigarettes and perfume ads pay photographers a lot of money. Many guys are beating on those doors, and they get the jobs because they play the game. I don't play the game, so I get what's left over.'
Elliott Erwitt, photographer, New York

'Some ideas for Benson & Hedges ads come from flipping through books of pictures', says Nigel Rose, art director with Collett Dickenson Pearce. On one occasion he saw a picture of a table with a yellow cloth on it. His train of thought went something like this: 'That looks like a pack. And, if the pack is a table, what should go on it? What would make it a pack as well as a table? Certain items related to a restaurant arranged in the design of a pack, such as the napkin for the embossed logo and red wine for the red lettering. A crease in the cloth could be the flip top of the pack . . .

'I wasn't sure what I would do with the Royal Warrant', says Rose. 'Originally I had grapes or possibly black olives, but that was too "foody", which you are not allowed to use. So we ended up with Brazil nut shells, which nobody can argue is appetising!'

'One of our strongest drives is to KNOW. There's a sense of intrigue, a kind of mystery in the Benson & Hedges ads. You may not understand the image at first, but your subconscious niggles away at it, and next time you'll probably get it. And having worked for it and solved the mystery, you will attach more value to the picture and remember the product.'
David Lewis, research psychologist, Sussex University

Rose showed his drawing of a table cloth with restaurant-related props to echo the design on the cigarette pack, to London photographer Nadav Kander. 'It was a great idea, but if it had been shot by a photographer who was into self-justification, he would have messed it up. It had to be shown simply and beautifully', says Kander. 'I felt this had to be either in a restaurant, very much a narrative, where the diners have left and you can almost feel that people have been breathing there. Or absolutely plain.'

He opted for the plain, more surreal look, with no context in which to place the table.

'When I set up the table in a "cove", the main problem was to produce a smoothness of light in the background at the same time as lighting the table beautifully. When the table was on a flat floor, the background went into black. We therefore increased the tilt of the floor until the area you see just above the table is only about one foot away from the back of the table. This enabled me to light the background smoothly. The table had to be built with the back leg about four inches long, the front about four feet, and the sides about normal height.'

As the team had to be able to reach the table to arrange the props, they constantly had to walk up the steep canvas-covered slope. The floor or 'flat' was therefore built out of sturdy 4×4 inch wood and weighed three quarters of a ton. And at one point the whole structure collapsed. 'The whole assignment took several weeks and was terribly intense', says Kander. 'The preparations had to be carefully planned. The linen had to be made for us because there is no linen that wide that doesn't have a pattern to it, and the table cloth had to be sent to Nottingham to be dyed. Only when the cloth had been creased and laid down properly, could you start propping it. And until it was propped, you couldn't paint the wine splash.'

MIDDLE TAR As defined by H.M. Government
Warning: SMOKING CAN CAUSE LUNG CANCER, BRONCHITIS AND OTHER CHEST DISEASES
Health Departments' Chief Medical Officers

Gallaher (A) Collett Dickenson Pearce, UK (AD) Nigel Rose (P) Nadav Kander

After a week and a half of walking up the canvas, it moved, so it had to come off, and the whole process started all over again. 'It's often much harder shooting very simple subjects,' says Kander, 'because every detail shows and so it has to be perfect.'

'One of the problems that B & H has is that they zoom in on little ideas and make "A" tunes, when they should be writing a sonata. It's a small study on a huge canvas. You're not supposed to put a study up there, you're supposed to have a painting. They've missed an opportunity.'
Jimmy Wormser, photographer, London

'The photographer is allocated four or five days fee', says Nigel Rose. 'If he goes over that, apart from expenses, it's down to him. Many photographers spend a lot more time pushing, pushing, pushing. I think they see it as investing in themselves. They view a Benson & Hedges ad as an accolade. It gives them a certain standing within the photography fraternity.'

The final shot for *Table cloth* was very close to the original layout. This was often the case with cigarette advertising because the layout had to be approved by the Code of Advertising Standards and Practice. 'If the photograph deviates wildly,' says Rose, 'they can knock it out . . . after you've spent all that money!'

Whatever you may think about the habit of smoking, a lot of cigarette advertising rose above mere commercial considerations. The public were treated to a continuous exhibition of well-crafted mind games, which people could enjoy without damaging their health.

Now that cigarette advertising is an endangered species, the question has to be raised, what next? Should alcohol advertising be banned? Fatty products? Anything containing sugar? Automobiles?

Gallaher (A) Collett Dickenson Pearce, UK (AD) Neil Godfrey (P) Jimmy Wormser

CHAPTER 5

ADMONISH

BOMBED OUT

This is the chapter you should never have seen. But who can resist taking a peek at ads that never made it to the billboards or magazines?

Like fishersmen, most established photographers and art directors have their own horror stories about wonderful specimens that got away. With all the restrictions waiting to thwart clever ideas, especially for alcohol and tobacco, it's surprising that any ads ever see publication.

One powerful scene envisaged by Graham Fink for Benson & Hedges involved a cave with cigarettes as stalactites and stalagmites and the cigarette pack as an ancient cave drawing. It was a sombre scene, lit only by a caver's helmet light. 'We thought it would get through because there was nothing bright or colourful about it to associate it with children', says Neil Godfrey, art director with Collett Dickenson Pearce. 'But it was blocked because the censorship body asserted that the limestone formations were the product of a pure element – dripping water – and we could not imply that cigarette smoking was pure. We argued that the stalactites and stalagmites were, in fact, the result of *impurities* in the water, but to no avail.'

For decades, cigarette advertising has been tip toe-ing through minefields of restrictions. For another beautiful idea from Collett Dickenson Pearce that never got off the ground, Neil Godfrey drew a rough sketch of kites, with one kite being a Benson & Hedges pack. He duly submitted it to the Advertising Standards Authority, which approved the concept.

Kites were brought in from all over the world – Indian kites, Japanese kites – serious toys, not kids' stuff. In his studio, London photographer Jimmy Wormser photographed each of the kites individually using a 5 × 4 inch camera. Godfrey then carefully arranged the transparencies on a low-key evening sky, which Wormser had shot on 35 mm while in Egypt shooting the early classic Benson & Hedges *Pyramids* ad. They were put together using dye transfer.

'My contribution was to execute the art director's idea', says Wormser. 'I am the craftsman, Neil is the artist. You have to go for what is best for the whole ad. There's no point having a beautiful photograph if it doesn't contribute to the overall ad. In my opinion, *Kites* is the closest I have ever got to art in an ad. It's very Miro or Kandinsky.'

When they saw the final picture, the censors changed their tune: 'But we didn't realise it would look so beautiful!' They claimed that the ad was *too* appealing and child-oriented and therefore couldn't fly.

The vast majority of ads are bombed out long before they reach photography stage. But some good ideas are photographed, then shelved. Carlos, art director with London agency, Saatchi & Saatchi, hoped that his *Ghost in the shower* would be his first big break into the prestigious Silk Cut campaign.

'In cigarette advertising in the UK there are restrictions on showing people', says Carlos. 'So copywriter Jeremy Clarke and I thought "How can we portray someone without actually showing them?" We decided to depict a person that we cannot see; the picture of him is in your mind. That's how we briefed the photographer, François Gillet'.

The photograph took one week to prepare, and was then shot entirely in-camera. After Gillet had assembled the props and personally painted the background, Carlos went to his studio in Stockholm for five days while the shot was taken.

(A) Saatchi & Saatchi, UK (AD) Carlos (CW) Jeremy Clarke (P) François Gillet

Gillet prefers to avoid computers and wanted to demonstrate that a shot as complicated as this could be done entirely in-camera. 'Technically, it's a mad picture to do in-camera, made up of three exposures on the same original', says Gillet. The background, the bath and piece of silk on the hanger were shot together. The figure and water proved most difficult to perfect. The water spray and a specially made black dummy were photographed on a black background. In order to emphasize the body outline, the water was divided into three parts, to fall either side of, and between, the ghost's legs.

'Because it's all in your mind, we had to draw a keyline', says Carlos. 'As you don't see the dummy, we had to make the water define its outline. The ghost doesn't exist, so we had to "say" what it is with the water. You see him, but he's not there.'

The resulting picture is somewhere between a cartoon and a photograph. Charles Saatchi approved it. The censors approved it. But the Silk Cut *Ghost* did not materialize. Was it because of a whim of the selectors? Too much competition from equally appropriate contenders? Maybe the cut in the silk is not prominent enough. They won't say. But, in terms of concept and photography, the Carlos and Gillet ghost is as worthy as any in the Silk Cut campaign.

'You cannot sell great advertising to someone who doesn't like it, irrespective of how good it is.'
Boris Damast, creative director, Baker Lovick, Toronto

London photographer Bob Carlos Clarke added drama and excitement to the Smirnoff campaign when he adopted a paparazzi style.

'Bob's work is usually very posed, but I was taken by his eye for design and detail', says David Stokes, art director with the London branch of Young & Rubicam. 'For the Smirnoff ads he achieved a planned spontaneity. The camera was positioned for composition and lighting, then he got the people to move, creating an energy and vitality which dispelled the posed look. The shots are like quick snaps, which convey the tension of the moment. Rather than simply looking pretty, the models were expected to act and to show emotion.'

All this is fine. So what's wrong with the shot of the sidewalk cafe? Bob Carlos Clarke is exasperated: 'There are lots of restrictions on drink advertising', he says. 'For example, we are not allowed to show two people having a drink near a swimming pool in case viewers deduce they are going to fall in and drown. It all adds up to the most terrible paranoia when doing the ads; you're never sure if they'll pass it or not.'

Although this ad appeared in France, it was bombed out in Britain. Why? There is a type of logic that reasons thus: the man getting to his feet is clearly concerned about being photographed in this situation. He is therefore obviously famous. The censor felt that the ad implies that famous or successful people drink, i.e., 'If you drink Smirnoff you can become famous'. A subliminally corrupting influence that would, no doubt, enrage ardent teetotallers.

Jeff Weiss of the New York agency Margeottes Weiss Fertitta did not limit his imagination when he set out to revitalize sales of the magazine *Harper's Bazaar*. 'We told them that you can't tell people you're cool, you just have to *be* cool', says Weiss. 'I did a series of women reading the magazine while sitting on the best toilets in New York – Nell's, the Metropolitan Opera and so on.

Smirnoff (A) Young & Rubicam, UK (AD) David Stokes (P) Bob Carlos Clarke

That went too far for them; they weren't comfortable with that, but it gave us room to do what we ended up doing. Although that may not be as bizarre as the original idea, it's still six-and-a-half steps ahead of what everybody else is doing.'

Sometimes life can be too daunting to be acceptable in advertising. In 1991 the ubiquitous French supermarket chain, Casino, burst onto the advertising scene for the first time, with a massive campaign comprising 80 ads a year. The Paris agency Publicis formulated a strategy based on the notion that all the shops are like ordinary people: they come in all shapes and sizes, and have a variety of needs and wants. In France, Casino supermarkets also come in different sizes, offering a wide array of products to satisfy everyone's demands.

'We've always sought to build a connection with our clients which generates the sympathy of the public.'
Marcel Bleustein-Blanchet, founder, Publicis, Paris

Italian photographer Alessandro Esteri was chosen to shoot the campaign because the agency, which had already used him for Orangina and Nescafé, was impressed by the 'truth' of his pictures. 'We needed truth', says creative director Jean Claude Dussin. 'The people in the pictures have to be credible, otherwise it looks false, it looks like advertising, it's not life. We needed life.'

'The difference between art and life is that art is more bearable.'
Charles Bukowski

Each picture in the campaign tells a story. A 500 mm mirror lens was fitted to Esteri's 35 mm Nikon to throw the background out of focus, and Kodak EES Ektachrome P800/1600 high speed film was pushed to ISO 1600 to produce a grainy, slightly monochrome effect. 'I underexpose a little and then overdevelop the film slightly', says Esteri. 'The picture is not very good quality, and this makes it more real, not too polished, like a snapshot in the street.'

Ironically, on one occasion, real life proved to be too much.

Esteri has two casting directors working full-time, tracking down suitable people – real people – to fit the different scenarios in the campaign. One year, to promote an awareness of Mother's Day, the plan was to photograph the president of the UK chapter of the Hell's Angels, with the line 'One day a year is sacred; everybody got a Mama'. The implication being, everyone has a soft side, however hard they might appear to be.

Casino (A) Publicis, France (AD) Jean Marie Moissan/Jean Louis Tournadre (CW) Jean Claude Dussin (P) Alessandro Esteri

The real McCoy came over from England to Paris. Esteri photographed him on a Harley Davidson holding a bunch of flowers. 'It was like a scoop, because these people are very important in their society', says Esteri. 'But it was too much for the client.'

Strong, he could be. Tender, he found difficult to show. The words and pictures were not working together. For these ads to be successful, they had to find the equilibrium between the truth and an acceptable view of the people shown.

A Thai boxer was brought in from Belgium and caught the feeling exactly. Out of 100 pictures Esteri shot during the first year of the campaign, only four had to be reshot.

'In the beginning we did not show the casting to the client, only the roughs', says Esteri. 'Now we send a videotape of the casting, and only shoot when the client approves it.'

Casino (A) Publicis, France (AD) Jean Marie Moissan/Jean Louis Tournadre (CW) Jean Claude Dussin (P) Alessandro Esteri

• SIGN OF THE TIMES •

POLITICS, NEWS AND VIEWS

Sunday Times

MAKE A FEAST OF IT EVERY SUNDAY

Times Media (A) McCann Erickson, S. Africa (AD) Les Broude (CW) Merlin Grant (P) Angelo Avlonitis

Les Broude loves ruffling feathers. He is creative director with McCann Erickson in Durban, and he enjoys prodding the nation's conscience.

One of the agency's clients was *The Sunday Times* – the newspaper with the largest circulation in South Africa, amongst blacks as well as whites. Broude and copywriter Merlin Grant created 36 rough ads, of which only eight actually ran.

When F.W. de Klerk made his watershed speech marking the first major step towards dismantling apartheid, Broude felt compelled to produce an ad as a statement for *The Sunday Times*, which reflected the mood of change in South Africa. The result was a trio of black-and-white photographs of a hand, photographed by Angelo Avlonitis. A black hand was lit through a shutter which broke it up into a spectrum of white, black, and something in between – the colours of South Africa. The first hand was clenched in a black power fist; the second, a peace sign; and the third, with fingers crossed. The headline was *Sign of the Times*.

'The ad did not run because the client was afraid it would be too controversial', says Broude. 'But ten days later an opposition newspaper came out with a cartoon of the black salute, the peace sign and a dove.' Broude's ad eventually ran five months later. Remember, a mighty oak is a little nut that held its ground.

'Take an interesting editorial portrait of George Melly.' The brief to London photographer Brian Griffin was simple enough. The agency, Bartle Bogle Hegarty, wanted an ad for its client, Sony, as one of a series of six ads using personalities. Both Griffin and Melly have a great affection for surrealism, so art director Dennis Lewis and copywriter Steve Hooper knew they would produce something unusual. 'We wanted something that did not look like a conventional advertising picture', says Lewis.

Sony (A) Bartle Bogle Hegarty, UK (AD) Dennis Lewis (CW) Steve Hooper (P) Brian Griffin
(M) George Melly

"I vaguely understood what made the record go round on a wind-up gramophone. I got lost (technically speaking) shortly after that."

(George Melly, ambivalent owner of the world's most expensive headphones, the Sony MDR-R10s.)

"Of course I'm still nostalgic for those days, during the Hitlerian war, when I pressed my ear up against the horn of a portable HMV gramophone and tried to clarify, through the scratches, hisses and the crump of distant bombs, the words of my life-long goddess, the blues singer Bessie Smith. It didn't help, of course, that she had a near impenetrable Deep South intonation.

In consequence, for years I sang comparative nonsense. 'It must be something they call the Cuban Dog,' I misinterpreted. Now, much more logically I realise it was 'Cupid's Dart' which was troubling her.

Which perhaps helps to explain why I now possess the world's finest headphones, ludicrously priced at two and a half grand (aspiring yuppies, if they're not all extinct, please note).

They tell me, and admittedly they could tell me anything, but I believe them, that there's no measurable distortion. They achieved this, bizarrely, by growing the material for the diaphragm in a laboratory, because no material existed that was thin enough. (Do the London Rubber Company know this?)

They also tell me, the housings, which look like early Henry Moores, are carved from the wood of a 200 year old Japanese Zelkova tree, and the copper for the flex is 99.999% pure, while the flex itself is covered in silk so that it falls elegantly on the Persian kilim.

For me, though, the point is that I can now make out every word Bessie sings. In some ways it's disillusioning. 'The ruler of the livery,' a romantic figure in my early mythology, has become a mere 'rural delivery.' Still, that's the price you pay (apart from £2,500) for the best headphones in the world."

George Melly

SONY.

WHY COMPROMISE?

Sony (A) Bartle Bogle Hegarty, UK (AD) Dennis Lewis (CW) Steve Hooper (P) Brian Griffin (M) George Melly

As an only child, Griffin was accustomed to creating things in his imagination to entertain himself. 'I found that an amazing advantage as a photographer', he says. 'I am always looking at something that becomes something else.' Griffin made his first creative impact photographing business people for *Management Today* magazine. 'I've always done things with a multi-faceted tinge to them, where you can't quite put your finger on where the picture's coming from. I don't sit back beforehand and think out how I can produce humour or whatever; it just delivers itself naturally from an idea.'

George Melly arrived wearing the two 'eye' rings and that's when Griffin had the idea for this shot. 'George Melly is full of personality, open and game for anything', says Griffin. 'He is sufficiently confident about his public image that he is able to accept a portrait of himself with his hands covering his face.'

The agency were knocked out by the photograph, and John Hegarty went in person to the client to sell the ad, but Sony rejected it. 'They found it a bit threatening,' says Lewis, 'a bit too surreal and not quite Sony. Instead, they chose another of Brian's portraits of George Melly.'

'A car is an expensive item; it's the ultimate toy. You buy it with your stomach, not with your brains.'
Peter Harold, creative director, WCRS, London

The London agency Abbott Mead Vickers has an excellent track record of Volvo ads. The various campaigns are designed to convey qualities of durability, reliability, safety and comfort. Ron Brown, art director, and chairman and creative director David Abbott conceived an idea that miscarried several times, but eventually came out into the open.

'We worked the lines off the pictures, which is the old VW technique', says Brown. 'It's the line that makes the picture, and without it, you don't know what the ad's actually saying.' The ad of the red car suspended on a hook had a turbulent history. Ron Brown's original rough layout was drawn two years before the ad finally ran. It showed a baby under a suspended car, with a line about the welder's baby. 'The client in the UK loved it,' says Brown, 'so I sent it to Sweden to find out if there were any welders with children who would let us use them in the ad. But, apart from not being prepared to put their child underneath the car, they thought it was incredibly bad taste, and if we ran the ad they would all go out on strike! They were right actually; it *was* bad taste, but it was such a dramatic picture.'

Volvo (A) Abbott Mead Vickers BBDO, UK (AD) Ron Brown (P) Martin Thompson

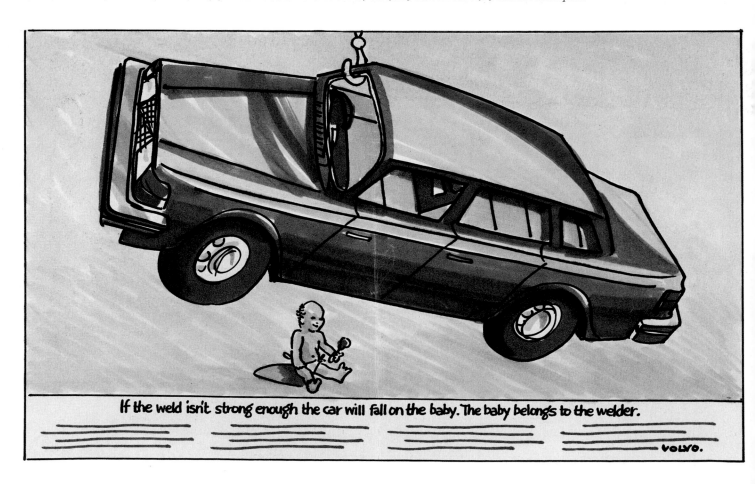

If the weld isn't strong enough the car will fall on the baby. The baby belongs to the welder.

The idea was shelved until later in the year, when Abbott rewrote the line: 'If the weld isn't strong enough the car will fall on the welder.' And they wanted to do it for real. Again Sweden said 'No way'. So it went back in the drawer for a year. Then Abbott said 'OK I'll go under there', and the ad was re-presented to the client, and this time he went for it.

'The problem with suspending a car in this way is that the engine is so heavy, the front drops down', says Brown. 'To balance it we filled the boot with sandbags, so it's actually heavier than the weight of the car.'

It was hanging from a huge crane, the arm of which is reflected in the roof of the car. While London photographer, Martin Thompson, shot the photographs, Abbott lay underneath for 30 seconds at a time.

'Managing creativity is not unlike driving a car in town: bursts of acceleration, frequent braking, unforseeable hazards, numerous changes of direction, and a high risk of accident.
Creative People by Winston Fletcher, Hutchinson Business Books

Volvo (A) Abbott Mead Vickers BBDO, UK (AD) Ron Brown (P) Martin Thompson

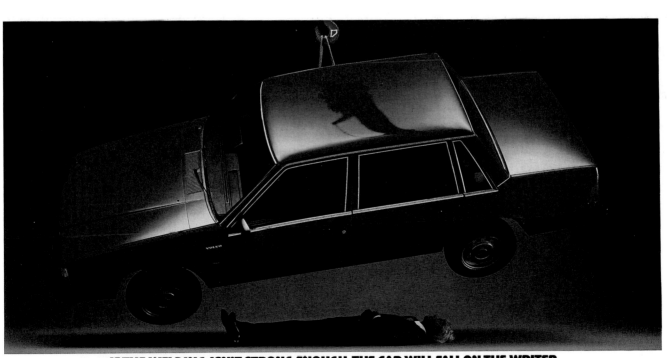

IF THE WELDING ISN'T STRONG ENOUGH, THE CAR WILL FALL ON THE WRITER.

That's me, lying rather nervously under the new Volvo 740.

For years I've been writing in advertisements that each spot weld in a Volvo is strong enough to support the weight of the entire car.

Someone decided I should put my body where my mouth is. So we suspended the car and I crawled underneath.

Of course the Volvo lived up to its reputation and I lived to tell the tale.

But the real point of the story is this; the Volvo 740 may have a different body shape, a fast and frugal new engine, a new interior and a new suspension system, but in one respect it's just like the Volvos of yore.

It's so well built you can bet your life on it.

I know. I just did.

To: Volvo, Springfield House, Mill Ave, Bristol BS1 4SA. Please send me details.
Mr/Mrs/Miss
Address
Postcode **THE NEW VOLVO 740. FROM £9249.**

NEW VOLVO 740 RANGE STARTS AT £9,249. 2·3 LITRE ENGINES. CARBURETTOR AND INJECTION VERSIONS AVAILABLE. PRICES INCLUDE CAR TAX AND VAT (DELIVERY AND NUMBER PLATES EXTRA). CORRECT AT TIME OF GOING TO PRESS. CUSTOMER INFORMATION TELEPHONE: HIGH WYCOMBE (0494) 33444.

Johnny Walker (A) Collett Dickenson Pearce, UK (AD) Neil Godfrey (CW) Indra Sinha (P)
Jimmy Wormser

CHAPTER 6

ADJUST

IMAGE MANIPULATION

A cigarette pack is placed erect on a wooden surface. Still-life. Lifeless. Nothing wrong with the photograph. All the ingredients are there, they just need a magic wand to elevate the image beyond reality. The technology is available – an art director can now experiment with a picture on a screen, substituting new skies, removing people, bending perspective.

In a few years time costs will fall and the level of technological finesse will rise further. Computer technology is moving so fast, magazines have a job giving state-of-the-craft information. By the twenty-first century this chapter will seem absurdly naïve – at least, technically.

Yet inspiration doesn't improve with technology. And photographers needn't feel threatened by it, as long as everyone is clear about the role of the photograph(s). Many photographers prefer to do as much as possible in-camera in order to retain control over the image. As soon as someone else starts tinkering with it on a computer, control is lost. If it is handled tastefully, that's fine, but the aesthetic judgements are no longer in the hands of the photographer.

'We cannot afford to go to the middle of the desert and wait till the vulture lands on the product.'
Alan Waldie, art director, Lowe Howard-Spink, London

Advertising photography, in its quest to shock, amaze and intrigue, frequently resorts to unusual juxtapositions of images. Sometimes purely for convenience. 'Because of time constraints, we have to expedite things and cheat', says Alan Waldie, art director with Lowe Howard-Spink in London. 'But this is not misleading the public; it's only an illusion, and people understand the language.'

Neil Godfrey, art director with the London agency Collett Dickenson Pearce, conceived a four-part photo-composition for Johnny Walker whisky to be shot in the Death Valley, California. 'The ripples in the foreground are different from those in the background', says Godfrey. 'I wanted to keep everything sharp and with the right perspective, so they had to be shot separately.'

London photographer Jimmy Wormser used a wide-angle lens for the foreground, and a normal lens for the girl. The girl was photographed on location, so as to use the same sand and light values as for the dunes. She was oiled down then sprinkled with sand. The hand holding the glass was photographed in the studio, then all the elements were stripped in together.

'We have better tools, more elaborate gadgetry, but it is still difficult to take a brilliant photograph. There is a lot of gloss and little content nowadays. Unfortunately a lot of people see only the gloss.'
Robert Dowling, photographer, London

A computer-generated photo-composition can be made by transforming any number of images into digital information. This is done by wrapping the transparency of artwork around the drum of a laser scanner which 'reads' the picture and converts it into electronic impulses – digital information. Several images can then be called up onto the screen, enlarged if necessary, and manipulated using a function keyboard or electronic pencil.

'Rules are what the artist breaks; the memorable never emerged from a formula.'
Bill Bernbach, Doyle Dane Bernbach, 1911–1982

Art director Kate Stanners and copywriter Tim Hearn at Gold Greenless Trott in London, chose Barney Edwards to shoot the print campaign for the painkilling drug Nurofen. Edwards had already directed the television commercial and there was no trouble pursuading the client to accept him for the stills.

On leaving Preston Art College, Barney Edwards joined the photographic department of a Fleet Street news agency. He then moved into advertising photography and soon made his mark, working for the American agency Doyle Dane Bernbach as well as Saatchi & Saatchi and Collett Dickenson Pearce in London. In 1980 he joined a film production company and then set up his own production company in 1986.

Using Arcimboldo as inspiration and a lot of unpragmatic soul-searching, the creative team came up with a layout for Nurofen, which the model-makers, Assylum, turned into a piece of sculpture. 'Arcimboldo did it with fruit and vegetables, but we used "uncomfortable" objects with sharp jagged edges to create a feeling of pain', says Edwards. 'I've always been interested in impressionist and/or expressionist images. I want people to ask "What does this make me *feel?*".

It's the question an expressionist artist would be asking of himself and the viewer. Hopefully the answer would be *pain*.'

Edwards shot the head on a Leica using the fine-grain Velvia colour film. The background was photographed on Polaroid black and white transparency (Polapan 125), producing a gutsy, grainy texture. A 14 × 11 inch transparency was made of the Velvia, and two 14 × 11 inch transparencies of the Polapan. One of the black-and-white transparencies was given to retoucher, Dan Tierney, who hand-tinted it. Tierney and Edwards then sat down together at the retouching house, Tapestry, with a Scitec computer and fed the three images into a Quantel Paintbox.

'We took separate elements from each image and built up a composite image', says Tierney. 'For over 20 years I have been visualizing and putting images together without a second chance. But on a computer it doesn't matter if you don't like something, you can just change it. You could have done the Nurofen job conventionally, using traditional methods, but it would have taken twice as long, and we would not have been able to make the decisions as we went along. It would have been totally my job in the sense that they would have had to brief me precisely at the beginning. They would have had to make those decisions *before* doing the job.'

Film is dead! Long live photography!

In response to a request from the Pentagon, Eastman Kodak developed a high resolution digital image system capable of producing near-instant images, manipulating them and then transmitting them around the world. By the time you read this, finer clones will no doubt have superseded it and our attitudes to the production of photographic images will have changed. Photographers' approach to work will certainly change.

'The advantage is the speed', says Alessandro Esteri, one of the first photographers to use the system for a commercial assignment. 'We are working in a world now where everything is going very fast; I'm here today, in England tomorrow, then off to Germany. With labs, you lose a lot of time, and you don't have the control. But with this system you have the prints exactly as you want them on the same day you shoot them.'

The system incorporates a Nikon F3 equipped with a digital back made by Kodak. A lead connects the camera to a little box containing a floppy disk. Its memory can hold up to 600 black-and-white or 350 colour images. No film is used. When a picture is taken, the information is stored digitally on the disk. This can then be inserted into an Apple Mac and the memory transferred into the computer's larger memory.

Ideally, a working studio would need two Nikons with digital backs (one for colour, one for black-for-white), two Macintosh Quadra 900s, a scanner and a Kodak XL7700 printer. The first stage can be bypassed and trannies or negatives can be scanned directly into the system. Then, using software called Photoshop, which functions much like Paintbox, the image can be brought up onto a screen, enlarged and manipulated – removing unwanted items, adding elements from other photographs, changing the colour, grain, contrast and so on. The new retouched image can then be stored on the disk and produced again at any time with exactly the same modifications. It does not require a skilled printer, just a technician who can call up the image and output it in the desired form – print or transparency.

Crookes Healthcare (A) Gold Greenlees Trott, UK (AD) Kate Stanners (CW) Tim Hearn
(P) Barney Edwards (Hand tinting) Dan Tierney

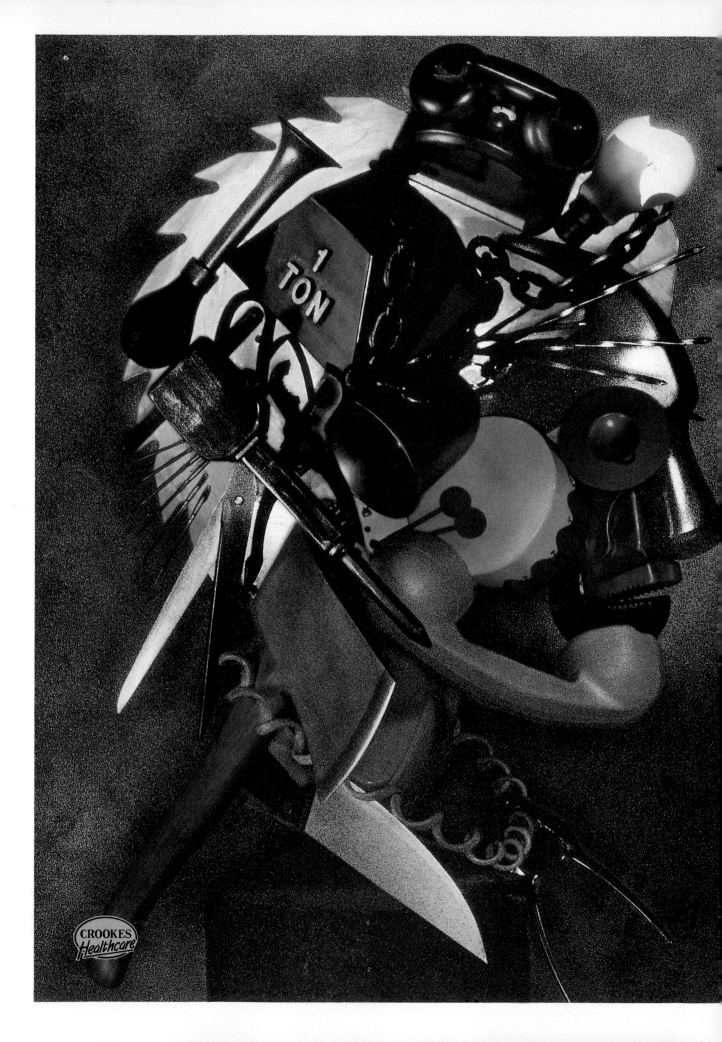

Splitting, nagging, pounding, blinding.

If you can describe it, we can relieve it.

Nurofen contains ibuprofen, which works in 3 different ways. It quickly and effectively eases the pain of headaches, migraines, periods, backaches and toothaches. It also lowers the temperatures of colds and 'flu, and thirdly reduces swellings and helps with muscular and rheumatic pains. It comes as original tablet or as Nurofen Soluble. But more to the point, it comes as an indescribable relief.

'The image itself is different', says Jacques Bergaud, owner of Pin-Up Studios in Paris, the first studio in the world equipped with this system. 'It has a different feel to it. Yet, although it is produced digitally, the quality is comparable to that produced by a good lab.'

Using a Modem, the pictures can be transmitted to anywhere in the world that has a telephone and a compatible system to receive the information. As the data is digital, what goes in one end, comes out the other – with no loss of quality. It means that an agency on the other side of the world can have the image on their screen almost immediately. While the photographer is on a shoot, the art director can say 'OK I think you've got it', or 'Can you try it another way?'

'Speed is not the only benefit', says Bergaud. 'Digital technology is changing the way photographers work. They shoot as usual, then make their choice of images on a screen just after shooting. They store the images they want to keep, and erase the rest. Then they work on the prints and have the results they want by the end of the day.'

As a freelance job, art director David Dye and copywriter Mike McKenna were commissioned to find a way of demonstrating the Barco system to promote the retouching house O'Connor Dowse. High-tech retouching houses usually go for ads with clever and complicated imagery, which is not necessarily very appealing to art directors. So Dye and McKenna opted for the light-hearted route.

'We had to do something that would be noticed by people in the business', says David Dye. They persuaded the client to place the ad in *Campaign* magazine in preference to small technical journals. Then they set to work on the question 'What causes a stir in *Campaign*?'

'Advertising is very incestuous,' says Dye, 'so we felt that showing the people involved in the business would be an instant attraction.' They married that idea with the skills being offered by the company, i.e., retouching, and they had the two ingredients for an effective ad. The people the ad was aimed at would know two or three out of the five, so they would find it *involving*. They'd want to know who the others are.

O'Connor Dowse (A) Overnight Productions UK (AD) David Dye (CW) Mike McKenna
(P) Malcolm Venville

London's leading Art Directors demonstrate the benefits of our new gizmo.

O'Connor Dowse (A) Overnight Productions UK (AD) David Dye (CW) Mike McKenna
(P) Malcolm Venville

The client had a limited budget. All the services were donated free, except hiring the studio and a couple of props. Dye and McKenna appealed to the art directors to donate half a day by saying that the headline would read 'London's leading art directors . . .' and that the ad would be going in *Campaign*. Some of them had said 'Yes' before the end of the sentence!

'We chose people who are very good and who we thought would be recognized', says Dye. 'The one on the right was going to be Paul Arden, then we were going to use John Hegarty.' But as it evolved, some art directors were too busy, away on a shoot or felt it was not right for them. The final line-up included Mark Denton, Mark Reddy, Graham Fink and Malcolm Gaskin.

Malcolm Venville, who works out of O'Connor Dowse, shot the photographs – about ten in all. Then Mark Denton, who is actually quite thin, was blown up. That was simple enough, but to show the retouchers how he wanted the image of Mark Reddy to look, Dye copied the photograph, cut it up and incorporated it onto the layout. The initial idea for Graham Fink worried them a bit, because it involved no clever retouching. They sketched out 20 ideas and Fink chose the one they went with, which involved photographing his ponytail in a number of different ways, and joining them together. Gaskin was stretched, and, finally, the baby was retouched on computer – nappy cleaned and little muscles expanded. They called the baby Hass because of the legendary youthful approach adopted by creative director Derrick Hass.

BOB LAMBERT · RETOUCHING · 835-2166

ADVANCE

SELF-PROMOTION

He looks an upright man. Reasonable enough. A little serious, but sincere. Perhaps a businessman. In the retail trade or decorating business. A family man, devoted, patriotic. Caucasian, but certainly not Aryan. Almost Jewish.

Bob Lambert stands out from all the retouchers who are capable of adding or removing a moustache. Why? Because his self-promotional ad says he is a rung above the rest. Not only does it announce what he can do, but it does so *in an arresting and memorable way.*

Ad agencies, photographers, retouchers, set-builders, model-makers . . . and the rest, all make their living promoting things. And, unless they are total cynics, they must believe in the power of advertising. Yet most of them don't pass muster when it comes to self-promotion. They are in the communication business, but do a poor job of communicating their own skills. This chapter is about some of the exceptions . . .

Bob Lambert (A) Fallon McElligott, USA (AD) Tom Lichtenheld (CW) Mike Lescarbeau (P) stock

Art director Tom Lichtenheld and copywriter Mike Lescarbeau at Fallon McElligott in Minneapolis had time on their hands while filming a television commercial on location. Their mental meanderings led them to a variety of uncommissioned advertising ideas. They helped Bob Lambert promote his skills simply by finding a suitable stock shot and letting Lambert do the minimum of retouching. The ad appeared in local trade magazines and drew a good response. Then it showed up as an award winner in advertising annuals, and Lambert started receiving calls from around the country.

> *'A good picture is like a gold bar in the bank.'*
> Nadav Kander, photographer, London

It is true that every piece of work that is seen by someone is an investment in the future, a form of self-promotion, whether you're a builder, an artist or photographer. Those who do not actively advertise their wares say: 'I don't need self-promotion; the work speaks for itself.' It may well speak for itself, but it'll speak louder if more people can hear it.

A photographic giant, such as Patrick Demarchelier, does not find the need, or the time, to produce promotional material. His editorial photography, which is spread so prolifically across the world's top fashion magazines, provides promotion enough. But for those whose work is not so visible, it is almost essential.

Your image, your name, your phone number on the walls of those who commission pictures can work subliminally to keep your name in people's minds. A poster or print can be one of the most persuasive carrots photographers can dangle in front of art buyers, or ad agencies can put before potential clients.

If you want people to hesitate before binning your masterpiece, turn to those who produce effective promotional material and find out why it works for them.

> *'Whatever you do, make it good, because if it turns out big, it had better be good.'*
> Harry de Zitter, photographer, Massachusetts

Minneapolis photographer Jim Arndt has been earning a living in photography for over 20 years. He feels that national and local promotion has been critical to his success. 'My first promo piece was a black-and-white editorial photo mailed to all local art directors', says Arndt. 'The success of that first piece prompted me to do four more in the next couple of years.'

He has since advertised in the *Black Book, American Showcase, The Workbook, Archive Magazine* and used direct mail. The direct mail comprises both reprints from the sourcebooks and original promotional material. It is sent out three or four times a year. 'In the beginning the mailing list was blanket "throw-it-against-the-wall-and-some-will-stick" coverage, but I found that targeting specific art directors, agencies and clients was more profitable', says Arndt.

The photograph of cowboys in the snow was shot in Jackson Hole, Wyoming, while on a shoot for US West, a client of Fallon McElligott. It was shot with a 300 mm lens and Kodachrome film at 1/1000 sec with an open aperture. 'The shot was set up to be a full-length horse and rider photo,' says Arndt, 'but as they kept coming at the camera, I kept shooting.' This particular shot was not used as an ad, only for self-promotion. It was part of a series on cowboys and cowboy life.

The first was an overall view of cowboys in the landscape. This was the next – a much tighter, more intense action shot, which provided a striking contrast to the first image.

When Houston photographer Arthur Meyerson photographed California Street in San Francisco, he had no idea it would be adapted and used as one of the most memorable Nike ads. The original shot, taken on a Nikon F3 with 500 mm lens using Kodachrome 64 film, was a vertical image with no runner on the skyline.

US West (A) Fallon McElligott, USA (AD) Pat Burnham (P) Jim Arndt

©1987 Jim Arndt

ARNDT
JIM ARNDT PHOTOGRAPHY
400 FIRST AVENUE NORTH #510, MINNEAPOLIS, MN 55401
(612) 332·5050

Meyerson used the photograph as a self-promo ad in *Adweek Portfolio*. David Jenkins, at the time an art director with Wieden & Kennedy in Portland, asked if he could use it as a two-page ad for Nike. Enlarging a section of a vertical 35 mm photograph to cover a horizontal spread sounded like wishful thinking, and Meyerson suggested recreating the situation on location. But budgets and time constraints did not allow it. He was, however, commissioned to photograph a runner using the same lens, film type and perspective as the original. This was added to the original using a computer, which also cleared the street of some of the cars.

Los Angeles photographer Richard Noble believes in showing something different from most promotional pictures. He goes for images he likes the most, whether or not they are considered commercial.

'I feel that using ads in self-promotion can be boring', says Noble. 'I know that people need to see that you can do the work they need. But I also think most art directors will look at an ad they didn't design themselves and be especially critical of it, because they don't like the typeface or something.' The ballet dancer was shot as a part of a series for the Los Angeles Ballet Company, and Noble rates it along with his best work.

'Photographers' portfolios have two sections: the work they love and the work they have produced for ads. The first is fantastic, beautiful, gentle, subtle – everything great photography should be. But their advertising photography is overlit, over-obvious, brash.'
Jeff Weiss, creative director, Margeottes Weiss Fertitta, New York

'As long there's great work in the portfolio, there'll always be more great work coming in', says London photographer Nadav Kander. Yet he also sends 400–500 posters to carefully targeted people, including those who handle accounts he would like to work on. Kander's personal work reveals a passion for photography. It shows a commitment and intensity which is lacking in the work of jobbing photographers. He views advertising commissions as running in parallel to what he does solely for his own gratification. Each fuels the other.

The picture he selects for a promotional poster has to be one that can be appreciated outside the context in which it was shot. 'I want people to call up and ask for another poster because they want to take it home', he says. 'The picture has to be one you would buy in a gallery.'

Nike (A) Wieden & Kennedy, USA (AD) David Jenkins (P) Arthur Meyerson

The dancer's feet were commissioned for an ad for W.H. Smith. The intention was just to photograph dance positions. Then on the last sheet they suddenly thought of having the girl on tip toes, while she was supported on a hang frame. It looks like she has been caught at the peak of the action, whereas the others were more of an essay on a dancer's feet.

'A dancer's foot is not a perfect foot', says Kander. 'For authenticity, we couldn't use a foot-model; their feet are too perfect, and anyway models can't point their feet like that.' Kander, who always prints his own black-and-white work, printed the feet softer for the ad, and much harder for the promotional poster.

(A) USA (P) Richard Noble

RICHARD NOBLE
7618 MELROSE AVENUE LOS ANGELES CA 90046 213 · 655 · 4711

W. H. Smith (A) DMB&B, UK (AD) Lee Ripper (CW) Tooki Rendell (P) Nadav Kander

104

NADAV KANDER

1-7 BRITANNIA ROW, LONDON N1 8QH. TEL. 071-359 5207. FAX 071-359 8925.

Represented in London by David Burnham. Telephone 071-482 1003

Born in Belgium, Harry de Zitter grew up in South Africa, moved to America, then to England and back to America again. In his early teens he went to boarding school, only going home twice a year. 'It made me stand on my own two feet and defined my disciplined attitude towards the way I run my operation', says de Zitter.

Harry de Zitter promotes himself as a no-nonsense photographer with a very professional approach towards his business, and an eye for producing solid, enduring images. 'London is riddled with overtalented creative people, but they are often reluctant to promote themselves', says de Zitter. 'It's partly to do with the British hang-up about being successful. The way you promote yourself and run your show is a science; it's how you respond to phone calls, how you follow up after a job, how you do mailers – collectable posters, not blatant commercialism. It's a changing world out there and you've got to do all that. The guys who were giants in the sixties are very aloof and feel they don't have to get involved in that sort of crass promotional thing. But it's not crass; you have to be visible in order to stay ahead of the game.'

Some advertising people and their clients want to be reassured by seeing big name accounts in photographers' portfolios. London photographer Ken Griffiths produced a video of his editorial photography, which he sends around the advertising agencies. 'If they want to see ads, I show them ads, but if they want to see *my* work, then I show them what I'd like them to see', says Griffiths. 'I'm in the business of taking photographs, and if they want to use them for advertising, then I'm in the market. Why show ads, most people know that ads are made up by several different people. Whereas my video illustrates how I look at life. It says "*This is me*". If you're going to travel for a couple of weeks with someone, you've got to know who you're dealing with.'

'Nobody holds a good opinion of a man who has a low opinion of himself.'
Anthony Trollope 1815–1882, *Orley Farm* (1862)

New York photographer David Langley invented the 'Red Box'. Frustrated by the difficulties of getting to see art directors personally, he shot his samples on 5 × 7 and mounted them on 8 × 10 chromes. He designed a distinctive-looking red box which he sends by messenger to named art directors, after first calling them. Langley even hired an art director and copywriter to create an ad campaign selling his system of selling. 'It's expensive,' says Langley, 'but it has paid off'.

Toronto photographer Shin Sugino used different psychology. One year he produced a very desirable jacket which was given only to art directors he had worked with, as if to say 'You are part of my team', or vice versa. It was expensive, special and oozed cachet. Rather than talking about photography, it expressed an attitude towards his relationship with his clients.

Peel back the often amiable exterior of most advertising photographers and you'll find a tough, resolute core. Without it, nobody could survive the emotional buffeting which comes with criticism, rejection and the ever-present competition from other talents. New photographers have a great barrier to cross when breaking into advertising. Established photographers have a similar problem when trying to make a name for themselves in a new country.

With the confidence and capital of one who has built up a healthy photography business in Britain, Frank Herholdt decided it was time for him to slice into the American apple. His New

York agent had been taking his work around and sending cards out for a few years, but with so many competitive photographers vying for jobs, a major offensive was called for. Herholdt gave the design company, Bull Rodger, the task of coming up with a job-winning formula – that extra push to make him stand out. The result? Not just a card or poster, but an entire magazine devoted to Frank Herholdt and his work. 8000 copies were sent out to art directors, creative directors and art buyers. One job resulting from that self-promotion exercise – albeit a 13 week job – covered the cost of producing the magazine.

Many photographers dream of producing calendars or even books of their work. A calendar is a prestigious showcase which provides prospective buyers with a constant, yet changing reminder, with up to 12 images a year. Tokyo photographer Hiroshi Nonami has been in photography for over 20 years, and has been experimenting with this unique style for about seven years. Before becoming a photographer he dreamed of being an artist in the style of Utrillo or Rembrandt, but he found the medium too laboured. 'Painting takes time, and the scenes I want to express change in front of me', says Nonami. 'I found that photography was the best way to keep my impression of the scene.'

(P) Hiroshi Nonami, Japan

Every year he produces a personal calendar for his prospective and established clients. 'Most of the pictures were taken with my own ideas,' says Nonami, 'with no thought for what art directors are looking for. I use very few advertising pictures for my self-promotion, because I am never satisfied with the results after art directors and/or designers have worked on my pictures. Consequently people usually ask me to produce images in my own original style.'

This photograph appeared in one of Nonami's personal calendars. It triggered an idea in the mind of an art director who wanted to develop it to advertise a department store. The client liked his theme of people and plants and he was commissioned to reshoot it for the ad.

Born in Seoul in 1952, Sang-Hoon Park graduated in photography from Joong Ang University in 1976. Since then he has been involved in advertising and editorial photography and made a particular impact with his fashion work. He produced this image while experimenting with different techniques. 'I think a good artist should develop his own techniques, and enjoy the challenge', says Park.

This fashion photograph was produced specifically for an ad in *The Art Directors' Index to Photographers*. He shot and printed a black-and-white photograph, erased elements of the picture by painting over the print, then reshot it on Kodak Ektachrome 64.

Bold, inventive approaches to promotion stand a better chance of being noticed. For example, when the rest of Europe watched open-mouthed as events in Germany took a historic turn, Paul Cowan, the account man at Saatchi & Saatchi in London, had the idea of buying some advertising space on the East side of the Berlin Wall.

'The Agency had the guts to spend money on something which might never have been seen by anybody' says Paul Arden, executive creative director at Saatchis. 'But it paid off for us because of the media coverage it generated.'

(P) Sang-Hoon Park, Korea

(A) Saatchi & Saatchi, UK (CD) Paul Arden

AD LIB

SAATCHI & SAATCHI – OFF THE WALL

Once upon a time there were two brothers, Charles and Maurice. In 1970 they founded an advertising agency that was to become the largest in the world. Not just in size, in IDEAS.

At the heart of all the world's top creative agencies is an 'ideas' person, someone who *likes* ads. For an agency to excel, it must be driven by a creative force. Take Bill Bernbach (DDB), David Abbott (AMV BBDO), Tom McElligott (MWMW), John Hegarty (BBH), Ingebrigt Steen Jensen (JBR), Frank Lowe (Lowe Howard-Spink) and Marcel Bleustein-Blanchet (Publicis).

Charles Saatchi set the creative tone for the agency, and Paul Arden was in the creative front line. He joined the agency in 1979, was made group head in 1981, joint creative director in 1985 and executive creative director in 1987. 'The thing that makes this agency different is that you can be a bit of a rebel', says Arden. 'You don't have to conform. You can go beyond normal ways of working and not get fired for it.'

Saatchi's nurtures adrenalin. The sort of adrenalin that fuels almost fanatical commitment to an idea, and passion to push it through. 'People must be willing to commit suicide for their work', says Arden. 'We are prepared to be wrong. If you take a big risk, you stand a chance of failing. The gamble is greater, but the rewards can also be greater. You never *know*, and that's why it's always so exciting. Putting our name on the Berlin Wall is a typical example; it could have been a complete waste of money, but it was worth trying.'

'In fact, they are very ordinary clothes, but Avedon thought of putting the dress on the girl's head.'
Paul Arden, executive creative director, Saatchi & Saatchi, London

For many creatives, the greatest buzz comes from originating a mould-breaking idea. But Arden isn't possessive about creativity. 'My greatest pleasure comes when other people are incredible', he says. 'The highlight of my life was when I was walking out of Richard Avedon's studio with some pictures in my hand, thinking I would be fired because the pictures were so wild. It was a moment of fear, almost, as well as a thrill. I had never seen pictures where the model has boss eyes.'

Contrary to appearances, the Nivea *peaches and cream* ad was a nightmare to put together. It took ten days to shoot, and caused considerable frustration. London photographer Michael Joseph had made a name for himself orchestrating orgy scenes. But Arden chose him for his

Alexon (A) Saatchi & Saatchi, UK (AD) Paul Arden (P) Richard Avedon

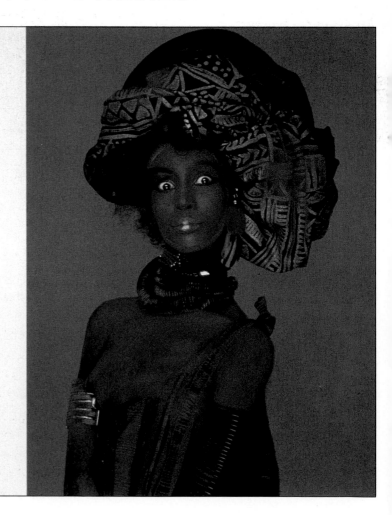

AVEDON ALEXON AFRICA

A

Yee hoo!, the old woman cries, as she butts the dancer gently in the belly. The dancer has been approved. The dancer is outstanding. The eye popping, limb contorting swirl of magic and colour that is the tribal dance of the Nomads of the Niger has reached its mesmeric climax. In a great white egg of a studio somewhere on New York's East Side, Richard Avedon the photographer who Truman Capote has called "The man with gifted eyes," breathes the tingling magic of the Wodaabe tribe into Alexon's African collection. Colours and primitive pattern woven into cloth, woven into clothes bring Alexon screeching into the now.

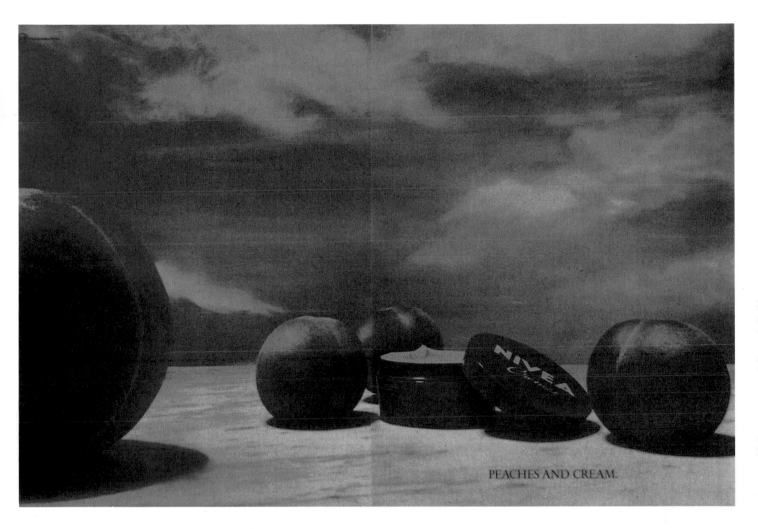

Nivea (A) Saatchi & Saatchi, UK (AD) Paul Arden (P) Michael Joseph

visual taste, his ability to position things so they look natural. 'I like casting photographers *against* their normal role, because then you get something unexpected', says Arden. 'I knew that Michael would keep working until it was right, and if I pushed him enough, we could get something superb.'

The first peaches arrived at the studio and Joseph was ready to shoot, when Paul Arden stepped in with 'No, no, no, . . . the peaches are not right'. Joseph arranged for some ex-assistants in New Zealand and California to ship over crates of peaches, as the English ones were too small. But even the imported peaches were not perfect enough. Eventually they used window display dummy fruit!

'Using Sebastião Salgado for Le Creuset was, I thought, the best use of reportage photography in advertising. The pictures made me feel I wanted to be a photographer.'
Terence Donovan, photographer, London

Sebastião Salgado is a photographer known for his perceptive social observations, which contribute to our collective conscience. A Brazilian photographer living in France, Salgado has a gift for adding an extra piquancy to our knowledge of the world's embarrassing sores. In Portuguese Salgado means 'salty'. His pictures have no sugar coating.

Salgado pours his heart through the camera, and the resulting pictures reflect both his passion and his compassion. Unhappy with what has been labelled the 'tourism of poverty', Salgado is no hit-and-run photographer. He stands, he shoots, he stays in solidarity with his subjects, whether 50,000 mud-covered men hauling sacks of dirt up and down slippery ladders in search of nuggets of gold, or emaciated victims of famine silently enduring suffering.

'Salgado has succeeded in creating the tremendous atmosphere of product integrity. You believe they are made of the very best ingredients. These are real guys. That's what scores."
Derrick Hass, creative director, Publicis, London

'Most Magnum photographers go for the heart of the story and don't worry so much about the shape of the pictures', says Arden. 'Whereas Salgado instinctively gives us pictures of form as well as a story. That makes him a notch better. He has a visual eye as well as a story-telling eye.'

Art director Anthony Easton sold the client the idea of using a Magnum photographer to portray the inside of the Le Creuset factory, then asked Salgado. 'The people working in the factory were intrinsic to the idea of the campaign, and suited Salgado because he has so much humanity in his pictures', says Easton.

As Salgado had been working on a major project about the end of man's industrial age, the subject was of sufficient interest for him to accept.

'While agencies place a great deal of importance upon the credibility of a headline and the copy, they have frequently failed to place enough importance on the credibility of the photographs. The Le Creuset photographs have that credibility.'
Max Forsythe, photographer, London

As Anthony Easton and his copywriter, Adam Kean, entered the factory, the ideas for the ads started to flow. They knew immediately they would use the cooking analogy. All the ingredients were just there; the pig iron was shaped automatically into the pan, which was automatically weighed. 'Le Creuset is all about traditional French cooking,' says Adam Kean, 'so we wanted to make Le Creuset the traditional French pot. If you want to get a taste of France, get a Le Creuset in your kitchen.'

They spent five days at the factory, during which time Salgado shot some 3000 photographs. 'We went there with specific set-ups in mind that I knew would serve a purpose', says Easton. 'But in the end we didn't use any of them, though Sebastião was incredibly amenable to it.'

Most of the men were Algerian and Italian immigrant workers, and Salgado conversed easily with them in fluent French. He is master of the art of blending in and not causing offence. 'We didn't want someone who was going to trivialize what they were doing, or appear to be pulling a fast one on them', says Easton. 'They got a good-natured banter going, and everyone wanted to be in the pictures. There was no feeling of embarrassment, as Salgado didn't interrupt what they

were doing. His photographs are emotional, witty, intelligent. I really feel that Sebastião is touched with greatness, not just as a photographer, but as a person.'

He didn't have an assistant, but carried three Leicas around his neck, two huge bags stuffed full of film and two small shoulder supports on two of the cameras. It was pretty dark in the factory and all the pictures use natural light. The results are gritty, gutsy, true-to-life and unposed. The pictures have integrity.

Instead of the small ads in the national press, which the clients initially requested, the campaign ran as double page colour magazine ads. Although nervous at first, the client felt the campaign did justice to their work, to what they felt was important.

'It's hard for advertising to be a positive addition to someone's day. If you can get that to happen, it doesn't matter how big the logo is, if they like you, they like the product.'
Antony Easton, art director, Saatchi & Saatchi, London

The Kitchenware Merchants (A) Saatchi & Saatchi, UK (AD) Anthony Easton (CW) Adam Kean
(P) Sebastião Salgado

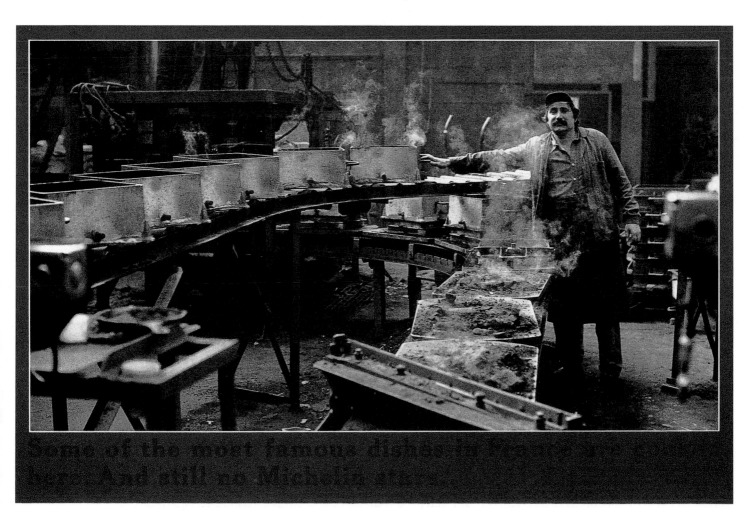

Paul Arden likes to encourage art directors to have a clear idea of what they want before they bring in a photographer. But it doesn't always work like that. 'Sometimes we have a feeling for what we want, yet we can't express it', says Arden. 'Then you *do* rely on a photographer. I regard that as bad art direction, but it can also be the best art direction, because you get something completely fresh. I wish there were rules. But there aren't.'

Matt Ryan, senior art director and group head, originated the concept for a British Airways campaign, responding to a brief to promote weekend breaks. It was a simple proposition. 'Essentially it is about getting away for a naughty weekend', says Ryan. He wanted to convey a flavour of the location, without losing sight of the romantic couple. He chose to use London photographer John Brown, who had previously worked on a Saatchi's ad for Lanson champagne.

'I wanted someone who was good at photographing locations, but could also add a bit of life', says Ryan. 'It wasn't going to be a close-up fashion ad with the location coming off as second best. I wanted the location to be grand as well.

'Before the shoot I had an idea of just using the three key colours of British Airways – red, white and blue', says Ryan. 'I wanted to give the campaign a distinctive look. I had an inkling in the back of my mind about doing some hand-colouring, and this idea developed during the shoot.

British Airways (A) Saatchi & Saatchi, UK (AD) Matt Ryan (P) John Brown (Hand tinting) Dan Tierney

John shot some colour Polaroids for colour reference, and, because of the strange way Polaroid colours sometimes come out, these indicated some different ways we could treat the black-and-whites. It was largely guesswork and experimentation.'

Ryan was conscious of the fact that the Lanson campaign used hand-colouring, and he wanted to avoid simply repeating the effect. He and Dan Tierney discussed a variety of possible techniques and, slowly, the atmosphere evolved. 'I had a feeling about it, more than an actual vision', says Ryan. 'It was one of those things, when you see it moving in the right direction, then you know it. I couldn't give Dan a picture and say I want it like that.' In a colour transparency tonal texture is lost, whereas more detail is retained in a black-and-white, so Brown shot in black and white. Dan Tierney retouched the negative, then Brown comped the image together, adding a lamppost on the right and removing two poles from the water and a pigeon from the foreground. 'You go into the darkroom and something starts happening,' says Dan Tierney, 'so you pursue that line because you like what's happening. Three weeks later you may not like how it develops because you're in a different mood or something else is going on. It's a creative process and, to an extent, it's unpredictable.'

Is the XXXX crocodile real? There's no doubt in the mind of London photographer Peter Lavery. 'Definitely!' he says. 'We always try to use the best possible props and locations, rather than cheat on them.'

The original concept for the ad was created by art director Zelda Malan and copywriter Peter Barry. In Darwin in northern Australia Peter Lavery engaged the services of a 14 ft crocodile called

Castlemaine XXXX (A) Saatchi & Saatchi, UK (AD) Zelda Malan (CW) Peter Barry (P) Peter Lavery

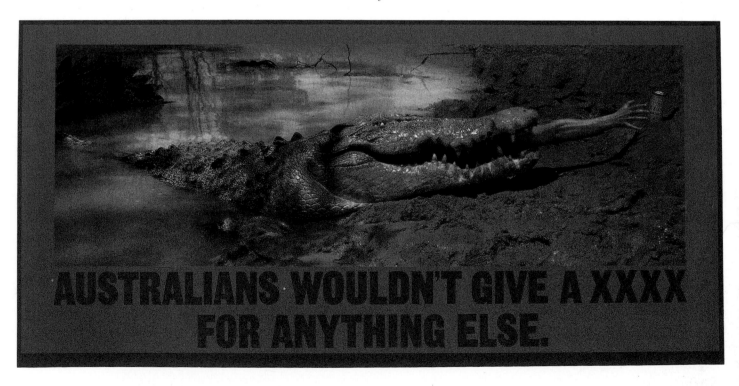

Blackie. In the grounds of a crocodile sanctuary a JCB digger gouged out a hole in the bank of a pond so that Lavery could get the camera low enough. They then built a pier under the water with the aim of securing Blackie to it with heavy-duty rope. Sedated and with its mouth tied, ten people loaded it onto a trailer, walked it half a mile to the pond and manhandled it onto the platform. 'As soon as we took the rope off its mouth for me to take the shot, the croc rolled sideways, broke all the restraining ropes and ended up in the water next to me!' says Lavery. 'We had to do this four times before we had the shot we wanted.'

The arm and XXXX can were, of course, added later, photographed by Dan Tierney.

The Silk Cut campaign, originated by Paul Arden and Charles Saatchi in 1983, was faced with the same problem as all cigarette advertising. Restrictions. Arden's solution was bold and simple. His concept focused on a piece of purple silk and a cut. 'It seems easy, but in fact it's easy to be boring, and very difficult to be original', says Arden. This was an attractive and prestigious project and many art directors submitted ideas that were filtered through creative directors to Arden for his judgement.

'If at the end of the whittling down process anybody feels particularly strongly about their piece of work and it's not gone through, then they can go to Paul and explain the virtues of their idea', says Matt Ryan. 'If Paul feels that you believe in something strongly enough, he will reconsider it. It's not easy to change his mind, but he feeds off the amount of commitment he can see in your presentation.'

After a few amusing variations on the theme it was difficult to see how the campaign could progress; it looked like it was losing momentum. Several creative teams were churning out roughs, but nothing really inspiring. 'The ads need a secondary level of interpretation for people to live off for a month or two', says Ryan. 'If the image is too simple, too first-level, then interest wanes really quickly.'

Graham Fink, who relishes an off-the-wall approach to everything, was determined to make his mark, and worked on Silk Cut for his first eight weeks at the agency. 'I did hundreds of them. They're quite easy to do. Anyone can do them, but it's hard to do a really really good one. I thought "If you're frightened of failure, you'll never ever do anything original", so I just kept thinking and thinking. Then at the end of one day I took a whole load to Paul Arden. "I've seen all these before", he said.'

'The tougher you are in this business, the more people like it', says Arden. 'As long as the cause is right and providing you are honestly aiming for good work. I'm not interested in whether somebody is nice or not. In fact, the more difficult a person is, the more enthusiastic I am about using them, because they are a bit more passionate in what they're doing.'

Fink had had enough and was ready to forget Silk Cut. He went back to his room to pack his bags and was thinking of photographers to shoot an idea he had involving a Samurai sword. 'I thought it would be interesting if we used completely the wrong photographer. Not a still-life photographer, why not a nature photographer, such as Eric Hoskins? He had his eye pecked out by a bird . . . The minute I thought of this nature photographer and his eye, I just drew the ad . . . a mother bird feeding the three babies. I did it in the same nano-second that I thought of using Eric Hoskins to shoot the sword. "That's it", I thought. "It's great!" As soon as I stopped trying, as soon as I let go, it came. Trying too hard is the single most common reason for not being able to do anything.'

Fink pinned his sketch on Arden's wall, with a note 'Dear Paul, hope you think this idea is as good as we do'.

He did. 'I like the idea of having scissors as birds, and think that the rivets as the eyes is very clever', says Arden. 'Immensely witty, a remarkable piece of work.'

The ad jumped to the front of the queue and was shot a few weeks later by London photographer Barney Edwards. He used a 35 mm Canon camera with a combination of Velvia colour film for the silk against a hand-drawn charcoal background shot on black-and-white Polaroid.

'I don't think Silk Cut would make it here; I don't think people would understand it. We don't rely as much on a visual invention as Europeans do. In America we rely more on conceptual word-picture associations.'
Allan Beaver, Levine Huntley Vick & Beaver, New York

The Silk Cut campaign runs in the UK, France, Spain and Greece. A good visual idea transcends international boundaries. But Helmut Newton's *Legs* only ran in France.

When deciding on a photographer, Alexandra Taylor, group head at Saatchi's, felt it had to be Newton because of the subject matter. 'Of all the people I could have worked with on that one, I felt that Helmut Newton would give me the better shot. It was a case of finding different places to put the dummy legs to see which would look best.

Silk Cut (A) Saatchi & Saatchi, UK (AD) Graham Fink (CW) Jeremy Clarke (P) Barney Edwards

LOW TAR As defined by H.M. Government
**Warning: SMOKING CAN CAUSE LUNG CANCER, BRONCHITIS AND OTHER CHEST DISEASES
Health Departments' Chief Medical Officers**

'I find working on Silk Cut a great honour because the budget enables me to work with the best photographers in the world. It's interesting because every photographer approaches a job in a totally different way. But it can be risky because you spend a lot of money working with a heavyweight photographer, and yet the shoot can go terribly wrong. When you're working with great photographers, people expect great work.'

Taylor tells photographers, particularly on Silk Cut, that she doesn't want them to think in terms of an advertising shot, but rather to produce their own personal photograph, that they are happy with.

For the Silk Cut *Legs* they couldn't use a real model because there was a regulation saying that cigarette advertising cannot be connected to a human being. They had to be dummy legs. It is a black-and-white shot, hand-coloured by Dan Tierney. Newton's narrative to this picture was that he felt the legs were looking out to sea and waiting for their lover to come back. 'It was something different for him,' says Taylor, 'and he says he loved it.'

'A lot of people just exist on their past reputations and never do anything new', says Arden. 'If you don't take risks, if you're not on the edge, it's boring. Bravery is the essence of this agency.'

'Doing business without advertising is like winking at a girl in the dark; you know what you're doing, but nobody else does.'
Edgar Watson Howe

Silk Cut (A) Saatchi & Saatchi, UK (AD) Alexandra Taylor (P) Helmut Newton

ADOPT

RIP OFF

'Originality is the art of concealing your source.'
Franklin Jones

There are no new ideas. But plagiarism comes in all shapes and guises, from subtle to blatant, from conscious to subliminal. They are most honest when they bounce off other ads in an esoteric in-joke, like the ingeniously simple parody of the original Silk Cut ad, produced for Heineken, which showed the brand's characteristic piece of purple silk with no cut. And in place of the government health warning was the line: 'Only Heineken can do this.'

Another playful take-off of the early Silk Cut ads showed the slash in the silk in the shape of a smiling mouth, advertising a smoker's toothpaste.

French Tourist Board (A) Doyle Dane Bernbach, USA (AD) Bill Bernbach (P) Elliott Erwitt

ADOPT RIP OFF

John O'Driscoll at Lowe Howard-Spink came up with another Heineken spoof, this time using Elliott Erwitt's classic shot for Bill Bernbach, promoting tourism in France. 'This is the one time I was hired to copy my own picture', says Erwitt. 'Generally people just steal your idea, but in this case they had the decency to ask me to do it.' David Ogilvy, not given to understatement, called Erwitt's original photograph of the bicycle and loaf 'The best photograph in the history of travel advertising'. The plagiarized version was pretty good too.

In 1971 Saatchi & Saatchi in London produced a memorable ad for The Health Education Council. By inverting logic, the ad made men think more seriously about contraception. When the poster first came out, *Time* magazine published an article about it and printed the ad. Suddenly it was not only famous in advertising agencies; it was world famous.

Twenty years later John Pallant and Matt Ryan, group heads at Saatchis, were researching some ideas to show that *Time* magazine creates an impact. The account group found the article about the pregnant man. 'We used that to say that anything that appears in *Time* is going to be seen by a lot of people', says Ryan. 'The word insertion came when John Pallant was talking to an account person who just happen to mention the word "insertion" in the context of the ad being inserted in the magazine. John hit on that and turned it into an ad.'

Whitbread Heineken (A) Lowe Howard-Spink, UK (AD) John O'Driscoll (CW) John Kelly
(P) Elliott Erwitt

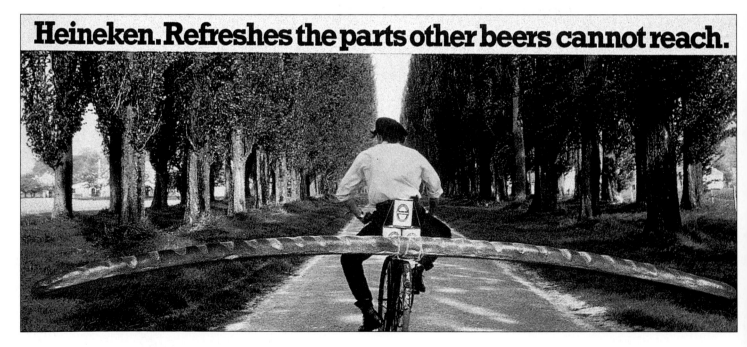

126

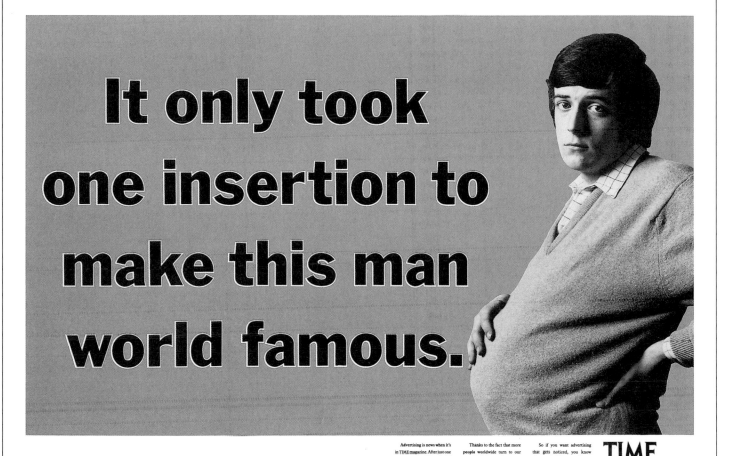

Time magazine (A) Saatchi & Saatchi, UK (AD) Matt Ryan (CW) John Pallant

In 1978 Tessa Traeger produced a very tasteful food collage of a face for *Vogue* magazine. Some 12 years later John Adams in Australia photographed a similar idea for a series of ads for Salad Magic. But where did Arcimboldo get it from?

'The Arcimboldo effect has now become an advertising gimmick', says Tessa Traeger. 'Many people have copied the idea, but I can't complain because, after all, I copied it from Arcimboldo. When I started photographing these collages, food advertising was very straightforward. Gradually it has swung around and, today, advertising agencies frequently show my pictures for *Vogue* to their clients, and I get a lot of work from something I've done editorially. They feed into each other.'

The Salad Man was invented by Andy Fackrell at Connaghan & May in Sydney for their client, Cerebos. It was originally designed for a television commercial using a mechanized man of latex rubber and stop-frame animation. The print campaign followed to promote the different varieties of salad dressing. On a still photograph the eye has time to notice mistakes that go unseen at 25 frames per second. Thus, the fruit and veg man was created, and cropped up in a variety of different versions for different countries.

'The media spend was tiny compared with the major multi-national brands', says Andy Fackrell. 'So the idea had to stand out. For the *Stars and Stripes* ad I wanted him to look like a vegetarian Colonel Sanders, complete with goatee beard made from peppers.'

The concept was in place by the time Fackrell approached Sydney photographer John Adams. But then Adams took over. Normally unflappable, Adams' patience started to wear thin as he laboriously graded individual blueberries for size and colour while creating the backdrop for the vegetarian *Stars and Stripes*. To these were added cherry tomatoes, celery and star fruit sections.

The logistics of the shoot become more of a mouthful when you appreciate that the Salad Magic man is life-size. Decorating the wooden framework with real fruit took up to 12 hours. Adams photographed it on a 8 × 10 inch Sinar, all in-camera.

'It was a huge team effort', says Adams. 'The most time-consuming aspect of it was experimenting with each fruit and vegetable to find which individual piece best fitted the design. We were constantly replacing the things which started to look tired, and we went through hundreds of cherry tomatoes for the American flag.'

Cerebos (A) Connaghan & May, Australia (AD) Andy Fackrell (P) John Adams

An original idea? Of course not. Derivative, yes. But appropriate. An idea slickly adapted to the product.

Benetton. 'Rip 'em down!' declares the voice of public outrage.

Thousands of people around the world have not been happy with the Benetton advertising campaigns. If the pictures were presented in an editorial context, no one would turn a hair. If they appeared as ads inside magazines, the outcry would have been faint. But on the commercial art gallery of the billboards, ads are saying: 'I'm important, look at me.' Add to this the ingredients which make ads stand out – originality, intrigue, drama – and some people are bound to be upset.

Although the ads depicting a white girl as an angel and black girl with devil's horns annoyed those who felt it reinforced racial stereotypes, the new-born baby (Baby Giusy) ad was the first to prompt widespread offence. One company even re-ran the Benetton baby ad attacking it with the headline 'It should have been strangled at birth'.

Benetton (A) In-house, Italy (AD) Oliviero Toscani (P) Oliviero Toscani

Mills & Allen (A) Mills & Allen Media Media, UK (P) Paul Lovelace

'But the Emperor has nothing on at all!'
Hans Christian Andersen 1805–1875, 'The Emperor's New Clothes'

The UK poster site company Mills & Allen were less aggressive, but equally sympathetic to public opinion, when they launched their 'Twins' product – two 48-sheet poster sites. With charm, wit, topicality and relevance to the twin poster concept, they performed a baby transplant. The new, few-day-old baby is supported by a 'mother', appropriately clad in a Benetton pullover.

Jane Rowe, a partner at Media Media in London, was looking for new ways of applying computer technology, when Mills & Allen approached them with the idea to promote 'Twins'. *Daily Express* photographer Paul Lovelace shot the baby and the poster site in Clapham Junction. The baby was then superimposed twice onto the poster sites and a lamppost was retouched out.

Besides the one insertion in *Campaign* magazine, Mills & Allen sent proofs out to creative directors, art directors and key clients. Plagiarism is alive and thriving.

Barneys New York (A) In-house, USA (CD/CW) Glenn O'Brien (AD) Doug Lloyd (P) Elliott Erwitt

CHAPTER 10

ADORN

RAGS AND NICHES

The model donned her smile. The client held his breath. The art director bit his tongue. The photographer gripped his pistol. The Next tie flew over the green cotton, no-longer-padded shoulder, brushing the carefully dishevelled hair, streaming away from the wind machine.

It's time to change our clothes advertising.

> *'I feel that advertising people find straight fashion pictures boring, because they are not interested in fashion.'*
> Terence Donovan, photographer, London

Clothes brands. We sit on designer labels. We embrace them on our T-shirts. We make a stand in Timberland boots or Nike trainers. We all need clothes. So why advertise them? Market share. Manufacturers need to dress their ads to target a particular section of the market. With a classic 'me-too' parity product, how else can newcomers to the rag trade carve their niche?

Advertising is one of the sharpest implements a company can use to chisel out its place in the market. Sharper still, many believe, if they bypass the ad agency and produce their advertising in-house.

'Ad agencies tend to convert fashion into advertising ideas, instead of vice versa. The fashion should dictate whether the girl sits or stands, but the agencies try to make the fashion work in terms of the idea.'
Barry Lategan, photographer, London

Benetton did it when photographer Oliviero Toscani took over the art direction and guided the company into the headlines. The Gap jealously guards its marketing strategy to keep copycats from scratching its patch. And Barneys, New York, dispensed with more than just the middleman when they risked the risqué and selected from the Magnum Photo files an Elliott Erwitt stock shot of a nudist camp for one of their ads.

'In our context, the pictures are about people with an individual sense of style', says Neil Kraft, vice-president of BNY Advertising, the in-house agency.

'We wanted an image campaign that would be intriguing, and appeal to both men and women, while also reflecting the taste and intelligence of the company', says creative director Glenn O'Brien. 'I got the idea for the campaign from looking through various copies of Comme des Garçons' publications. Doug Lloyd, Neil Kraft and myself then looked through every photo

Benetton (A) In-house, Italy (AD) Oliviero Toscani (P) Oliviero Toscani

book and archive we could get our hands on. Erwitt's nudist camp shot was chosen because we thought nudity was a funny theme for a clothing store.'

But *The New York Times* was affronted and refused to show Barneys bottoms. As a result the store probably enjoyed even greater exposure.

Well-versed in the art of capitalizing on media exposure, Benetton has received high praise and violent criticism in equal measure for its successive campaigns. Bold and controversial, they have certainly achieved one objective of advertising – to be noticed. But the shock tactics employed have often so antagonized people that they have mis-read the message. The company's stated aims have aroused unprecedented suspicion and scepticism. Is Benetton a baddie? Or is the company taking advertising into a new arena, elevating the medium to a compassionate, rather than simply commercial, level? The evolving campaign warrants serious attention which goes beyond the kneejerk reaction it has so widely received. Chapter 12 examines some of the implications.

'If you can put just any startling image up, with no relevance to the product, then we are all obsolete and may as well go home.'
Neil Godfrey, art director, Collett Dickenson Pearce, London

From 1984 Benetton began advertising outside Italy and France, and its pan-global campaigns are now presented in 100 countries. From 1990, the photographs used in the ads became symbolic, where the product was no longer shown, such as two hands, one black and white; a black child sleeping on a blanket of white teddy bears. 'We are in the privileged position of having 6,300 shops around the world, and that's a very good place to show our product', says Oliviero Toscani, who masterminds the campaign together with Luciano Benetton. 'We decided not to show the product any more, but rather we would *talk* to people. We know that people don't go immediately to buy a product, having seen an ad. Sometimes they just look at the picture and want to get something out of it. If they find the image is not so stupid, then they realize that perhaps our product is not that bad.'

'Unique individual visual statements go above most people's heads. We have to recognize it, then normalize it, then do something different from our competitors.'
Alan Waldie, art director, Lowe Howard-Spink, London

The creative approach was to link the brand to a powerful social message. In one ad, three children – black, white and yellow – are sticking out their tongues. What can be deduce from this? Whatever colour you are on the outside, we are all the same colour inside. This image was deemed 'pornographic' and therefore withdrawn from display in Arab countries, where the depiction of an internal organ is prohibited.

'In traditional advertising you see only the products, but, in our market, there is no longer a great difference between one brand and another. So we are trying to use our advertising budgets, which are considerable, to do something which is a little more useful.'
Luciano Benetton, president of Benetton, Italy

DRAMA.

IT'S HOW YOU SCULPT A MONUMENTAL

STATEMENT ABOUT STYLE FROM SIMPLE

LIGHT AND DARK. CLASSIC GAP, FOR

THOSE WHO FIND THEY FAVOR SUBTLETY.

GAP

The Gap (A) In-house, USA (AD) Nevil Burdis (P) Albert Watson (M) Horst P. Horst

136

Do we need to see the clothes in the ads? Or is the message more important, whether it's Benetton's social message or The Gap's 'mood' message or the Next style message? Most advertisers still feel more secure showing their product, and preferably also their logo, although many are prepared to be refreshingly inventive about *how* they show them.

The Gap has a mature attitude to advertising. Its personalities, photographed with great clarity, present a gallery of 'who's who' of a counterculture which has a high cachet in the minds of the public. Most of the target market is sufficiently well-informed to know who the often trendy personalities are. And those who are in-tune with the artistic echelons, will also have heard of the photographers: Annie Leibovitz, Herb Ritts, David Bailey, Albert Watson.

'All the best fashion advertising is in-house. You can't do it through an agency; they've got no idea. It's a whole different way of thinking.'
David Bailey, photographer, London

Albert Watson became a photographer in 1971 and is now in New York, shooting mainly fashion for the French and Italians. 'I am shooting almost every day', says Watson, 'I have shot in Paris early one morning, then shot the entire day in New York, having flown over on Concorde.'

Watson tries to research every job in detail. If it's a personality, he makes sure he knows who they are and what they've done. In the case of Horst P. Horst, who was 86 at the time, that was no problem as Watson had known him since the 1970s.

'I was trying to get the sort of feeling that if Horst shot a self-portrait it might have looked something like this', says Watson. 'I could have shot it against stark white, but in the end I opted for something that was a little more his style than mine, out of respect for him really.'

'When a mainstream agency picks up a fashion account, they tend to treat it like any other product – anything from beer to beans. They try to build a very concrete advertising strategy for a fashion image, and that doesn't work because fashion changes on a monthly basis.'
Glynne Hayes, Aston Hayes, London

People born in the post-war baby boom are now the most affluent and influential section of society. They have grown up without growing old. They make the ads; they have the money; they buy the products; and they have children.

Fashion, too, has grown up. In most developed countries young people have been declining as a portion of the total population, and fashion companies now target a broader, or at least older, market. Bruce Weber's interpretation of Calvin Klein's perfume 'Eternity' switched from erotically intertwined bodies to caring-sharing images of father, mother and child. High-powered businessmen cradled their babies to promote anything from wool to automobiles. The child became a symbol of caring and commitment. Babies even became fashion accessories – carefully colour co-ordinated, of course. The adland fantasy became more attainable, so the target audience could empathize with, rather than envy, the social position portrayed by the models. But however the situation changes, the job of the agency remains the same: develop a creative strategy that will work.

'The macho man who only cares about himself is vanishing. Society is moving towards caring about personal relationships and the state of the planet.'
John Hegarty, Bartle Bogle Hegarty, London

The advertising campaign for the UK clothing company, Next, is concept-driven. Style is more important than specific clothes. This is the 'us' generation where everyone is 'thirty-something'. 'We positioned the advertising to coincide with what was happening in society, just as people like Calvin Klein were doing in America', says Glynne Hayes, creative director of Aston Hayes, the London agency specializing in fashion advertising. 'The nineties heralded the caring, sharing generation, when we were getting more concerned about our planet. In the eighties we consumed so much; now it's time to get our priorities right.'

George Davis was the founder of Next. When he left, the company needed to show that there was life after Davis. The agency chose Patrick Demarchelier to set the seal on the future image of Next. The agency had frequently worked with Demarchelier and knew he could produce the look they wanted.

Next (A) Aston & Hayes, UK (AD) Glynne Hayes (P) Patrick Demarchelier

'Advertising is a mirror of what we would like our behaviour to be. We can't get involved with what is really happening; we've got to get involved in the myth.'
Richard Steedman, president, The Stock Market photo-library, New York

'Although we wanted to get a strong contemporary flavour to the advertising, we needed to go to a photographer who was experienced enough to give us a new style with a strong fashion edge', says Hayes.

The agency did the casting together with the directors of Next, then discussed it with Demarchelier. 'The brief to Patrick was to capture this group of people having a good time', says Aston. 'We set up the scenario for him and he took the story from there, creating an ambience, developing a rapport. Patrick never just shoots what he is told to shoot. He is a spontaneous photographer and always shoots a library of photographs, which explore beyond the layout.'

Secure in his point of view, Demarchelier works fast, using a reportage approach to produce an animated series of images, with the movement and variety of a television commercial.

'Advertising was more lavish in the eighties because society was more lavish. Now overtly expensive or gratuitous displays of wealth are not appreciated. Advertisers do not want to be perceived as being greedy or money-grabbing.'
Alan Page, creative director, Harari Page, London

Although Demarchelier's Next photographs are black-and-white, colour can be used, sometimes indirectly, to empower communication. Colour doesn't necessarily mean 'LOUD'. Compare the impact of some pictures in colour and mono. Colour communicates directly, as with traffic signals, or indirectly by creating a mood.

The American Color Research Institute has found that certain tones automatically attract the female eye. Red signals passion and sex appeal, white and red indicate optimism, blue is reliable and so on. Semiotics – the study of non-verbal symbols – has shown how colour works in a subliminal way: blue skies give a feeling of infinity and serenity, white symbolizes purity, while red and yellow is the most powerful coupling of colours in advertising.

'The ones who know most about the pictures they need are the clients, especially the bigger clients. They want pictures that are relevant to the market, not just pictures that photographers like to take.'
Richard Steedman, president of The Stock Market photo-library, New York

Liz Claiborne is known for its colourful hosiery. When New York agency Altschiller Reitzfeld Tracy-Locke set about creating a new campaign, associate creative directors Steve Mitsch and Rosiland Greene looked for ways of saying 'colour'. Janice Lipzin, who initiated an advertising department at Magnum Photos in New York, spent four years cultivating a relationship with the ad agency. Magnum photographer Dennis Stock produces stunning colour editorial work in lavish coffee-table books, but does very little advertising. 'Show us some ads,' said the agency, 'our client wants to see ads'. Eventually Lipzin convinced them that Dennis Stock's eye for a picture was more important than a bunch of ads.

'Bringing someone from fine art into advertising creates lots of additional problems; it almost detonates problems.'
Steve Mitsch, associate creative director, Altschiller Reitzfeld Tracy-Locke, New York

Dennis Stock lives in Provence. Besides landscape photography, he has covered reportage, documenting James Dean and the jazz scene in the 1950s. 'From his books you can see that he is interested in graphics and colour', says Steve Mitsch. 'He possesses the wonderful combination we were looking for – a sense of graphics, colour, humanity, life and humour.'

The aim of the print ads was to draw the viewer's eye to the legs. Ironically, all the colours selected by the client were the best-sellers, which were mostly neutral colours. As the eye is drawn to the highest key colour – the lighter end of the scale – Stock had the problem of creating an attention-grabbing image, without overwhelming the stocking. He did this by highlighting the stockings against a contrasting background.

Liz Claiborne Hosiery (A) Altschiller Reitzfeld Tracy-Locke, USA (AD) Steve Mitsch (P) Dennis Stock

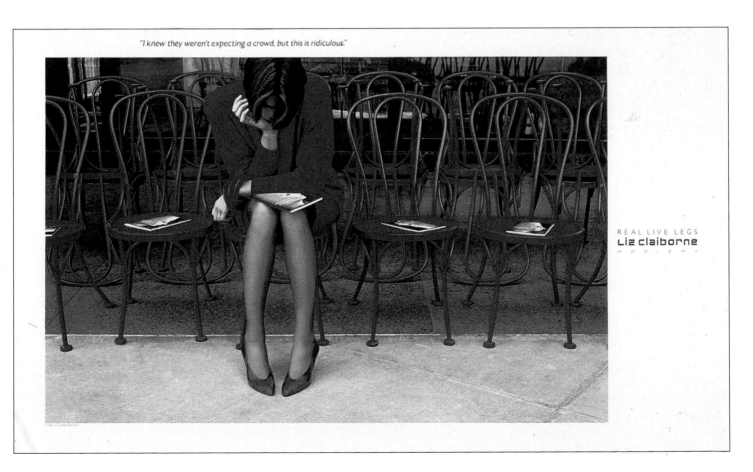

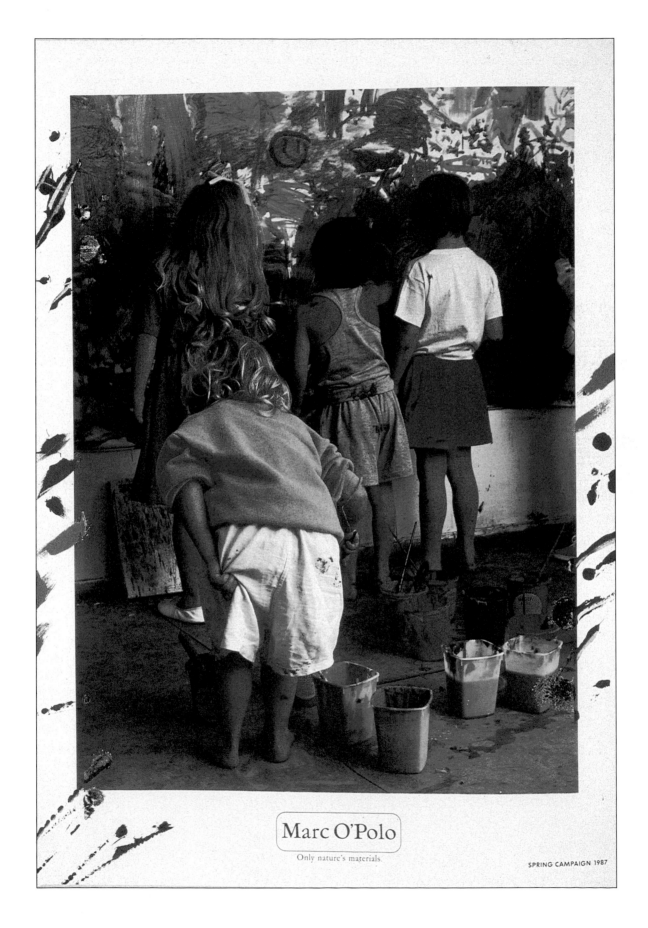

The Marc O'Polo Clothing Company was founded in Sweden in 1967. The clothes are made of natural materials, and use quiet, unobtrusive colours from nature. 'Print advertising in Sweden is not very loud and over-selling', says Torbjörn Lindgren, creative director and partner in HLR & Co BBDO, Stockholm. 'Advertising here is cleaner and more honest, probably because it is a small country with a fairly well-educated population.'

Both the advertising and Marc O'Polo's concepts were built on two themes: 'Only Nature's Materials' and 'Longlasting Fashion'. The agency chose to use natural models without make-up. For the picture of the children, Lindgren added another dimension: 'Moments of Life', which was caught by Swedish photographer Staffan Tranaeus.

'I wanted to get away from the traditional, made-up image of fashion pictures, and make them just as you would see in a family photo album', says Lindgren. 'Therefore I chose photographers who could shoot "from the hip". I also wanted a photographer who could follow my intentions with the soft, natural, Swedish imagery of Marc O'Polo.'

'Playing it safe can be the most dangerous thing in the world, because you won't have impact.'
Bill Bernbach, Doyle Dane Bernbach, 1911–1982

Teenagers and trend-setters were the targets for the Levi's campaign art directed by Stefano Colombo at McCann Erickson, Milan. 'All jeans ads were fashion-oriented, with American stereotypes – cool kids wearing jeans', says Colombo. With a brand that is so well known, Colombo felt he could take it a step further and make it different from the American style. Bouncing ideas around with his copywriter Alessandro Canale, his train of thought went something like this: Levi's are such a legend that the ads don't have to show them being worn. Maybe they can be worn in different ways, such as an Arab head dress . . . or further, something really wild . . . a Sumo wrestler . . . and then as a horse's reins. Using them for something peculiar, something that people are not accustomed to seeing. The copyline '501 fit for whatever' has the same double meaning in the original Italian as in English.

'It was difficult to find subjects that were believable, and also striking', says Colombo. A fan of British photography, Colombo went to the London office of McCann Erickson to look at still-life portfolios. One photographer turned down the job because he felt the horse would be too difficult. Columbo then looked through Graham Ford's book and liked his use of lighting.

'Great ads say one thing simply and imaginatively. The minute you try to do more than that you're into problems.'
Nigel Bogle, joint managing director, Bartle Bogle Hegarty, London

Marc O'Polo (A) HLR/BBDO, Sweden (AD/CW) Torbjörn Lindgren (P) Staffan Tranaeus

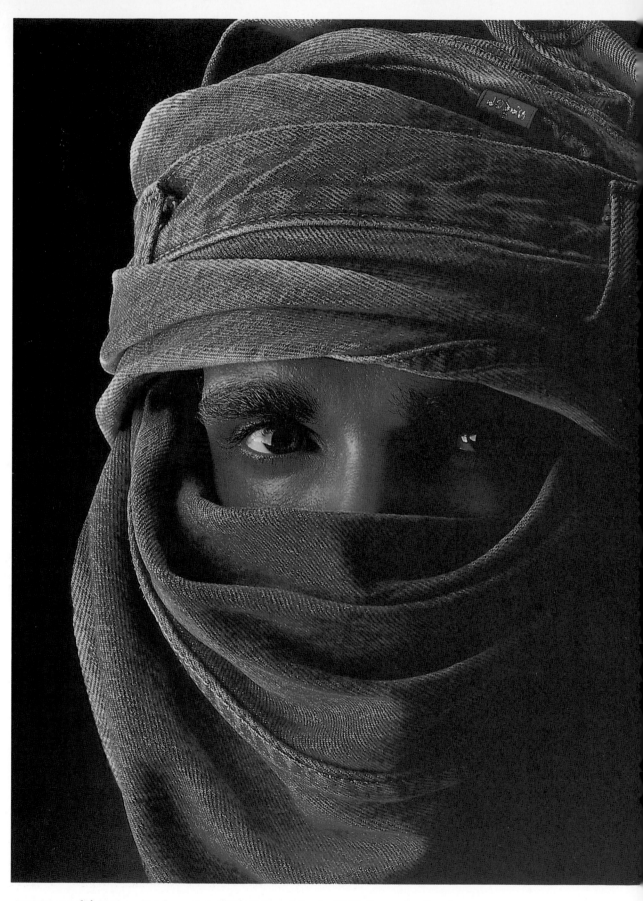

Levi Strauss (A) McCann Erickson, Italy (AD) Stefano Colombo (CW) Alessandro Canale
(P) Graham Ford

501 **Levis** PORTATI AD OGNI ESPERIENZA.

Graham Ford specialized in physics and chemistry at school before discovering the fascination of photography. He then worked as an assistant for eight years, five of them with photographer David Thorpe. Thorpe had a clear idea of the function of advertising photography, and passed on many of his attitudes to Ford. A photograph always had to communicate an idea. It had to be arresting, and it had to stimulate the viewer's imagination.

'For me, the excitement of photography is to create a controlled environment where a transformation can occur from an often mundane object into an absorbing photographic image', says Ford. 'This is an intuitive process, and like all photography, contains an element of chance. If I feel that I can't achieve this transformation then I will often turn the job down. I don't work to a set formula or style; I prefer to find the most elegant solution to the problem.'

Ford almost turned down the Levi's campaign because one shot was a close-up of a horse's head in motion with reins made from jeans and a tiny red tab Levi's logo which had to be readable. 'We spent two days shooting on 6 × 9 mm film with a standing horse, lots of patience and a video camera to check each image as it was shot', says Ford.

The man wearing an Arab head-dress was more controllable, and could be shot on 8 × 10 inch format. He was treated like a still-life, with sculptured lighting, rather than as a fashion shot. The brief was to have 'wonderful eyes', and to show the character, the texture of the denim. 'These are no ordinary jeans,' says Ford, 'there are about three pairs of jeans, all bleached, aged and reconstructed by model-maker Nancy Fowler at Shirtsleeves. They couldn't look too new and blue. That was part of making the idea work.'

Ford had no difficulty in making a strong image out of it. He lights his subjects to the limit. 'If the model moves, some area is going to go black or you are going to lose a shape', says Ford. 'A fashion photographer might have a lighting set-up that doesn't change very much, and all the atmosphere comes out of the movement of the model. But I light according to the position of the object; if it moves half an inch it doesn't work any more. I tend to use a strong side light or back light, often going to the limits of what the film can handle in terms of contrast. Space and shadow form important elements in my photographs. By using the imagination to interpret them, the viewer unconsciously becomes involved in making the picture.'

'You need to be streetwise. And it's no good being three years ahead of time; you should be three months preferably.'
Alan Waldie, art director, Lowe Howard-Spink, London

Pure advertising photographers simply use models as props for frocks, whereas fashion photographers pull a performance out of a model. Pamela Hanson brings a lot of life to her pictures. She has the ability to make people look like they're enjoying themselves. Hanson's shots of Triumph Bras are both sexy and light-hearted, appealing to both men and women.

In order to achieve this feeling, she must have freedom to control the shoot. Brian Stewart, joint creative director at the London agency, Delaney Fletcher Slaymaker Delaney Bozell, gives her a rough sketch and briefly sets the scene. 'I wouldn't give her much more than that, because you can over-promise with a drawing', says Stewart. 'With drawings, people cheat on perspective and depth of field. I try to keep it as loose as I can. I want to enjoy it too, so there has to be some surprise for me.'

Tri-action sports bra.

The bra designed for the woman's movement.

The bra for the way you are.

Triumph International (A) Delaney Fletcher Slaymaker Delaney Bozell, UK (AD) Brian Stewart (CW) Greg Delaney (P) Pamela Hanson

John Swannell is another fashion photographer adept at developing an easy rapport with his models. Angie Hill from Models One in London filled a pair of Pretty Polly stockings, then Swannell filled the frame with her. 'John has the feel for graphic composition – shapes and contours', says Marcus Vinton, art director at Bartle Bogle Hegarty in London. 'His heart and soul is in his work and his photography sessions just flow. As an art director, the danger is to try to be too involved.'

'A great idea comes out of understanding what makes a brand tick', says John Hegarty of Bartle Bogle Hegarty. 'The first things that go through your mind are: "Is this right for the brand? Does it belong? Is it what the brand needs?" Once you've done that, then you ask yourself, "Is this going to startle people? Will it present information in a way that hasn't been presented before?" If you do that there's a chance that you've created something that's memorable. Then finally, "Does it make the hairs on the back of your neck stand up?"

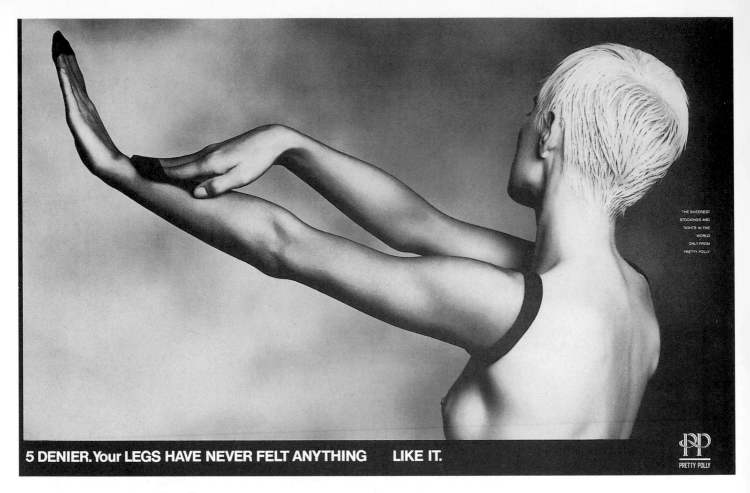

5 DENIER. Your LEGS HAVE NEVER FELT ANYTHING LIKE IT.

Pretty Polly (A) Bartle Bogle Hegarty, UK (AD) Marcus Vinton (P) John Swannell (M) Angie Hill

'All advertising is trying to put the product in the best light possible. One of the ways you do that is by making it look good, by making it *feel* good. It's like wrapping something well. If you do that you feel better about it before you've even opened the present, or product.'

'For an idea ever to be fashionable is ominous, since it must afterwards be always old-fashioned.'
Carl Sandburg, 1878–1967

Martin Riedl's intimately blue photograph of a couple wearing nothing but Ellesse shoes helped sales to rocket by over 300 per cent in a year. Riedl got the job thanks to a self-promotion poster of a nude he had distributed. For this image he used a high-powered projector to shine the words 'It's Ellesse or nothing' onto the guy's thigh. A normal projector would have required using a long exposure of 10 to 15 seconds – which was impractical for the pose, which was hard to hold. Riedl used a Hasselblad and flash to shoot a black-and-white image which was later blue-toned.

This single shot was used on showcards, leaflets, posters, even on the tickets on the shoes themselves. It became the image of Ellesse. Then the agency re-assessed the situation. The brand was moving towards an esoteric fashion image, and the London agency, Harari Page, had plans to push it further using Herb Ritts, but the client applied the brakes. He felt that a purely fashion shoe would have a short lifespan. Brands such as Nike and Reebok survive on the fact that they are fashionable, but with sporting credibility.

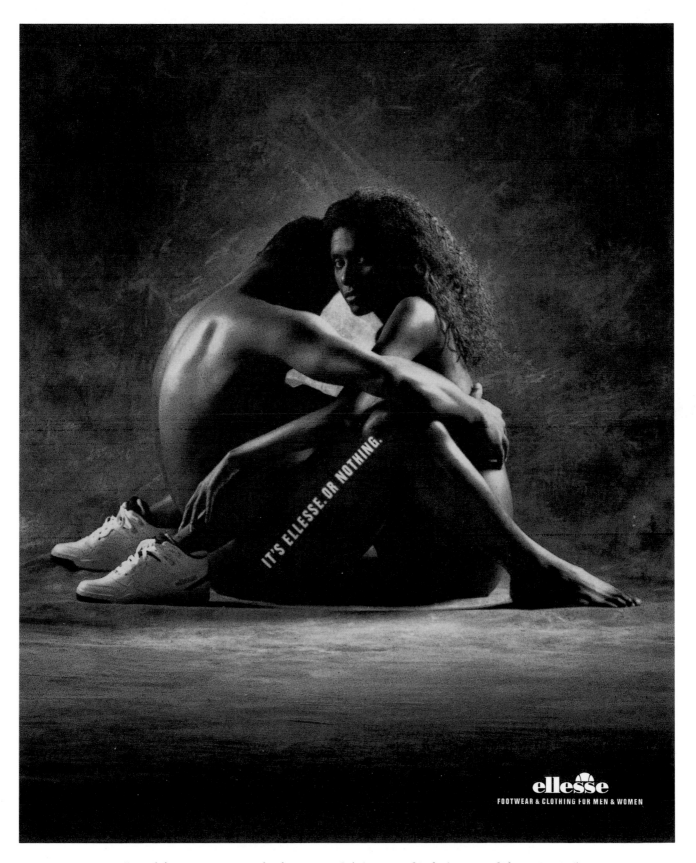

Ellesse (A) Harari Page, UK (AD) Steve Brooks/Alan Page (CW) Alan Page (P) Martin Riedl

In the young, active leisure footwear market, Ellesse could not compete head-on with the giants, so creative director Alan Page suggested positioning the brand as something for sporty people who are a little more discerning – 'Ellesse is more'. A niche can be narrow, and the nuances of a photograph can make or mar the brand's identity.

'Simplicity for me is the art of telling the whole story using as few elements as possible.'
Neil French, The Ball Partnership, Singapore

Nike spells power and success. So does Bo Jackson, whose status on the baseball and football fields provides an ideal opportunity for Nike to make a product proposition. Art director David Jenkins at Wieden & Kennedy in Portland chose Richard Noble to shoot the photograph.

Nike ads talk to people. 'No telephone number was given in the ads', says Jenkins, 'yet people tracked us down and phoned and wrote to say "This advertising changed my life". It shows how important advertising can be.'

Nike's turnover rose from $10 to $150m in four years. It's not all down to advertising, of course. The products are good, the delivery system is good and then the advertising pushes it out the door.

Nike (A) Wieden & Kennedy, USA (AD) David Jenkins (P) Richard Noble
(M) Bo Jackson

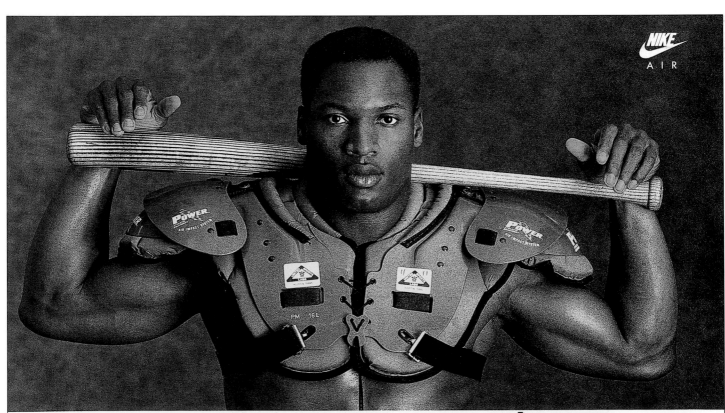

IF BO JACKSON TAKES UP ANY MORE HOBBIES, WE'RE READY.

Who says Bo has to decide between baseball and football? We encourage him to take up everything from basketball to cycling. And to train for them all in the Nike Air Trainer SC. A cross-training shoe with plenty of cushioning and support for a number of sports. Or should we say, a number of hobbies?

Air Trainer SC

'In fashion everybody is creative, so you have lots of egos, lots of artists. If you can't respect
each other, you have a problem.'
Steve Mitsch, associate creative director, Altschiller Reitzfeld Tracy-Locke, New York

John Merriman, art director with Lowe Howard-Spink in London created a campaign for Reebok
shoes. 'As we're talking about shoes, the soles seemed like a good place to start,' says Merriman,
'especially as they are such an important part of the design. They also bear the logo, Reebok, and
more colour than on the uppers.'

When musing over the idea, Merriman took a Polaroid shot of his copywriter standing on
the desk, and immediately knew it would work. 'In the ads we used actual sportsmen rather than
models, because they had to have the right build for that particular sport or activity. We put them
on the perspex platform and just told them to do what they do. The clean white background was
a conscious effort to reproduce the fashion look of *Vogue* and *Elle*.'

He wanted to use Brian Griffin as the photographer because of the way he shoots people
and his appetite for experimentation.

Brian Griffin was kept in the dark – literally. To shoot the pictures he climbed inside a black
tent with just his Hasselblad lens poking out. A wooden rig had been set up to support a perspex

Reebok Sports Shoes (A) Lowe Howard-Spink, UK (AD) John Merriman (CW) Chris Herring
(P) Brian Griffin

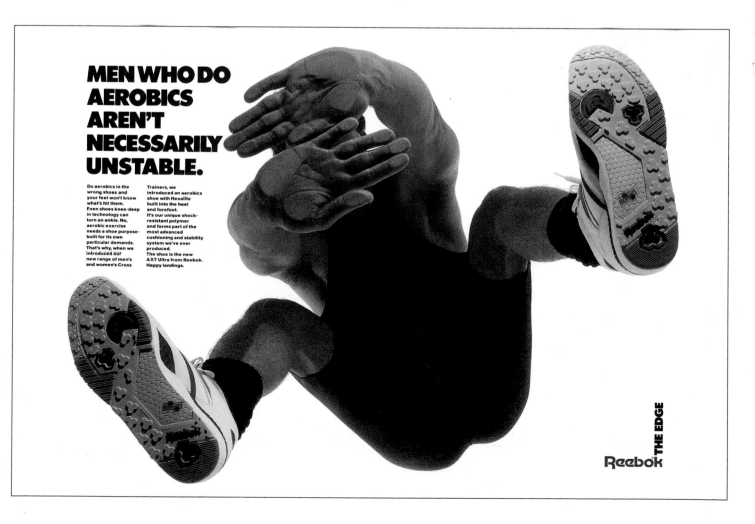

platform about six feet off the floor of the studio. A selection of sportsmen then strutted their stuff on the platform, while Griffin photographed them from underneath.

'I had experimented with this technique a number of years ago, while I was doing a pop promo for Elvis Costello and wanted to film him through 360 degrees', says Griffin. 'It's really just a technical exercise. The worst problem was trying to keep dust off the perspex.'

'If a creative person doesn't have an instinct about how people work and live, they're not worth anything in advertising.'
Steve Mitsch, associate creative director, Altschiller Reitzfeld Tracy-Locke, New York

For Timberland, Harry de Zitter was briefed and then left to shoot the pictures. Brian Fandetti, the art director at Mullen, specified the subjects, then de Zitter chose the equipment and the

Timberland (A) Mullen, USA (AD) Brian Fandetti (CW) Paul Silverman (P) Harry de Zitter

Timberland. Where the rugged outdoors isn't just a look, but a way of life.

However great our gear performs on the annual wilderness trek of many a casual user, we'd like to point out that two weeks of recreational wear merely scratches the surface of what Timberland can do. The true test comes from people who use and abuse our products the other fifty weeks as well.

People who view the harsh outdoors not as a vacation but as an occupation. Who rise with the cold clouds of dawn and ask the same of their clothing as of themselves. Stand up to anything.

Boots, shoes, clothing, wind, water, earth and sky.

treatment of the subject. The client's intention was to communicate a lifestyle, a real situation with real sailors and real cowboys.

'I push for that anyway,' says de Zitter, 'the gnarled hands, the sunburned face, the body language, the way they hold a hammer or pliers. If you get some pretty boy from L.A. or Milan, he can't do it properly. I want my pictures to have an honesty, an authenticity.'

There is no mystery to the picture. Just a straightforward connection between the image and the product, which does not present the viewer with a puzzle.

Three classic ads have one thing in common: Ogilvy's Rolls Royce 'At sixty miles per hour'; Ogilvy's Man in the Hathaway Shirt; and Bernbach's Avis 'We try harder'.

No logo.

Clients break out in a cold sweat if you try to play down their logo. It's their lifeline, their safety net. If the ad fails, at least people will notice the logo. In fact, if you show the product, the logo will probably be on it. And anyway, people buy products, not logos.

'What are the essential elements of a press ad? Headline, copy, picture, logo', says Neil French, The Ball Partnership, Singapore. 'My contention is that you should be able to reduce these to three to give you a better ad. If you can reduce the elements to two, you have a potential winner, you can't fail to communicate your whole message.

'A logo immediately screams at the consumer "I'M AN AD, IGNORE ME!". The best answer, if you're faced with the bigger logo plea, is to offer to start again. Usually it's a huge relief to the client; it's what they really wanted in the first place.'

'More will mean worse.'
Kingsley Amis, *Encounter*, July 1960

Maybe you don't like the picture of the boots on the stepping stones. I'm not sure why I do. The intrigue? The soft sell? The un-advertisingness of it? No headline. No logo, or signature, except on the scuffed and soiled boot on the right. The environment is a harsh one, and you need to be properly equipped. The intimidating atmosphere is enhanced by the fact that the man is leaving the picture. Product is hero. Dunham boots get the job done. The boot has a heritage and a loyal following. The company has been around for over a century, appealing to blue-collar workers.

'As we moved into the nineties, after the spending spree of the eighties, it was time to reappraise priorities and realign how we spent our income', says John Doyle, president and creative director, Doyle Advertising and Design in Boston. The emphasis shifted away from status and towards functionality. Products that get the job done.

'When economies get tough, consumers will look to obscure, functional brands and make them fashionable', says Doyle. 'Dunham makes good boots and shoes that can take you into the great outdoors and get you out to work in the morning. The image that was borne out of the brand's personality. I wanted a look that glorified the proletariat, the everyday working person who makes a purchase of a product because it, first and foremost, gets the job done.'

'People are more likely to buy into your product if you credit them with some intelligence. I believe that human beings really enjoy thinking.'
Jeff Weiss, creative director, Margeottes Weiss Fertitta, New York

Doyle has always been impressed with the journalistic images of the thirties, forties and fifties, the stark, austere quality to them, full of inescapable truth. 'This definite tone of photographic execution would help carry the voice of Dunham. And I thought it should be done with the power of black-and-white photography.'

He wanted the composition to be unexpected, avoiding traditional formulas of 'an ad'. The copy, rather than going through an exhaustive exposition about the fabrication of the product, should describe the user who represents a certain lifestyle, has certain priorities, has certain needs. Even the boot itself should tell a narrative. It should carry all of the time-honoured nicks, scars and wear that accumulate with time.

The intention was for the viewer to get all of the appropriate information before realizing he has just confronted an ad. In that way Doyle eliminated the consumer's filter of scepticism.

'Nadav Kander was my first choice for several reasons. He created powerful black-and-white photographs. He created images that conjure up more than was defined in the shot. He created images that you wanted to spend time with. And he understood the voice that needed to be created.'

Kander immersed himself in the assignment. He forgot about the assignment he had just finished. He didn't worry about ones to come. The resulting images are the testimony to the voice

Dunham Boots (A) Doyle Advertising, USA (AD) John Doyle (CW) Ernie Schenk (P) Nadav Kander

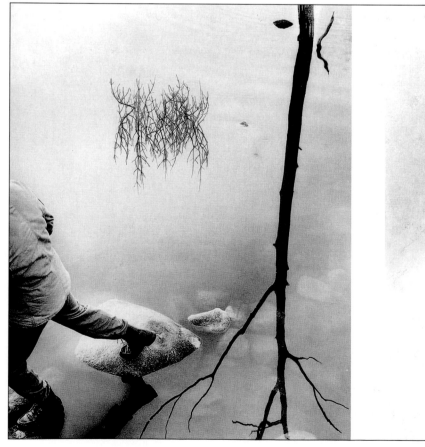

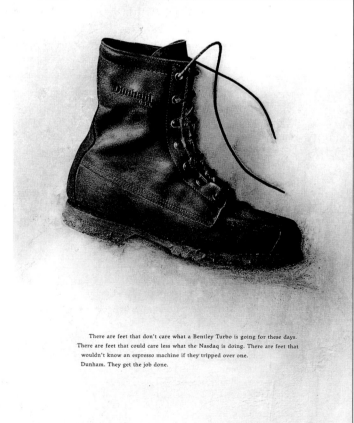

There are feet that don't care what a Bentley Turbo is going for these days. There are feet that could care less what the Nasdaq is doing. There are feet that wouldn't know an espresso machine if they tripped over one. Dunham. They get the job done.

of this brand. Images which are so beautiful that they can live outside of the context of an ad. And, for that reason, make advertising.

Kander liked the original layout Doyle showed him for Dunham Boots. 'With no headline and no logo, it was really different and fresh', says Kander. On the original layouts the boots were pristine, yet Kander felt strongly that the boots should look worn but the background pristine, thus presenting a contrast. 'How far can we go?' he asked. 'This far', replied Doyle, indicating his own beaten-up boots.

'I admire the client for agreeing', says Kander. 'It's great advertising, because it's not hammering the message home; it doesn't treat the public like fools.' He welcomes the opportunity to work in America, and has found more scope there for suggesting changes to the layout. 'Art directors in America listen, and are much more open, more direct. It's a true and honest way of working, much more upfront. It's wonderfully involving.'

The original idea for the shoes ad from the PRO agency in Brazil was to make two different shots and combine them using a computer. Art director Carlos Garcia chose photographer Milton Montenegro, who has made a name for himself using computer technology. The headline reads: 'Mesbla always has a shoe which looks like your foot', a pun that makes sense in Portuguese. Montenegro suggested using two models, one for the head and one for the feet, thus making the picture in one shot.

Mesbla (A) PRO, Brazil (AD) Carlos Garcia (CW) Fred Coutinho (P) Milton Montenegro

Most Hush Puppy ads from the Fallon McElligott agency in Minneapolis are product ads which evolve from a strategy document. But not this one. Art director Bob Barrie and copywriter Jarl Olsen were visiting the client in Grand Rapids, Michigan to present some new work. While flipping through the company's in-house newspaper, they happened upon a news item about Hush Puppy shoes being sold in the Soviet Union – the first US manufacturer to do so.

'The client was so close to the story, he had not even mentioned the fact to us', says Barrie. But, sensing a great opportunity for an image ad, Barrie and Olsen came up with the idea of using the corporate symbol, the Basset Hound, with a Gorbachov birthmark on its head. Photographer Rick Dublin was briefed with a very tight layout and some photographic references of Mr Gorbachov. Then the ad was sold, produced and ran in the trade press in a matter of two weeks.

If you don't get the joke straight away, so much the better. He who laughs last . . . remembers the ad for longer. Once you've cracked it, you are a member of the club, and feel good about it.

Benetton (A) In-house, Italy (AD) Oliviero Toscani (P) Oliviero Toscani

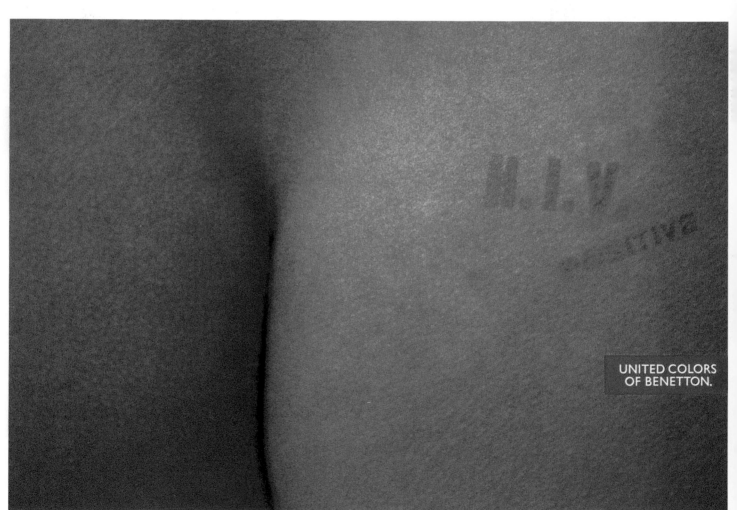

Glasnost Hush Puppies.

In an historic gesture, Hush Puppies Shoes was invited to be the first American company to manufacture and sell footwear in the Soviet Union. Thank you, Mr. Gorbachev.

Hush Puppies (A) Fallon McElligott, USA (AD) Bob Barrie (CW) Jarl Olsen (P) Rick Dublin

British Gas (A) Young & Rubicam, UK (AD) Trevor Melvin (CW) Jeanne Willis (P) Michael Portelly
(M) Lauren Heston, Billy Zeqiri

CHAPTER 11

ADVENTURE

LOCATIONS

'I don't go out to shoot a product, I go to take good pictures.'
Duncan Sim, photographer, London

There is a remote spot somewhere on the wild open Steppes, which is destined to be the stage upon which a remarkable marketing proposition will be enacted. All it needs is an art director to have the idea, a client to accept it, a location finder to discover it, a production manager to minimize the logistical hassles and a photographer to keep warm enough to trigger the shutter. The scene is fresh. The creative senses are tingling. And there's an award or two in it if everyone can keep their heads.

There is another venue, in Arizona, with equal barren beauty, yet its coarse mantle has been worn threadbare by decades of overuse in car, drink and cigarette ads. It has become too comfortable. Too familiar.

Try a totally different tack. Look, instead, down into the coral gardens of the Red Sea, where most mortals are preoccupied with survival. Add the breath-catching ingredient of a water baby, and you have a story. It's a scenario flooded with intrigue and tension, whether you are advertising baby food, insurance or, in this case, British Gas.

Trevor Melvin, art director with Young & Rubicam in London, was charged with the task of

promoting gas as a controllable fuel. A magazine article about swimming Russian babies gave Melvin and copywriter Jeanne Willis the idea for the television commercial and print ad.

Having seen his earlier underwater work, the agency turned to British photographer and film-maker Michael Portelly, who researched the feasibility of the idea, then modified it on the basis of what the babies were able to do. Portelly's producer, Amos Manasseh, consulted Dr Michel Odent, the French obstetrics specialist who pioneered natural childbirth underwater, and Anne Hawley, one of the leading proponents of teaching babies to swim. 'It was very, very important to know that this shoot was possible *and* safe, before we even started casting', says Manasseh.

When they auditioned 50 babies in a swimming pool there was no question of coercion. 'During the casting it wasn't so much a matter of training the babies,' says Portelly, 'it was more a case of educating the mothers to recognize the innate ability of babies to swim underwater. This isn't surprising when you consider that, at six months old, they have already spent most of their lives underwater inside the micro-ocean of the mother's womb. At this age they are perfectly happy to swim in the ocean without any fear.'

Four babies were chosen, and each of them appears in the television commercial. A salt-water pool was found in London and the water temperature and salinity levels were brought up to those of the Red Sea, where the shoot was to take place. In a series of acclimatization sessions, Mike Portelly, the film crew and Lauren Heston – the 'model' mother – spent time with the babies in the pool to make sure that they were happy in that aquatic environment.

On the four-day shoot itself the crew had to be precisely rehearsed for each scene, as each baby was only able to be in the water for up to four minutes at a time, and underwater for up to 10 seconds at a time. You couldn't say 'OK let's do it again'.

Two doctors were standing by on the boat, and Anne Hawley was by Portelly's side at all times in the water. 'She was our monitor', says Portelly. 'She would be able to detect any discomfort in the child, although it would also be really obvious to me through the camera. If the baby's expression wasn't happy and smiling, we just took him out immediately.'

As six-month-old babies eat or sleep most of the time, the sessions took place before meals – in the morning, at lunchtime and in the afternoon, with two babies at a time. 'On one occasion we were all set up in the water, and I said "Right bring on the babies", then waited', says Portelly. 'Then I felt a tap on the shoulder. "What's going on? Why can't we have a baby?" "They're all asleep!" came the reply. "We've flown them three thousand miles; we have the whole camera crew set up; it's costing God knows how much an hour, and you're telling me they're asleep?" I looked up to the boat and at the mothers' apologetic faces, and just couldn't be angry. And I couldn't very well sack the babies!'

Portelly works with the same crew for most underwater assignments. A close-knit bond exists between the members. They live all over the world and, when the button is pressed, they fly in ready for the next adventure.

Just five pictures. The UK clothes company, Next, wanted five photographs of models wearing their clothes to advertise the Next Directory. The agency, McCann Erickson in Manchester, England, wanted the models to be underwater, yet looking as though they weren't.

'To the uninitiated the idea of photographing fashion underwater sounds ridiculous', says Portelly. 'Yet, far from looking a bedraggled mess, hair and clothes float elegantly when totally immersed.'

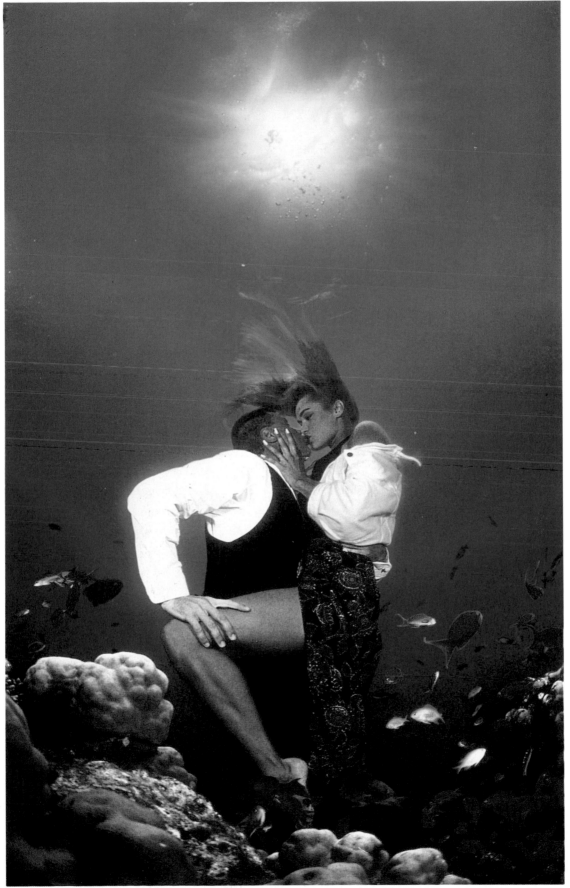

Next Directory (A) McCann Erickson, UK (AD) Steve Jones (CW) Steve Mees (P) Michael Portelly

(M) Yolanda van den Herrick & Bailie Walsh

The brief was to make the models look as natural as possible underwater. A series of scenarios had been devised, in which the couple were engaged in the sorts of activities you would see them doing on land, such as walking through a park or lovers kissing, except they just happened to be 45 ft down below the surface of the Red Sea. 'It was important that we were able to choose models that were able to sustain a natural look even though they were in a particularly uncomfortable environment', says Portelly. 'If you open your eyes underwater in the sea, your eyes go very red. After a long photographic session of 45 minutes, you feel extremely cold down there, even in tropical waters. Yet all these physical discomforts have to be put aside as the models perform for the camera and create the illusion.' Communication is very difficult between photographer and models. The training has to be meticulous.

After training in a pool, the team transferred the rehearsed activities into the coral environment of the Red Sea. 'The selection of location is very important, we don't just jump into the water and take the pictures', says Portelly. 'The models have to be secured in the precise position. I have to find the right shape of coral, work out the lighting at the time of day the shoot will be, conceal a weight in the sand on a plate which has a concealed catch on it, then bring the models down and attach them via a quick-release mechanism to this plate. Once they are in position you can't move them because any slight disturbance of the bottom stirs up sediment in the water, which the flashlight picks up and reflects back into the lens, creating a snowstorm effect in the final photograph. Although the water appears clear, we create an illusion of clarity that really doesn't exist, by using very wide lenses and lighting the scene to avoid highlighting the suspended particles.'

The clothes themselves had to be modified. A normal cotton shirt goes transparent underwater, so that had to be painted with a material that reflected the light and appeared white. The man's jacket had to be stiffened, and his trousers were soaked in resin to give them a crease. For one of the shots his tie was held in position with a concealed wire.

'We've now reached the point where we create an aquatic studio, do tests and show the client the results as we're working', says Portelly. 'The client can talk about miniscule detail in the hand position or the relationship of one piece of material to another – underwater – which I find quite gratifying. I welcome their input and at the same time I am secretly pleased that they take for granted what, by most people's standards, seems extraordinary, bearing in mind the environment we're in. It is now possible to work there with the same control that you can achieve in a studio.'

Harry de Zitter loves funky Americana, such as rocking chairs on porches, art deco architecture and old Wurlitzers. He has a reputation for seeing it all slightly differently. 'I pick up on details that locals overlook, because I didn't grow up with it', says de Zitter. Part of the honesty of his photography comes from having a reportage approach. 'I like to be able to catch people off guard, make them look at a picture and *then* realize it's an advertising shot.'

For the campaign for George Dickel Whisky, art director Bob Wyatt at Leo Burnett, Chicago, set out to capture the romance of the South. It was tailor-made for de Zitter. He and Wyatt made a shortlist of locations and types of locations that might be suitable, and a barber's shop in Texas was one. That's where the brief stopped. It was then up to de Zitter to interpret the atmosphere required, to present his window on the world.

'All my shoots are scouted beforehand, and the people involved are aware of what we're

using the photograph for', says de Zitter. 'They sign releases before we get involved, so there are no surprises.'

This was shot on 6 × 12 format, between f16 and f22 at a shutter speed of $\frac{1}{8}$ sec. It is a timeless shot, using available light, with no fancy tricks. It took just two or three hours, waiting for the light to move around a little, and the job was finished. 'The art director came along,' says de Zitter, 'but he is the kind of guy who is smart enough to let me be my best.'

'When you go on location things aren't predictable. If you go with a particular picture in mind, you're not going to take advantage of what's there already. Instead of a brief in the form of a drawing, it's far better to know what the picture has to say.'
Max Forsythe, photographer, London

United Distillers-Glenmore (A) Leo Burnett, USA (AD) Bob Wyatt (P) Harry de Zitter

City Barbershop, 322 S. Kearney Street "No appointment necessary—sideburns our specialty." Clarendon, Texas and George Dickel. Ain't Nothin' Better.

When Louis Vuitton opened his first shop at rue Neuve des Capucines in Paris in 1854 he had no idea how popular and prestigious his luggage would become. In 1975 Vuitton's employed 70 people and had two shops. Today there are over 2000 employees and 120 stores. A wider public has developed a penchant for stylish travel, and has responded to the product's pedigree – the family heritage of Louis Vuitton. They are buying a bit of a legend. Traditional luxury luggage is back in vogue.

'In the luxury business you are selling a dream as well as an object', says Louis Vuitton's director of design, Françoise Jollant-Kneebone. 'This is reflected in our advertising, which focuses less on the product than on the idea – the *soul* of travel.'

In 1980 Jean-François Bentz founded an agency in Paris called Le Creative Business. His first major project was to create a strategy that would bring Louis Vuitton to a wider audience. 'We did one or two ads in Italy and America, but they were desperately bad', says Bentz. 'We had not yet developed the right style. It is hopeless trying to serve the product without all the background research.' Following market research in America and Japan, Bentz recognized a need to give

Louis Vuitton (A) Roux Seguela Cayzac & Goudard, France (AD) Michel Delacroix (P) Jean Larivière

character to the public face of the company. His strategy began with the designing of the Vuitton shop in Paris. In formulating the concept for the shop, Bentz thought of Vuitton as a person with a physique, a personality and a style. 'I wanted to embrace the subjective, emotional element as well as the objective, physical side', he says. 'Vuitton products are physically strong and robust; Vuitton is unique; and the style is not fashionable as such, but *de temps* – "in its time".'

In order to explain and convey these concepts, Bentz designed a brochure, in which the product was recognizable, without being too visible. 'Too strong a presence would dilute the image, the dream', he says. 'It would then be in danger of losing its mystique and going down-market. This is why I chose Jean Larivière to shoot the photographs for the brochure, and then the first Vuitton advertising campaign in 40 years.'

Based in Paris, Jean Larivière had become well known for still-life pictures that epitomize taste, style and mood. Bentz presented him with an irresistible challenge: to transfer the magic of his studio photographs into the great outdoors. Larivière started shooting aspirational pictures of the lavish luggage in Guadeloupe, and each year since then he has been to the ends of the earth seeking suitable settings for exceptional cases: Yemen, China, Kashmir, Thailand, Rajastan, Patagonia, Nepal . . . He transformed 'the spirit of travel' into a photographic *tour de force*, which produced one of the most coveted campaigns of the eighties.

Sometimes Larivière spends a month creating a picture. Often a week. Anything less would seem reckless. Within the framework of the strategy, the ideas are his. He agonizes over each one, sketching out its exact composition within a variety of scenarios. He methodically builds up each element of the picture, much as an attentive child might construct a castle of bricks. When he is happy with the composition, he sets off with 40 mm and 50 mm lenses on his Hasselblads and cases full of Ektachrome film to look for the ideal location.

He goes beyond the brief, taking the voyage back into his childhood, and picks out evocative feelings and images from his past, displaying them beautifully, appealing for empathy. His devotion to detail demands dedication from his support team. 'When he's set on an idea,' says one assistant, 'he must have what he wants. The result is the difference between producing a picture of passing interest and creating an arresting one.'

It is Larivière's uncompromising approach that has secured his reputation and exhausted his assistants. In Kashmir, for example, a serene lake was marred by unsightly weeds. No problem. Just wade in and pick them all out!

The elegant fantasy of the photography belies the often painful logistical reality experienced by the valiant team. 'There is never a problem in Vuitton travels; it's always been a royal way to travel', says Larivière, who enters into the spirit of the dream by employing an entourage of helpers. 'When travelling I always have a mixture of feelings; it's like being in a dream, but this doesn't stop me having creative energy on the spot. There must be a first plan and a second plan. I imagine a lot of things in my mind before going on location. Then, when I arrive, it is sometimes very different. But at least I have a starting point.'

Besides an enormous amount of luggage, weighing perhaps 1000 kilos, he takes a few carefully chosen props and *jouets* – a picture of the Eiffel Tower to echo the mountain peaks in Cameroon, a violin for Iceland, a chess set for China and a wooden polar bear on wheels to set on an iceberg in Greenland. The props tell an imaginary story and add to the intrigue, enhancing the spirit of travel in the best traditions of romance and nostalgia.

'The concept developed in two phases', says Bentz, who took the Vuitton account with him to the agency RSCG – Roux Seguela Cayzac & Goudard. 'The first phase was more realistic; it told the story of somebody who could have been a real person. You could imagine the person in the ad having plenty of freedom – both time and money. You could imagine yourself in the picture. Then the second stage moved into surreal travel. The lake with the bed was the best expression of that intention.'

'We want the pictures to portray a sense of *raffiné*. Like a Rolex watch, the luggage is well-designed and well-constructed so it is durable, while also being a luxury product which evokes *l'âme du voyage.*'

Time was short. London agency Chiat Day was facing frightening deadlines on a major campaign for the Australian Tourist Commission and the country's airline, Qantas. Surveys put Australia at the top of the league of most desired holiday destinations. Qantas Airways and the tourist commission wanted to turn this desire into action.

Joint creative directors, Ken Hoggins and Chris O'Shea, had just joined the agency and were immediately thrown into urgent copydates. Their mission was to compete with the 90 other tourist boards in London. A persuasive solution had to be found to elevate Australia – and fast.

'There was no time for us to go down there', says Ken Hoggins. 'Not even time to commission a photographer to shoot something specially.' They needed something stunningly

Australian Tourist Commission (A) Chiat Day, UK (CD) Ken Hoggins/Chris O'Shea (P) Phil Gray

innovative and singularly appropriate. They chose to focus on the epic nature of the place – big skies, broad beaches and the room-to-breathe image of the country.

It was Hoggins' job to scan the picture libraries for suitable images. He faxed their agency in Australia, requesting as much material as they had which fitted the strategy. 'I went through thousands of stock shots, looking for "huge" pictures – ones with a lot of distance in them. We chose three main photographs – a coastal scene, the Outback and Sydney Harbour. Only the last one used a Linhof 6×12 camera, although they all convey the great sense of space.'

The ads exploited the vastness of the country by using a seven-page gatefold for the first time ever in UK publishing. It was thanks to new technology that enabled magazines to bind in the gatefold by creating another page at the back. The wide panoramas were splashed across the front four pages of the gatefold in selected weekend magazines. Their aim was to inspire people to turn their dream of a holiday in Australia into reality.

'We have stepped away from simply using pretty pictures,' says Pia Byrne, ATC manager UK, Ireland and Scandinavia, 'and are now asking people the direct question "Just how long can you keep saying 'one day I'll go to Australia'?" This strap line creates curiosity, surprise, amusement and most important of all, recognition that Australia is now within reach.'

Photography in travel advertising has to work hard to pull our imaginations out of our claustrophobic existences and release us into our dreams.

The Greek National Tourist Organization was impressed by the work done for British Columbia by the Vancouver office of McKim Advertising, and asked the agency to pitch for their account. Art director Bill Cozens and copywriter/creative director Alvin Wasserman, who worked on the British Columbia account, then created an overall look and feel for the tourism in Greece ads. 'The campaign sought to tie-in the physical beauty of the islands with the heritage of Greek philosophy – and everyone there including the cab drivers is still a philosopher!' says Cozens.

Some of the ads were photographed by Joel Baldwin, but the windmill is a stock shot from Superstock, Montreal, unearthed by Cozens, who sifted through thousands of transparencies from stock houses in North America and Europe. 'One of the strengths of the photo was the vivid contrast between the cool and the warm colours. We pushed their intensity so that they would read strongly at double page spread size', says Cozens. 'The windmill in the foreground is grey and quite dark in the transparency, so we had to lighten and warm it up to make it "friendlier", as if the last light of day was hitting it. Finally, we removed a cruise ship and substituted a smaller Greek tour boat.'

Greek National Tourist Organisation (A) McKim Advertising, Canada (AD) Bill Cozens (CW) Alvin Wasserman (P) Superstock, Montreal

ON SEVEN SEAS AND SIX CONTINENTS, CAMELOT.

As mainland China appears off the bow, a classical guitarist plays a Venezuelan waltz. Deep in the Amazon, a waiter in white gloves serves tea. With the Adriatic before you, a sommelier pauses, then suggests his favorite Bordeaux. This is the singular world you will find aboard the ships of Royal Viking Line. Your travel agent can guide you to it, or phone (800) 426-0821 for a handsome brochure which maps the way to a quiet harbor in 150 ports. As always, we look forward to seeing you on board.

ROYAL VIKING LINE

Royal Viking Cruise Line (A) Goodby Berlin Silverstein, USA (AD) Rich Silverstein (P) Jay Maisel

Jay Maisel's converted Germania Bank building on New York's Bowery houses a permanent showcase of his work. The 40 × 80 inch dye transfers lining the walls make this the largest private gallery in New York devoted to the work of one artist.

Maisel studied colour in painting and graphics at Yale University with Bauhaus master Josef Albers, but is largely self-taught when it comes to photography. Important commercial clients have included General Telephone Electronics (GTE), United Technologies (UT) and the Royal Viking Cruise Line.

Maisel's brief from the San Francisco agency Goodby Berlin Silverstein was to photograph the Royal Viking in the Caribbean and make it look wonderful. 'If the ad agency is willing to let me do my best, the result is good work', says Maisel. 'I prefer not to go out with preconceived ideas, but to let the subject dictate what the photographs look like. And there is a clause in my paperwork which says that we will not recreate any layouts. It's not ego at all; I believe that if you recreate layouts you're laying yourself, the agency and client open to possible law suits for invasion of copyright because you do not know where the art director got the idea from. By allowing yourself more freedom you come back with something ten times better.'

When Jeremy Postaer, art director with Goodby Berlin Silverstein in San Francisco, first saw Duncan Sim's location photography, he hired him to shoot cruise ships in the Caribbean. 'I instantly thought he was the best location shooter I'd ever seen', says Postaer.

Next, Sim was dispatched to Finland where, in temperatures of minus 30 degrees, his brief was to capture the essence of Finlandia vodka. 'You should be able to distill the pictures and put them into the bottle', says Postaer. 'It's an unusual place, a surreal place, and the pictures should convey this. It was an extremely difficult shoot; I don't think many photographers could have coped with such harsh conditions. Period.' 'I have an aggressive attitude to my work,' says Sim, 'and so does Jeremy. That helps make the sparks fly, which gives the pictures more of an edge.'

The agency came up with the basic idea of a diver and lake, and Sim added to the story appeal with a sauna and swimming pool. Using a chain saw they cut three feet down into the ice, then melted the pool and surrounding area with blow torches. A black tarpaulin was laid down to make the six inches of water look deep. The water kept freezing and they had to keep adding

more. 'I had a ten-minute window from about 4.10 p.m., when the light was right and we had the necessary reflections', says Sim. The diver was photographed later in a pool in London, and stripped in using a Quantel Paintbox. The ad ran in major publications across the USA, including *Rolling Stone*, *Esquire*, *GQ* and *Vanity Fair*.

All his life Duncan Sim has thrived on fantastic, outlandish and often uncomfortable challenges, avoiding the mediocre or mundane. 'I don't want to go to a great location and make it look average', he says. He comes from a medical family who wanted him to become a doctor or dentist. But, after just one week at university, he decided to follow his heart, and set off in search of his own dream. 'I view the money I earn doing advertising photography as my opportunity to explore.'

Heublein (A) Goodby Berlin Silverstein, USA (AD) Jeremy Postaer (CW) Rob Bagot (P) Duncan Sim

A rose, twelve stories high.

Fish that eat fruit.

And the air you breathe.

This is the rain forest.

Every second another acre of rain forest is destroyed forever. World Wildlife Fund needs your help. 1-800-CALL-WWF.

World Wildlife Fund 🐼 Rain Forest Rescue Campaign

Ad No. WF-90-02-1
World Wildlife Fund—Air
This Advertisement Prepared By:
Ogilvy & Mather Advertising
To Appear In:
Life—1990
(130 sc)
Size/Color: 8¾ X 10⅝ pg 4/C
Job No. H-00264
Copy: A. Burroughs Art: L. Walburn Traffic: A. Davis Client: XX16
GSI# 009169-01 World Wildlife Fund

CHAPTER 12

ADVERTE

S.O.S.

Imagine the twenty-first century. We'll shoot pictures in Paris at the same time as an art director monitors them in New York. We'll redesign digital images faster and cheaper. We'll recycle ideas with increasing finesse. We'll apply new coats of paint with ingenious twists and turns, but with no major brushstrokes. Changes will be cosmetic. Harmlessly titivating. Quick fixes.

We can make ads look like a million dollars, but what about the content . . . the message? Are we going to restrict this medium to selling widgets? Or can we make better use of the fact that advertising has the power to do more than push pullovers.

'All of us who professionally use the mass media are the shapers of society. We can vulgarize that society. We can brutalize it. Or we can help lift it onto a higher level.'
Bill Bernbach, Doyle Dane Bernbach, 1911–1982

Today we can celebrate the rainforest, but we had better be quick. We can be smug about recycling paper, glass or tin cans. We can use unleaded petrol, which is just as finite and almost as

Worldwide Fund For Nature (A) Ogilvy & Mather, USA (AD) Lona Walburn (P) Duncan Sim

polluting as leaded petrol. We can feel good about the existence of organizations such as Greenpeace, Friends of the Earth, Save the Elephant, Save the Whale, Save the World. Yet each billboard poster is another tree or three. And the book you're reading is not on recycled paper.

> *'Discontent is the first step in the progress of a man or a nation.'*
> Oscar Wilde, *'A Woman Of No Importance'*

Duncan Sim went further. For the Worldwide Fund For Nature (WWF) he travelled on a shoestring deep into the Venezuelan rainforest, and discovered that photographing beauty can be a real beast.

'Let's keep it positive', said Parry Merkley when briefing a young creative team at Ogilvy & Mather in New York. The aim was to symbolize the magic and majesty of the rainforest, rather than show a literal portrait of it. 'We wanted magnificent, epic photographs that would make the rainforest seem mysterious, and like no other place on earth', says art director Lona Walburn. 'We could have taken a more negative approach – terrorist advertising – and shown the burned-down trees and devastation, but we wanted to show the beautiful side. And Duncan's photography stands out in this way.'

Sim spent nearly two months in Venezuela during the rainy season, when shooting conditions were often dire. He went to Angel Falls and, amazing though it was, decided that it couldn't be photographed properly without a helicopter. He then went to the Brazilian border, where his most successful photographs were shot.

Besides the physically demanding task of carrying his gear across the most inhospitable terrain, Sim had to contend with the humidity of the Amazon. Electronic cameras ceased to function within two days, and even his Linhof was trashed. As the lens would not come off, he had to forcibly remove the steel retaining pin through the casing, then fill the hole with Superglu to stop the light getting in.

On one occasion he wanted to shoot from a tiny island in the middle of the river where the boat could not reach. So he swam up-river with the cases tied to his legs, bobbing around in the water behind him. Suddenly a whirlpool held him underwater for long enough for him to wonder if he'd ever see the pictures.

The trouble with the rainforest is that, for most people, it seems so far away. And with kids on drugs and people dying from Aids, don't we have other things to worry about? Yet the impact of the rainforest is closer to home than most people realize. Every day an estimated 100 species of plant and animal are lost in the Amazon. One quarter of our prescription drugs are derived from plants found in the rainforest. The cure for Aids or cancer could disappear before we have a chance to find it.

Public Service Announcements, such as the one for the WWF, are often hard-hitting black-and-white images that leave you somewhat disturbed. They are handed out to major magazines, which run them free of charge when they have space. They are usually one page, or smaller, in black-and-white, tinted with guilt.

Now there's a green moral consciousness; the environment is a hot issue. Parry Merkley felt that magazines would want to be associated with the WWF ads, and decided to aim for bold brush strokes. 'We asked the client if we could do more than one of these, and they thought we

were mad', says Merkley. 'I said I'd like to do two in colour . . . unheard of!' Yet, far from feeling obliged to pay lip-service to conservation, magazines were actually requesting the ads, and they ran in such publications as *Life, Vanity Fair, Architectural Digest, Sports Illustrated, Us,* and *People.*

'A dull truth will not be looked at. An exciting lie will. That is what good, sincere people must understand. They must make their truth exciting and new, or their good works will be born dead.'
Bill Bernbach, Doyle Dane Bernbach, 1911–1982

Some of the world's most creative imaginations are employed in ad agencies, promoting products. Could all this sophisticated grey matter do more to help raise public concern over more fundamental problems such as Third World debt? David Trott, creative director with the London agency Bainsfair Sharkey Trott, took up the challenge. 'I don't have a solution,' he says, 'but at the moment nobody's even asking the questions. Aid money is still important, but giving a donation to charity is like putting a Band-Aid on a haemorrhage. A more far-reaching solution begins with the western governments deciding that the issue is important enough. But they will start talking about it *only* if they think people care about it.'

Advertising photography is a very direct and powerful way of communicating a message, and can be used to focus awareness on social issues, just as well as promoting watches or whiskey. Aware that an affective ad usually concentrates on only one theme, David Trott had to find a way of unravelling the involved story surrounding Third World debt. 'What's the single most important message we can convey?' he asked. '*Cancel the debt.* No need to raise more money, just cancel the debt.'

'At the end of every seven years you must cancel debts.'
Deuteronomy 15,i

The 'developing' countries have to maximize exports and cut right back on any investment in their own country to pay off debts to the West. This involves converting food crops into 'cash' crops, to be exported to earn cash to help repay the debt. Food, health, welfare and education are cut back. Children are not given the food or medicine they need. At the same time, the inevitable increase in pressure on the environment is destroying it, as in the Amazon, where the rainforest is being converted into money.

Although much of the debt is owed to the banks, they do not deserve all the blame. The banks must have economically sound incentives to cancel the debt. It is not their role to make moral judgements; that's for governments. If governments give the banks the monetary incentive to write off the debt, they could do so, while still following the profit principle.

This is where public opinion comes in. Advertising can be used to help the opinion be an informed one, highlighting the issues and their implications.

'Even if you don't care about the number of children dying each year, perhaps you care about your environment that's being destroyed', says Trott. The green issue wasn't an issue until public opinion made it one.

(A) Bainsfair Sharkey Trott, UK (CD) David Trott (AD) Eddie Greenwood (P) Shaun Bresnahan

London photographer Shaun Bresnahan used real flies from a maggot farm for his shot representing a politician. The flies were frozen then dipped in Copydex and stuck on his face or suspended on fine threads which were retouched out later.

'The groundswell of consumer awareness of green issues has got to increase because the information about the environment will get worse and worse. Green advertising should help re-educate people.'
Axel Chaldecott, creative partner, Howell Henry Chaldecott Lury, London

Photographer David Bailey combines a hard-working professionalism with a disarmingly human touch. His intuitive response to life placed him in the avant-garde of the sixties. Gossip columns grew fat on the exaggerated stories of his flamboyant lifestyle. But, he maintains, 'It's no good being well known if you can't back it up with material. If you're going to be any good, you have to be fanatical about the business; there's just too much competition out there.'

Together with his anti-fur trade television commercial, Bailey shot a poster of a model trailing a bleeding fur coat. 'The aim of the '40 dumb animals' ad was to embarrass people who wore them', says Alan Page, creative director at the London agency Harari Page. 'The ad is seen by many people in the industry as being a milestone in the development of "issue advertising". It's different from charity advertising in that it is not asking for money, it is asking people to address an issue.'

Lynx (A) Yellowhammer, UK (AD) Jeremy Pemberton (P) David Bailey

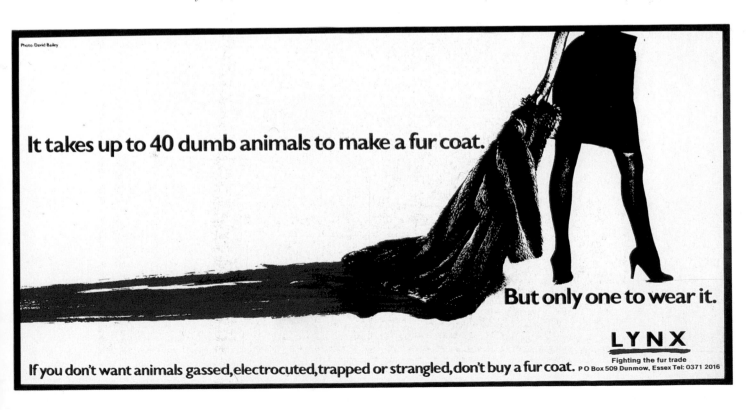

Synthetic blood was painted behind the coat. The photograph was shot in black-and-white, a line conversion was made and then it ran as a two-colour poster. This was originally a Greenpeace ad, but it caused the organization problems because in Canada, where Greenpeace originated, fur trapping is the mainstay of certain communities. As a result there was a lot of pressure in Canada for Greenpeace to withdraw the campaign. The team in Britain, which was running the anti-fur campaign, was asked by Greenpeace to tone things down. But they believed the issue was sufficiently important to warrant breaking away to form a new organization, Lynx. The poster by David Bailey helped to fuel the debate, and became an icon of the campaign. Although the agency, Yellowhammer, subsequently produced another powerful poster, 'Rich Bitch – Poor Bitch', depicting a fur-coated lady and a dead fox, photographed by Linda McCartney, the '40 dumb animals' ad remains the classic.

Lots of models *didn't* want to do the Aids ad. It took the agency, BMP DDB Needham in London, a long time before this Dutch model stepped into the part. Again David Bailey did the shot. He treats models as people rather than clothes horses, and his lively banter invariably coaxes that extra energy from them. 'The dresses never interest me too much; it's what's in the dress that interests me', he says.

The Health Education Authority wanted the girl to look like the girl next door, no earrings and not too glamorous. Art director Peter Gatley felt she should be beautiful, and Bailey was happy to shoot either. In the end he shot both – the same model with no make-up and a shirt on, then the glamorous version. The first one lacked the impact the concept required.

'I love my work; I wake up every morning excited', says Bailey. 'The adventure is in going forward. I hate nostalgia; it's too cosy. It's the future, the unknown, that's exciting. Every new experience in life rubs off and adds another texture.'

John Claridge's shot for the British Legion began as a much larger picture in which you could see the furniture, the man's wheelchair, his lifelong possessions and his wife standing beside him. The photograph told a whole story. At the very end of the shoot, Claridge and Brian Stewart, creative director with the London agency Delaney Fletcher Slaymaker Delaney Bozell, said, 'This is really just about *emotion*; it's about one person being troubled and puzzled, and another person caring about them.'

'I can put down on a page a picture of a man crying, and it's just a picture of a man crying. Or I can put him down in such a way as to make you want to cry. The difference is artistry – the intangible thing that business distrusts.'
Bill Bernbach, Doyle Dane Bernbach, 1911–1982

Health Education Authority (A) BMP DDB Needham, UK (AD) Peter Gatley (CW) Frank Budgen (P) David Bailey

IF THIS WOMAN HAD THE VIRUS WHICH LEADS TO AIDS,
IN A FEW YEARS SHE COULD LOOK LIKE THE PERSON OVER THE PAGE.

WORRYING ISN'T IT.

The virus that leads to AIDS is known as the Human Immunodeficiency Virus.

Or HIV.

A person can be infected with HIV for several years before it shows any signs or symptoms.

During this time however it can be passed on, through sexual intercourse, to more and more people.

There are already many thousands of people in this country who are unaware that they have the virus.

Obviously the more people you sleep with the more chance you have of becoming infected.

But having fewer partners is only part of the answer. Safer sex also means using a condom, or even having sex that avoids penetration.

HIV may be something that is impossible to recognise.

But it's also something that is easy to avoid.

AIDS. YOU'RE AS SAFE AS YOU WANT TO BE.

Claridge moved in close, minimizing the elements of the picture and conveying the essence of the message through the man's expression and his wife's hand. The mood is further enhanced by the use of tombstone typography. 'Black-and-white has an immediacy to it; it's uncompromising', says Claridge. 'Solving advertising problems has always been exciting for me, as long as it is also aesthetically pleasing. You know why you're there – to shoot a product or put across a message, but you then use the brief as a starting point from which to take off and explore your photography.'

> *'Great photography and great advertising are usually two different things.'*
> Dave Kelso, creative director, J. Walter Thompson, Toronto

The happy family group twists itself around your guts. The idea behind the ad was to convince women who have been abused to come forward and seek help.

'The intention was to achieve this by depicting an apparently nice, middle-class family and showing that wife-beating still takes place in this "friendly" environment', says Charles Greene,

Royal British Legion (A) Delaney Fletcher Slaymaker Delaney Bozell, UK (CD) Brian Stewart
(AD) Mark Robinson (CW) Mark Tweddle (P) John Claridge

RICHARD WENT OFF **TO WAR IN** 1950. HIS WIFE IS STILL WAITING FOR HIM TO RETURN

When a soldier returns home from war, he faces another battle. Everyday life.

Some find it impossible to adjust.

Anxiety attacks, insomnia and nightmares may continue for years, placing an enormous burden on their wives and families.

But they need not suffer alone.

The Royal British Legion was founded to help all ex-service people and their dependants.

Last year, we helped over 100,000 people (including Korean war veterans like Richard) providing everything from counselling and convalescent centres, to residential homes and jobs.

But though we are doing what we can, there are still a great many more who need our help.

The Gulf War demonstrates that continuing need.

We're not asking you to give as much as they did. Just as much as you can afford.

This Poppy Day, remember those who can't forget.

Thank you.

REMEMBER THE **DEAD** BUT DON'T FORGET THE **LIVING**

Women's Counselling Service (A) Grey Düsseldorf, Germany (CD) Charles Greene (AD)
Lindsay Cullen/Marina Lörwald (CW) Tanja Schickert (P) Harry Forsteher

creative director at Grey Dusseldorf. 'It was an attempt to break through the cliché that wife-beating only occurs in working-class homes with alcoholic husbands.'

The pain behind the smile is worse than the pain of the bruises. The headline reads 'Every year four million women are beaten in our country'. When the agency discovered this fact, they approached the Women's Counselling Service and offered their assistance.

'Good doesn't drive out evil. Evil doesn't drive out good. But the energetic displaces the passive.'
Bill Bernbach, Doyle Dane Bernbach, 1911–1982

Harry Vorsteher, who shot the picture, had just completed a series of ads for one of the agency's other accounts. They were so impressed by his ability to photograph people that they asked him to tackle this assignment, although the budget was small. 'The only disharmonious note in the whole picture comes from the wife's appearance', says Greene. 'Although she sits there looking elegant, we wanted her injuries, both physical and psychological, to be visible. The aim was to create a contrast between the perfect world on the surface and the hidden world of suffering.'

'Money changes hands,
They say,
And its habit
Is to change them into fists.'
(*Gerard Kelly* Rebel Without Applause, *'Small Change'*)

Tasteless, indecent, misleading! Thousands of column inches around the world are devoted to indignant bristling about Benetton's polemical advertising. But maybe the loudest voices miss the point, and perhaps that's all part of the plan.

The photograph of a Liberian guerilla carrying a Kalashnikov and holding a human femur was shot by Sygma photographer Patrick Robert in June 1991, at the height of the brutal civil conflict in West Africa. 'We wondered why reality proved so controversial', says Oliviero Toscani, who devises the advertising strategy for Benetton, together with Luciano Benetton. "All these pictures have already been published in the media, but nobody reacted. We have found that using the photographs in this way is even more effective than in the editorial media. We see these sorts of pictures every day on television and in newspapers, but as soon as we use one for advertising, everybody gets upset!'

'Advertising is either intrusive or invisible.'
Marty Cooke, creative director, Chiat Day, Toronto

Just how direct and intrusive can an advertising photograph be before it begins to have a negative impact? You're not going to win people over to your point of view by putting them off. The various Benetton ads are shocking to different people, but are they relevantly shocking? If the public can't see what Benetton advertising is trying to say, there's a danger that the target market will be left with a negative feeling about the company . . . and nothing else.

Benetton's stated aim is to display photos that overcome cultural barriers and human indifference, promoting international harmony and co-operation. The hidden agenda is to extend the range and impact of the advertising by causing a stir, deliberately inviting media attention. Benetton advertising has certainly done that, and can boast one of the highest levels of spontaneous recall in the history of advertising.

'Why is traditional advertising, which shows everything that is fake, acceptable, and reality is not?' says Toscani. 'We believe that advertising can be used to say something else besides selling a product, something more useful; it can be used to give information.'

A simple proposition is floated in the Benetton magazine *Colors*: '. . . the superproducts could stop spending money (and talent and resources) on ads that tell people about products and spend it on ads that tell people about the world.'

'We don't imagine that we are able to resolve the problems,' says Toscani, 'but nor do we want to pretend that they don't exist. We think we have a duty to talk about such things. I wish some cigarette or car company would devote their incredible budget to promoting social issues.'

Whatever the hidden agenda, it is a philosophy which can't be ignored. It is a jolt to complacency which can open doors to new directions for advertising.

Benetton (A) In-house, Italy (AD) Oliviero Toscani (P) Patrick Robert/Sygma

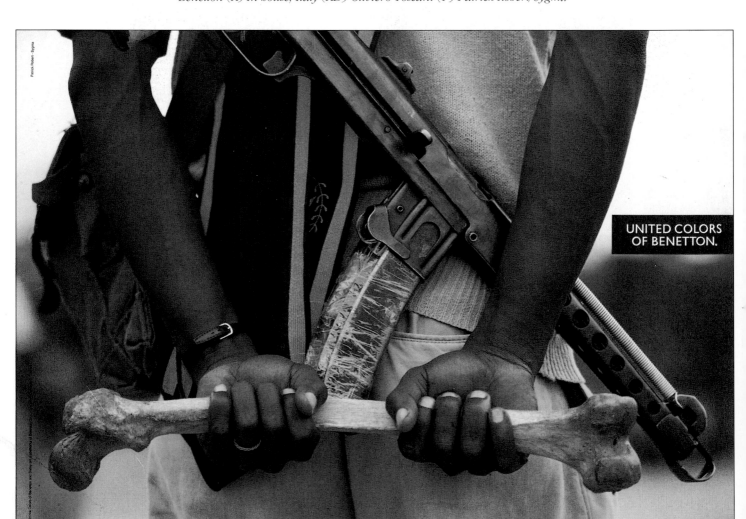

'We wanted to be contemporary', says Luciano Benetton. 'We wanted to leave traditional advertising. There are new formulae that permit us to go forwards.'

Recent Benetton campaigns are signposts to the future potential of advertising. The signposts are not always clear, and it is right to maintain a healthy scepticism about the motives, but they do clearly demonstrate the potential power of advertising to do more than shift shirts.

Volkswagen (A) Bates Backer & Spielvogel, Norway (AD) Per Charles Molkom (CW) N. Espen Olafsen (P) Dag Alveng

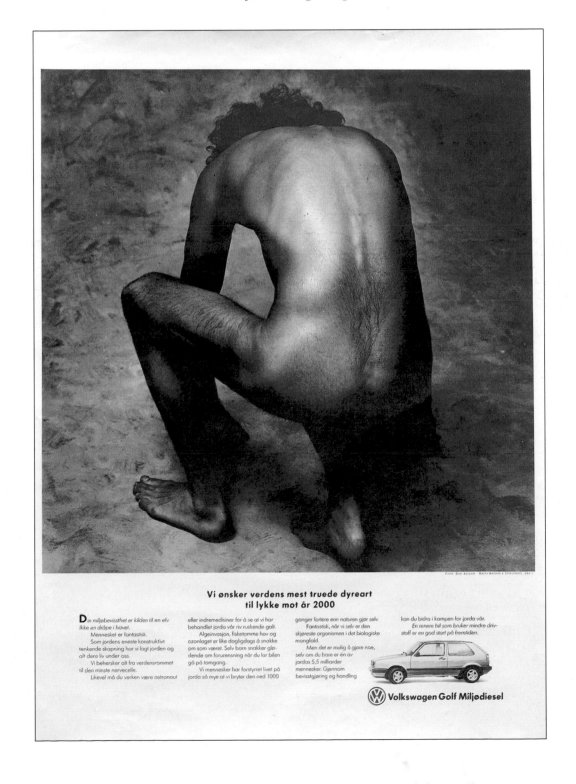

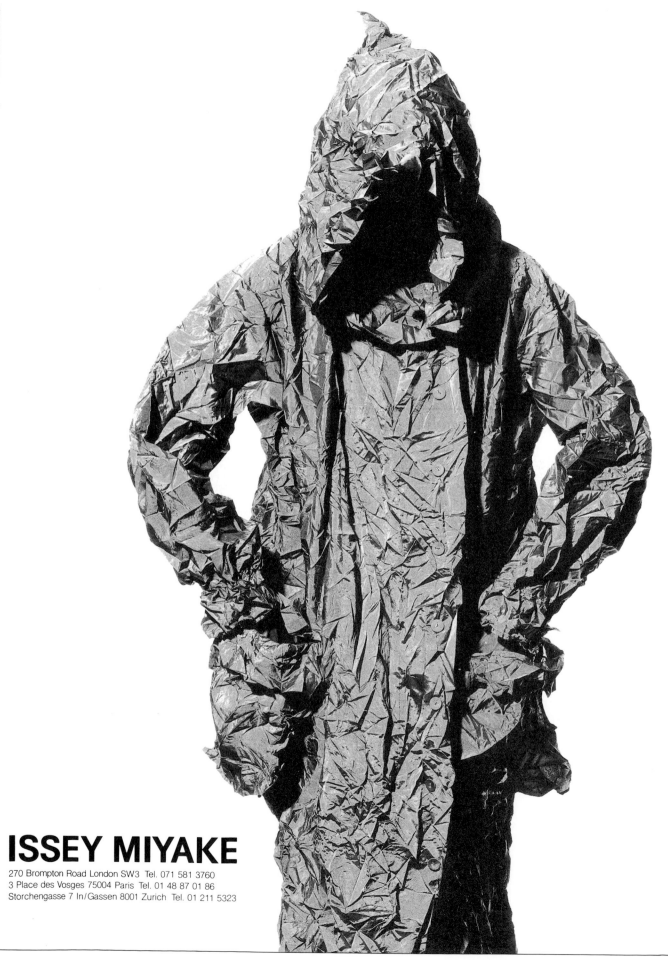

ISSEY MIYAKE

270 Brompton Road London SW3 Tel. 071 581 3760
3 Place des Vosges 75004 Paris Tel. 01 48 87 01 86
Storchengasse 7 In/Gassen 8001 Zurich Tel. 01 211 5323

ADVISE

PHOTOGRAPHERS . . . ON ART DIRECTORS

The better the art director, the better I am.
Hans Kroeskamp

One of the biggest obstacles is to overcome the personalities of the photographer and the art director. If they can meld together, you can concentrate on the picture.
Clive Arrowsmith

The agency has hired me for my vision, my interpretation. If they start to dismantle those qualities with their insecurities and inefficiencies, I've got to make a stand.
Harry de Zitter

Issey Miyake (A) In-house, Japan (P) Irving Penn

The art director should say 'These are the elements we want to show, now go away and do what you want'. That's when things start to happen and you progress. It's a matter of being given that trust and responsibility.
Christine Hanscomb

A good art director will employ a certain talent, start them in a direction, then let them go. Then they make the ad work around your picture. Those ads are more spontaneous.
· Robert Dowling

If the art director or client insists on my sticking exactly to the layout, I consider dropping the shoot, because it means they don't trust anyone.
Max Forsythe

A good art director is someone who has the self confidence to know that he has chosen the right person for the job.
Frans Jansen

I particularly like art directors who know what they want and let me join in with the early stages of the concept. That way we can collaborate on an idea and take it to the top.
Richard Noble

Before I get near the thing, copywriters and art directors have done a lot of arm-wrestling to reach that stage. I wouldn't be arrogant enough to think that I know more about what they're doing, when they have spent four months lining it up.
Terence Donovan

You don't need to draw to be a good art director nowadays. If you draw something, you set your mind on it and are hemmed in. Most art directors now are concept people.
Geoff Senior

A good art director should understand photography as well as the photographer . . . not the technicalities, but he should know if his layout will result in a strong picture.
Milton Montenegro

When I do an ad I always shoot one version for the agency and another version which is more how I feel about the shot. I'm very conscious that I can't go too far because there is a product to sell, and if they don't sell their product a lot of people are out of a job.
Alessandro Esteri

A good art director is one with a point of view.
Patrick Demarchelier

ADMIN

Thanks to the hundreds of extremely talented people who have shared some of the thinking behind their creativity.

My thanks also go to Michael Ash, Jack Bankhead, Bryan Bantry, Desmond Burden, Cheri Carpenter, Roy Carruthers, Axel Chaldecott, Anthony Clare, Leslie Cobden, Pat Cunningham, Annabelle Dalton, Erica Dreibholz, Amanda Fisher, Penny Foulkes, Martin and Anders Gaarder, Janet and Gil Galloway, Dave Gardiner, Mark George, Kerrie Griffin, Bill Hamilton, Bill Hammond, Sandy Heinen, Louise Higgins, Grace Hoo, Victoria Horstman, Hilary Howard-Grubb, Peter Hughes, Andrea Hyde, Branka Jukic, Lynn Kendrick, Frans Kuyper, Paul Langham, Sara Laurie, Roland Leach, Wendy Lietzow, Janice Lipzin, Rhoda Marshal, Eric Michelson, Robert Montgomery, Jay Myrdal, Deborah Nadler, Carolyn O'Connor, Noreen O'Leary, J. Barry O'Rourke, Gloria Palancia, Gail Pontrelli, Bob Prior, Tim Rich, Jane Rowe, Mark Shap, Robin Simmen, Sarah Smith, Steve Spelman, Tina Rogers, Nancy Scott, Dick Tarlow, Rick Tardiff, Susan Toland, Fritz Tschirren, Gwen Wallace, Marilyn Wallen, Alex Walton, Mary Warlick, Dave Waters, Graham Westmoreland, Nicola Wilkins.

For re-presenting this creativity so effectively, I am indebted to Christine Wood (design), Brian Robins (jacket design), Lisa Morris (design co-ordination and layout), and Richard Reynolds (commissioning editor) whose brickbats helped build the book.

INDEX